GRAPHIC-SHA

illustration
à la mode

an agent's point of view

CWC
CWC BOOKS

Edited by Junko Wong and Koko Nakano

junko wong
C.E.O. of CWC Group International

ジュンコ・ウォング　　CWCグループ・インターナショナル　代表取締役社長

Illustration à la Mode is a book about fashion—in the broadest sense. In an era of ever-permuting synergies, postmodern crossovers and unpredictable revisionism at every turn, it has become increasingly difficult to categorize fashion illustration. Just what is it? Fashion affects almost everything in the culture around us. Even fashion's most vocal detractors cannot escape it—indeed, "anti-fashion" as a critical viewpoint is, in its own way, a "look" that can be said to make a fashion statement of its own.

In the years I've spent as an agent, I've learned that someone who possesses good technique alone may not automatically make a good illustrator, either in fashion or in other fields. There is more to the illustrator's art. But if an image touches your soul and moves your spirit, then no matter how it was made, you know the artist will be successful. Our agency operates as a kind of curator for these talents, bringing them together with clients who need the assistance of image-makers to promote their brand, in order to make it stand out amongst the thousands of other brands trying to do the same.

Sensitive and thoughtful, original and creative, the illustrators whose work is featured in these pages are the in-demand image-makers who are routinely hired to capture and express the changing moods of society through the color, wit and fancy of their art. This is a book about their work—about lifestyle, humor, drama, sensuality, color, line and personality. The works in *Illustration à la Mode* reflect the evolution that each illustrator's style undergoes as they grow and experience life, savoring personal joys and confronting unforeseen challenges. After all, the world is in a state of constant flux, inevitably forcing the artists to respond to it with their art.

Illustration à la Mode showcases a select group of gifted individuals who have come to express themselves primarily through drawing. The images in this book have been chosen from a creative agent's point of view by CWC and CWC International. A brief artist's statement accompanies each selection of featured works. The artists comment on a variety of subjects, from favorite artists to current projects to sources of inspiration, and whether serious or whimsical, the answers to the interview questions bring us closer to the personality behind the image.

A little about us: in 1991, CWC incorporated and became the first Creative Agency in Tokyo to represent artists from foreign countries in the Japanese market. Today, we are a team of 9 agents who run a shop and gallery, and represent all of the artists in this book. In 1999, CWC International was established in New York, another step towards breaking down the wall of cultural and aesthetic differences and bringing the visual world together into one big, happy family. Today, many of our artists are represented globally. As mass promotional campaigns become borderless, we always marvel at how visual communication transcends cultural and language barriers. What touches one's heart and soul is essentially the same for everyone, everywhere in the world.

The artists we represent are the talents whose work is the soul and substance of today's illustration—as the title of this book indicates. Everyone here at CWC believes in our artists 100%. To us, they are unique, charismatic and extremely professional. At CWC, we are not just agents representing artists for a job—we take pride in being their producers and caretakers of their careers.

I would like to take this opportunity to dedicate this book to our counsel, Caroline Stone and all of the agents of the CWC Group who stand behind our artists—starting with senior agents, Malcolm Wong, Masaki Suminokura, Hiromi Sato, Yoshiko Koizumi, Azusa Kobayashi, Miyuki Kurata and especially to Keiko Hidaka, whose steadfast loyalty to myself and dedication to her job are truly appreciated and awe-inspiring.

「イラストレーションアラモード」は、最も広義におけるファッションについての本だと言えます。
近頃では、これまで人々が持っているファッションの概念を超えた新しいスタイルや、また、60年代、70年代のポストモダンのリメイクや、また、それらを融合した全く予想外のイメージなど、今や、ファッションイラストレーションをひとことで説明することは非常に困難になってきています。 それでは、本来ファッションとは一体何なのでしょうか？
ファッションは、私たちを取り巻くおそらく全てのカルチャーに影響を与えています。ファッションを声高に批判するものもまたファッションからの影響から逃れられないのです。 実際、ファッションに批判的な視点を持つ『アンチ・ファッション』ですら、ひとつのファッションのスタイルの表現として位置付けされています。

これまで、私が、エージェントとして学んだ事は、優れた技術を持つ人が必ずしも良いイラストレーターになれるとは限らないという事です。 イラストレーターには、テクニックの高さだけでは語れないものがあるのです。 言いかえれば、あなたの心に響く感動的なイメージに出会ったら、それがどのようなレベルのテクニックで描かれたものであっても、そのイラストレーターは素晴らしい表現者なのです。
私たちは、こういった才能をもったアーティストたちのキュレーターとしてクライアントと私たちのアーティストを結び付ける役割を果たしています。 よいアーティストと出会うことで、クライアントは、競争の激しい広告業界の中で自らのブランドをより効果的にプロモートできるようになるのです。

今回、この本に紹介されているイラストレーターたちは、それぞれが、感覚的でいろいろなアイディアに富み、オリジナリティあふれるクリエイターです。 色やウィット、そして卓越したテクニックを使って、常に変わりゆく社会のムードをとらえ、それを表現できるイメージメーカーたちです。
この本は、彼らの作品集でもあり、また彼らのライフスタイル、ユーモア、ストーリー性、官能性、作品の色、線、パーソナリティについての本ともいえます。「イラストレーションアラモード」に掲載された作品は、それぞれのイラストレーターが経験してきた人生の幸福や予期せぬ困難から得た成長の証しです。 常に流動的な世界で生きているアーティストが、社会からの影響を作品に込めて表現する事は当然の成り行きと言えるでしょう。

「イラストレーションアラモード」は、選ばれた才能あるアーティストたちが、ドローイングという手法によって自己表現した集大成です。 この中に紹介されるそれぞれのイメージは、クリエイティブ・エージェントの視点からCWCとCWCインターナショナルが選びました。 また、作品と一緒に、各アーティストたちの簡単なコメントも収録しました。 それぞれのアーティストは、自分の好きなアーティストについて、現在手がけているプロジェクトについて、あるいは、インスピレーションの源について、など、さまざまなトピックを、あるアーティストは真面目に、また、あるアーティストは軽いノリでコメントしています。 それらの言葉は、イメージの背景にあるアーティストのパーソナリティをより身近なものにしてくれるでしょう。

少しここで、CWCのことについて説明しましょう。
CWCは、1991年に日本のマーケットで外国人のアーティストをプロデュースする最初のクリエイティブ・エージェンシーとして設立されました。 現在、ショップとギャラリーを有し、9人のエージェントによってイラストレーションアラモードに掲載されているアーティストたちをプロデュースしています。 1999年には、ニューヨークにCWCインターナショナルを設立し、文化の壁、美意識の違いを越え、ビジュアルの世界をひとつの大きな "ハッピー・ファミリー" に統合しました。
私たちは現在、この本に掲載されているアーティストのほとんどをグローバルにプロデュースしています。 大規模なプロモーションキャンペーンが国境を越えて行われる今、ビジュアルコミュニケーションは文化的、言語的な壁を超越しています。人の心や魂に訴えかけ感動をもたらすものは、世界のどこであっても、また、誰にとっても共通なのです。

私たちがプロデュースするアーティストの作品は、現代のイラストレーション（"イラストレーションアラモード"の意）の真髄であり本質であるといえます。 CWCのスタッフは、アーティストの可能性を100%信じています。彼らはユニークな才能とカリスマ性を兼ね備えたプロのアーティストです。 CWCの仕事は、そんな彼らにただ単に仕事を取ってくるだけではありません。 私たちは、彼らのプロデューサーであり、彼らのキャリアを守り育てる手助けをしているのです。

この場を借りて、私たちのアーティストたちを守るために努力し続けているCWCグループのスタッフ全員に、この本を捧げたいと思います。 キャロライン・ストーン、マルコム・ウォング、角之倉真幸、佐藤裕美、小泉歓子、小林あづさ、倉田みゆき、そして特に日高啓子のエージェントとしての仕事への熱意とCWCへの変わらぬ献身ぶりには、心からの感謝とともに敬服をおぼえます。

koko nakano
Vice President of CWC International, New York

中野圭子　CWCインターナショナル・ニューヨーク　副社長

Junko Wong, C.E.O. of CWC Group International, interviews Koko Nakano, Vice President of CWC International, New York.

1. What do you love about illustration?

Illustration is one of the most primitive media of communication between people, yet it remains one of the most effective. It can convey abstract concepts such as trends, feelings and sophistication, while illustrating its subject realistically as well. Also, illustration allows the viewers to expand their imaginations and comprehend the illustrators' intent while tracing back the passage of creativity the illustrators took, beyond the limit of the realistic world. A good illustration can give you inspiration, joy and a positive feeling. And that is what we work with every day—that is what I love about illustration.

2. Do you find that the same artists are successful everywhere, or do various markets differ in terms of taste or expectations?

I think the same artist can be successful everywhere. I believe that a good illustration can touch the human heart deeply, regardless of place or time.

3. Why do you think CWC International has become successful? Persistence? The roster of artists? The international nature of the company?

All of the above. More important, however, is the trust between us and our artists, and the teamwork of the staff in New York and Tokyo. I trust our artists' talent and their potential for commercial success all the way. When a person is selling something, nobody is more convincing than someone who has 100% confidence in his or her product. I feel that the artists trust me as well, and that drives me to push myself even harder.

The bond between the American and Japanese offices is extremely important. Because the offices are situated in different markets, we have differing perspectives which can be very valuable when executing projects like this book, for example. Especially as clients' needs become more global, to be successful artists will have to be constantly evaluated by all different viewpoints and understood in the context of many different markets. To achieve this, the American and Japanese offices are in constant communication, discussing each artist's unique potential in our respective markets.

4. How do you see the future of illustration?

Though it is a slow process and there still exists a kind of barrier between fine art and commercial art—which is often difficult to cross, especially in the USA—the opportunities for illustrators are definitely increasing. Some of our illustrators have managed to situate themselves so that they can jump back and forth and essentially do whatever they want to do—sell their fine art paintings and at the same time, execute illustrations for a boutique window display, or hold a solo show in a gallery and design toy graphics at the same time. The future for commercial illustration is promising. Compared to when we started CWC International six years ago in New York, clients are much more willing and accustomed to hiring illustrators. Recently in the US, the hybrid of illustrations incorporating photography became popular due to illustration's ability to add warmth, friendliness and originality to the photographic image. I imagine that some people have become more receptive to illustration by seeing such transformed photographic images. Overall—though I must mention that there are some negative forces in the commercial art market like the dramatic increase of stock illustrations—it's an exciting time to be working in the illustration business right now if you are talented and have an original viewpoint and style. Today's market will undoubtedly present you with a multitude of opportunities.

ジュンコ・ウォング（CWCグループ・インターナショナル　代表取締役社長）が、中野圭子（CWCインターナショナル・ニューヨーク副社長）にインタビューしました。

1. イラストレーションのどんな部分に惹かれますか？

イラストレーションは、人と人をつなぐコミュニケーションの道具として、最も原始的であるにも関わらず、今なお最も効果的な道具として活用されています。リアリスティックに対象物を描く事もできれば、人の感情、テイスト、トレンドといった抽象的なイメージも表現できるとても有効なコミュニケーション手段なのです。　また、受け手側には、リアリティの枠に促われずにイラストレーションが導くイメージの世界を頭の中でさらに膨らませ、思い思いの解釈をしながら作り手の意図にたどり着くことができるという楽しみもあります。

良いイラストレーションは、人にインスピレーションや喜び、そして前向きな感情をもたらしてくれます。　そして、それがまさに私たちが日々扱っているイラストレーションであり、私がイラストレーションに惹かれる理由です。

2．同じアーティストが、世界中どの地域でも成功するという可能性はあると思いますか？　それとも、地域的なマーケットによってテイストとか求めるものは違うのでしょうか？

同じアーティストが世界の様々な地域で成功を収めることはあり得ると思います。　いい作品というのは、地域的な違いや時代の違い等に関わらず人の心の奥底に感動を与え、受け入れられると思います。

3．CWC－iの成功の鍵は何ですか？　粘り強さ？　アーティスト？　会社の国際性？

もちろん上記全てが必要でした。しかしもっと大切なのは、アーティストと私たちとの信頼関係、それから、東京とニューヨークのスタッフとのチームワークでしょう。

私は、CWC Internationalがスタートしたときから、私たちがプロデュースしているアーティストの才能と成功をずっと信じていました。　何かを売り込むときにその売り物に100％の自信を持った人が誰よりも強いというわけです。　それに加え、アーティストが私を信じてくれているという実感が、私をさらに前につき動かしてくれていると思っています。

日本のオフィスとアメリカのオフィスとのつながりも、また、とても大切だと感じます。　例えばこの本のようなプロジェクトを手がけるにしても、私たちのように違ったマーケットで違った視点を持っている人がつながる事は、私たちに大きなメリットを与えてくれていると思います。　クライアントのニーズがグローバル化する今、複数のマーケットの視点によって評価され、理解される事が成功の秘訣ですから。

私たちは、それぞれのアーティストのそれぞれの個性をいかにこの大きなマーケットの中で成功につなげるか常に連絡を取り合い議論を重ねています。

4．イラストレーションの将来について、どう思いますか？

イラストレーターの活躍の場は、ゆっくりとしたペースではありますが、多くなってきていると思います。　もちろん、ファインアートとコマーシャルアートの壁は、特にアメリカではまだまだ厚いですが、そんな厚い壁を乗り越えて、やりたい事を好きなようにできるイラストレーターが目立ってきています。　ギャラリーで自分の作品を売りながら、同時にファッションブランドのウィンドウディスプレイ用のイラストを描いたり、あるいは、ギャラリーで展覧会を開催しながら、おもちゃのフィギュアのグラフィックスを手がけたりと、さまざまなジャンルで活躍することが前よりも頻繁になってきています。

コマーシャルイラストレーションの展望について見ても、とても明るいと思います。　6年前にCWC Internationalが設立された頃から比べると、イラストレーションの需要は増えてきているのではないでしょうか。　特に最近、アメリカのコマーシャル界で目立って使われた写真とイラストを合成させたイメージは、写真だけでは表現し得ない温かみや親近感、個性が、イラストによって加わり人気となりました。　これらのイメージをみてイラストの重要性や魅力を認識した人も多かったのではないでしょうか。

今のイラストレーション界を語るとき、ストックイラストレーションの急増といった状況が存在する事も確かですが、オリジナリティと素質のあるアーティストたちにとっては、様々な活躍の可能性が持てるとても面白い時だと言えるでしょう。

global

The artists in this chapter are represented globally by the CWC Group.

本章に掲載されているアーティストは、CWCグループがグローバルにプロデュースしています。

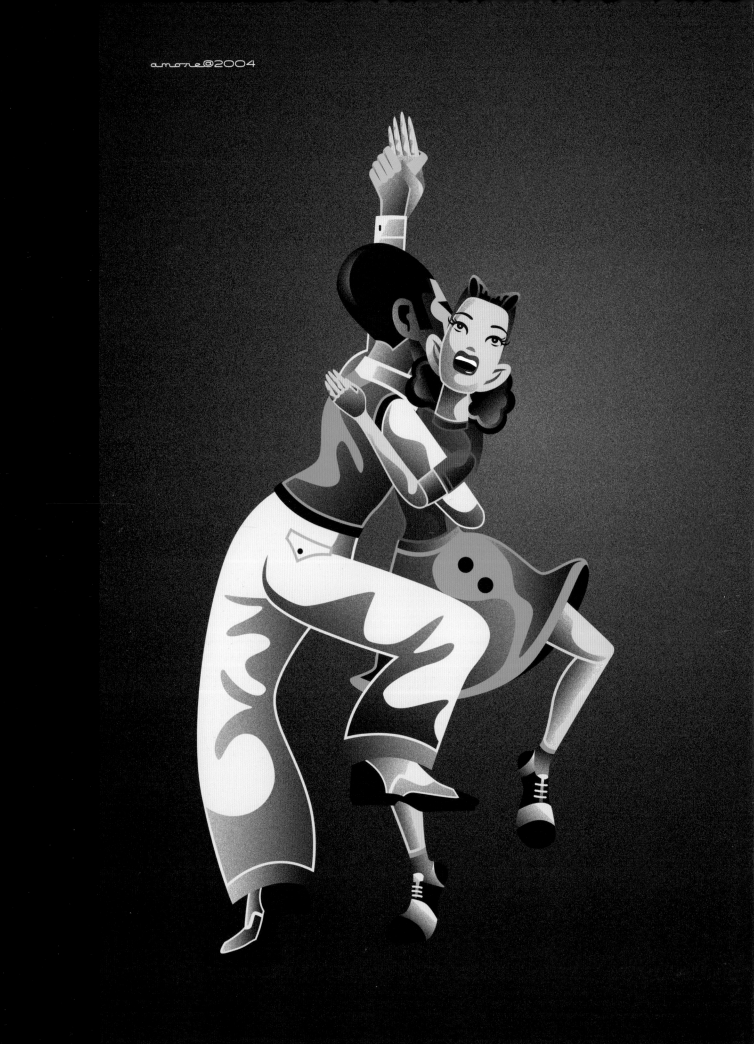

amore hirosuke

アモーレ★ヒロスケ

What is "fashion" in your context?
All the reasons to be living in a city.
Something I cannot live without.

Favorite food? Your favorite food as a child?
As a child, regular Japanese curry with rice. Now I can stomach spicier curries too.

あなたにとって、「ファッション」とは？
都会で生きている意味の全て。
これなしには生きていけない。

一番好きな食べ物は何ですか？子供の頃の大好物は何でしたか？
子供の頃は普通のカレーライス。今は辛いカレーも大丈夫。

this page: lindy hop, 2003
p.10: SWINGIN', 2004 (exhibition invite)
p.11: untitled, 2003

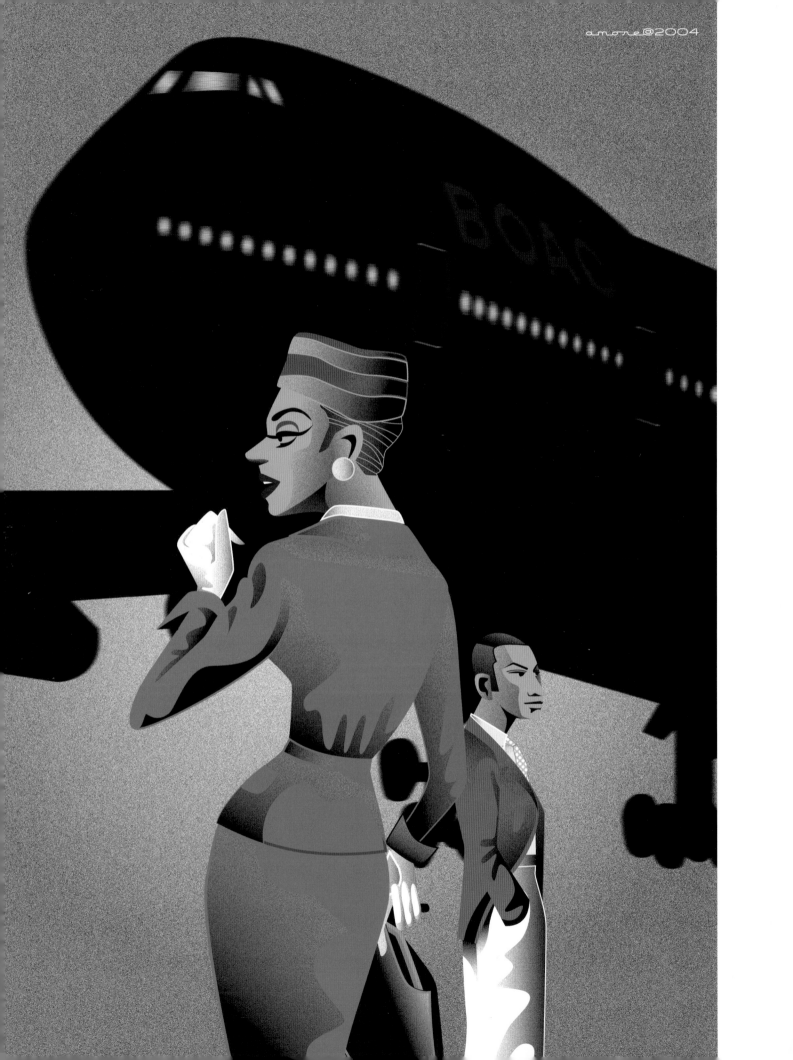

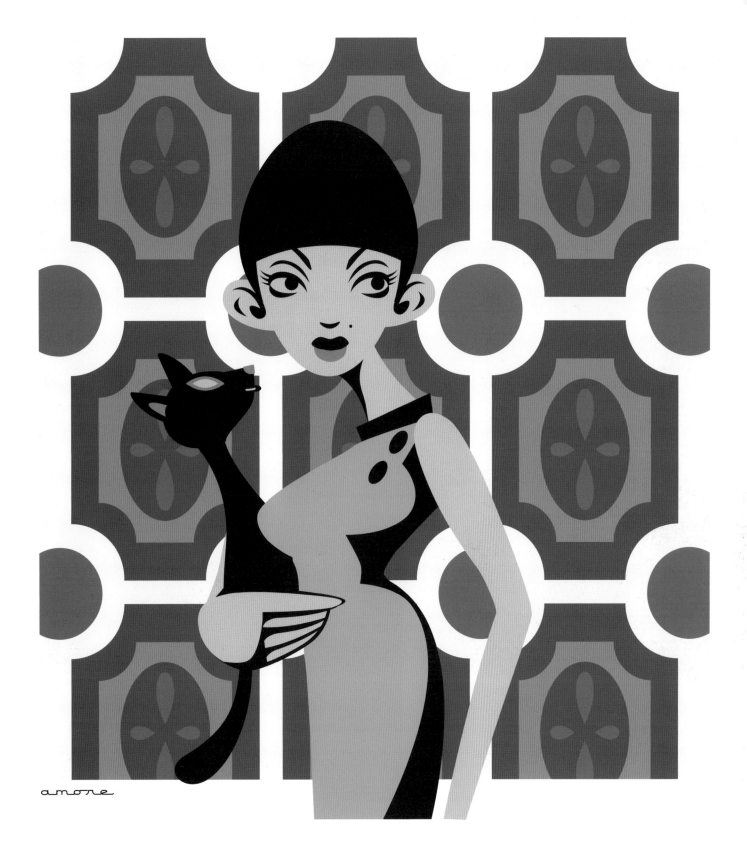

annika wester アニカ・ウェスター

What kind of changes do you expect in your art over the next few years?
I will work more on my own projects besides assignments—I will make some of my illustration ideas in 3D and have my work exhibited. For assignments, I want my illustrations to be seen more on ads and packaging.

What is your favorite fairy or folk tale?
The Moomin Valley

これから数年の間に、あなたのアートはどんな変化を遂げると思いますか？
お仕事以外の個人的なプロジェクトをもっと進めていきたい。自分のイラストを３Ｄで表現したり、どこかで展示会を開いたり。もっと自分のイラストを広告や商品パッケージでも見てみたい。

一番好きな童話は？
ムーミン

this page: Lucky, 2004 (Leva)
p.14: Fairy, 2005
p.15: Invitation, 2005

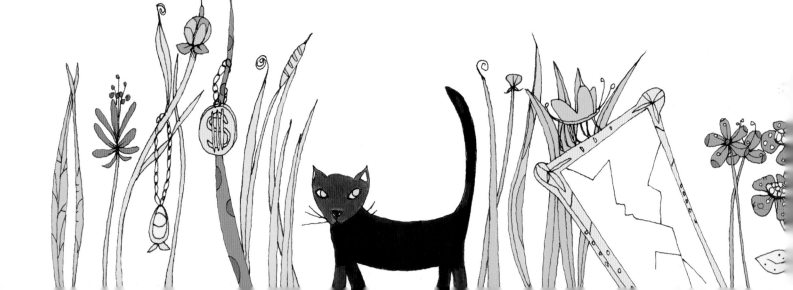

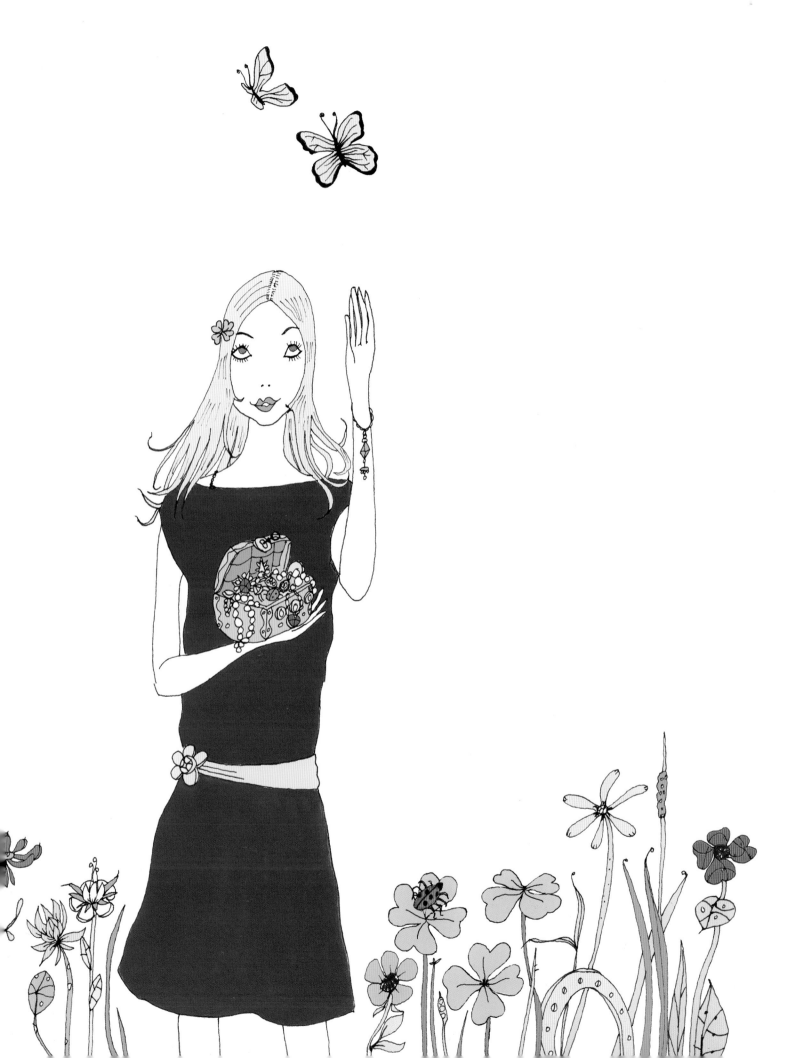

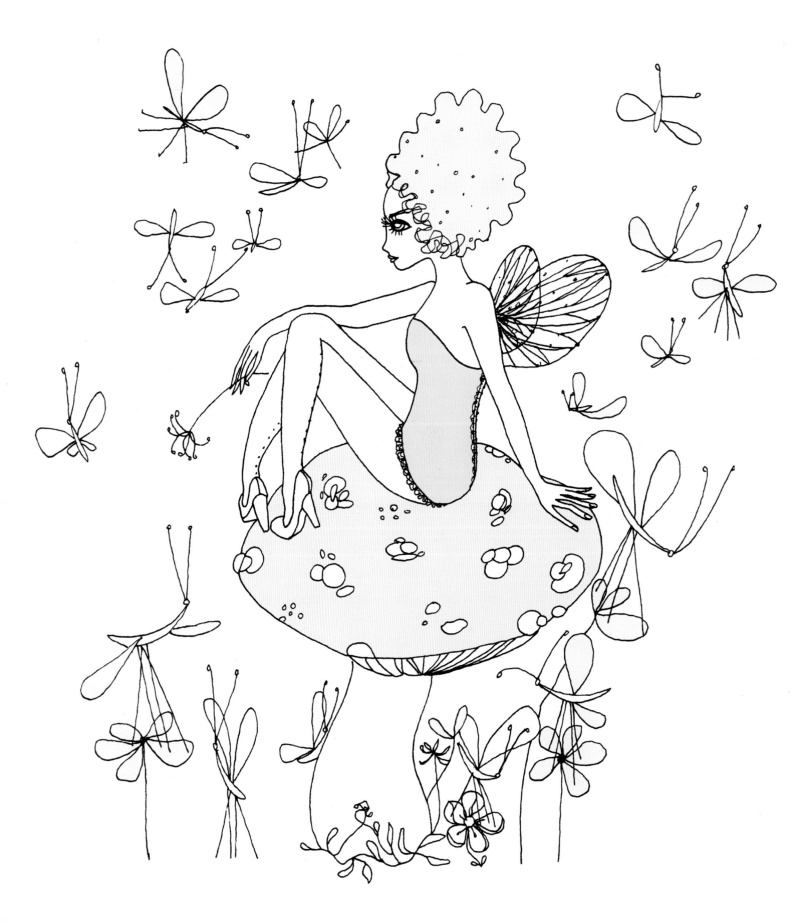

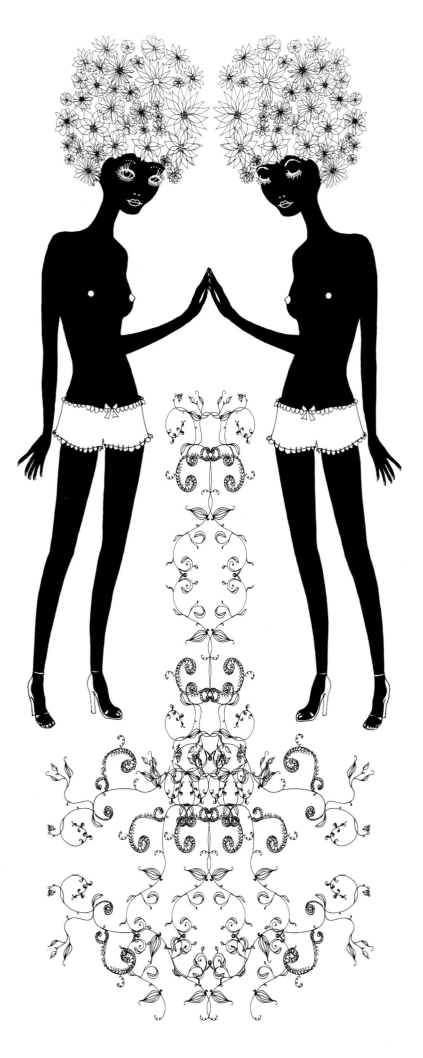

chico hayasaki はやさきちーこ

What is "art" in your context?
Whether creating or observing, art is something I have never tired of, and probably never will. For me, the act of illustrating is a series of discoveries, it is stimulation and experimentation, and it is also something of a haven for myself.

What is your current dream project?
I would like for my own works to be translated into various merchandise, especially those in the fields of interior decoration and fashion.

What skill or technique do you wish for?
I wish I had better foreign language skills and knew how to play an instrument well. I used to play the piano but quit, and have regretted it ever since.

あなたにとって、「アート」とは？
他人の作品を見ることも、自分が作品を作り出すことも、全くあきることのないこと、多分これからも一生あきることはないと思います。「イラストを描く」ということは、私にとって発見の連続であり、刺激の連続、いろいろと試してみたくなる実験の連続であり、また、自分の身を自由に置いておける居場所のようなもの。

あなたのキャリアにおける具体的な夢を教えてください。
自分の作品の商品化への展開、それを私の好きなインテリア、雑貨、ファッション関係に広げていきたい。

自分にあったらいいと思う特技、スキルやテクニックはなんですか？
語学と楽器。ピアノを習っていたのですが途中で中断してしまったので、もっとやっておけば良かったという思いから。

this page: untitled, 2005
p.18: busy town, 2004
p.19: Poppy, 2005
p.20-21: sofa, 2005

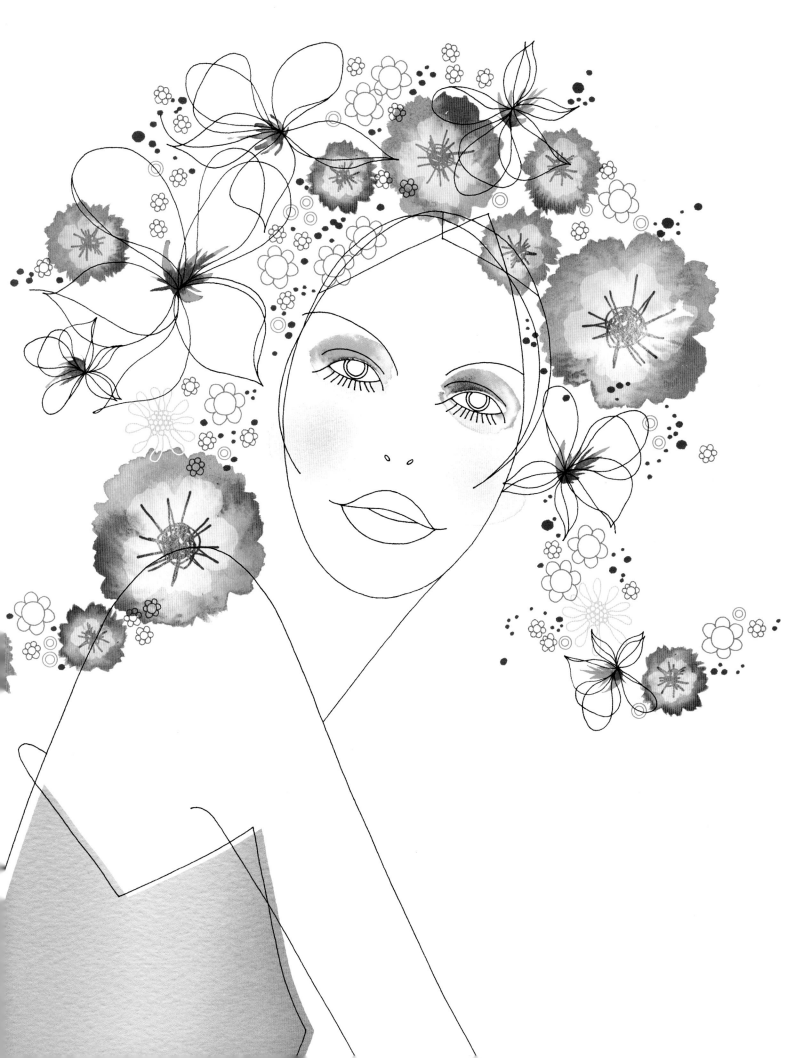

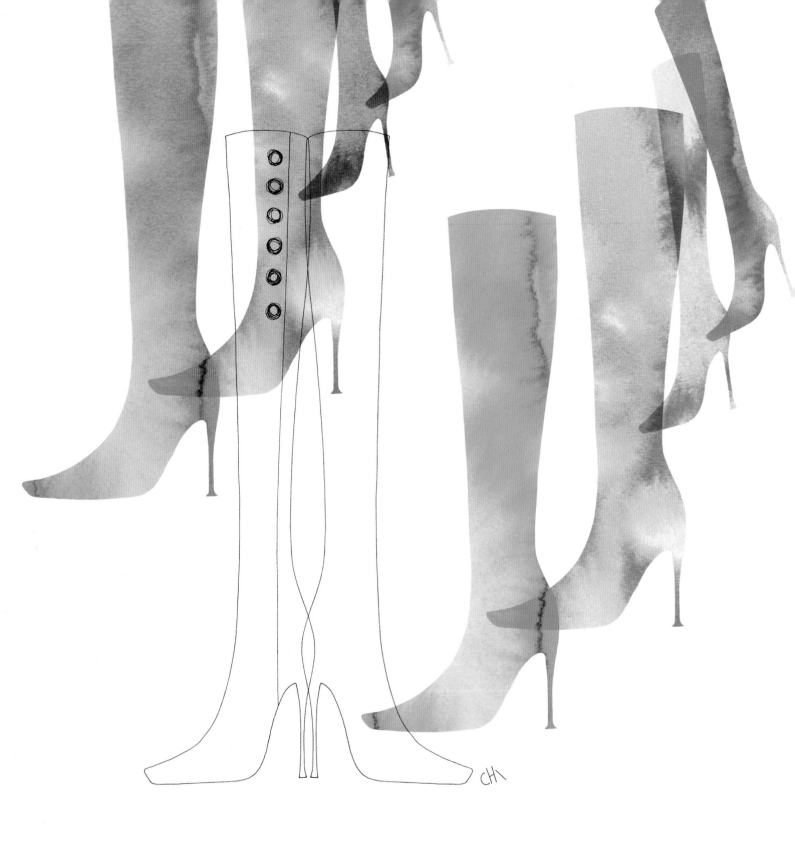

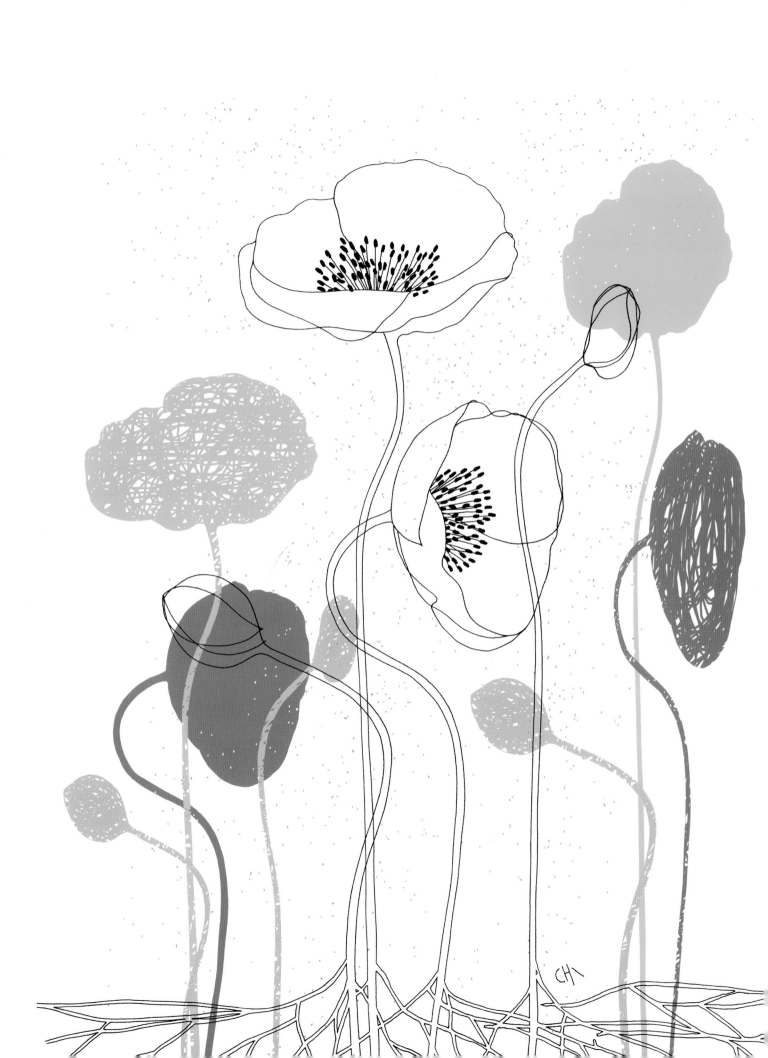

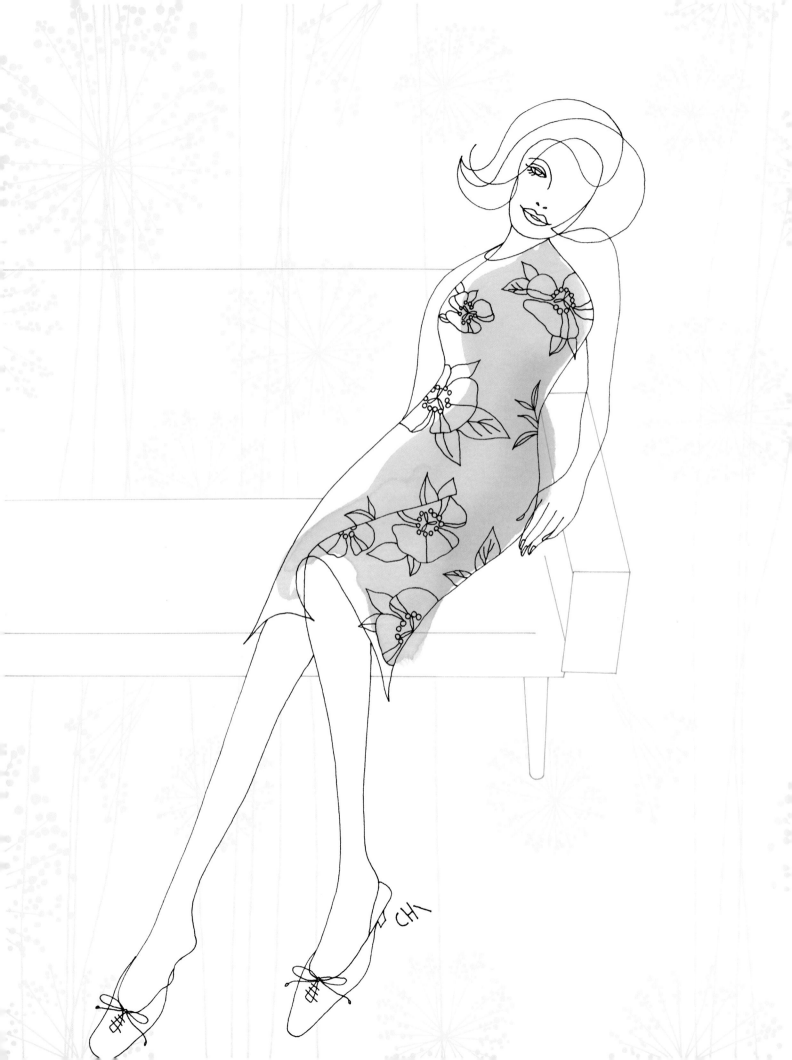

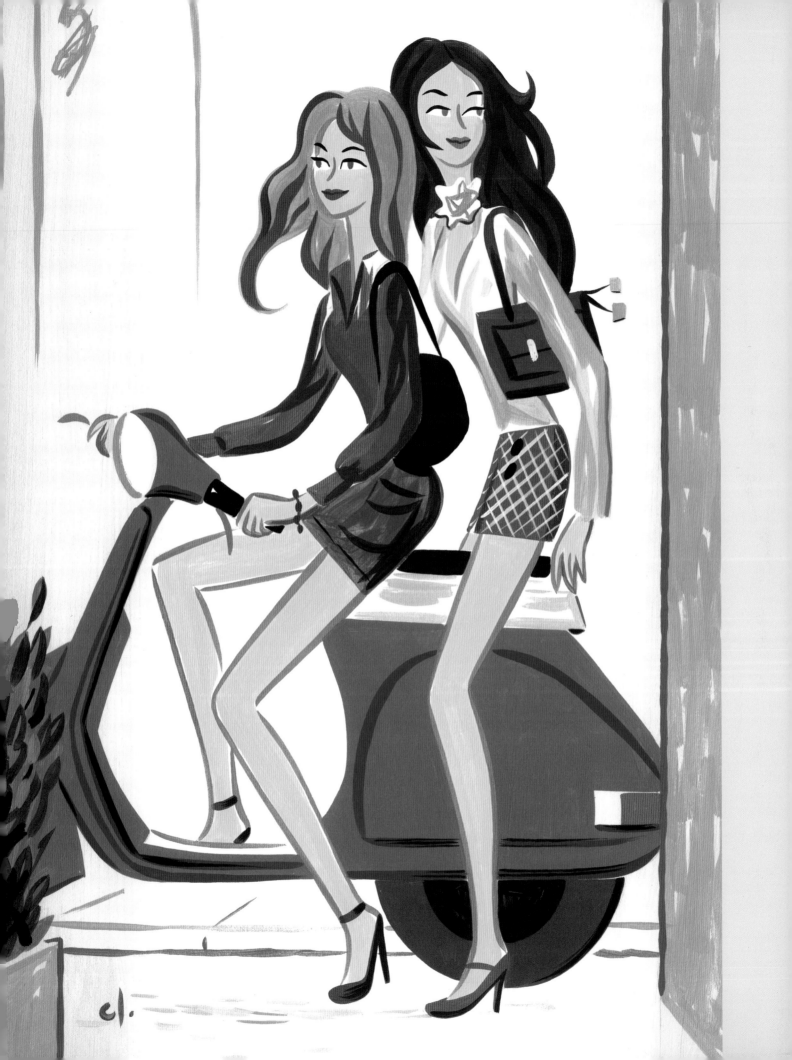

How did your background affect your art?
Well, I was brought up by the sea in Blackpool in the northwest of England, a place that is colorful in every sense of the word! It is a feast for the eye and, when I think about it, I'm sure that a large part of my visual vocabulary, the way I see the world, was nurtured amongst the neon signs of its amusement arcades and faded splendor of its Victorian ballrooms.

Where do you feel most at home?
The seaside always gives me a sense of peace (see above!) but London is my home now and if I've been away, I always look forward to walking its streets again and people watching. I love that.

あなたの育った環境はあなたのアートにどのような影響を与えていますか？
そうだね、僕はイギリスの北西部ブラックプールの海辺で育ったんだけど、そこは本当にあらゆる意味でカラフルなところなんだ。まさに目の保養と言える。考えてみると僕の視覚的なボキャブラリ、言うなれば僕の世界を見る目はあそこのアーケードのネオンサインやビクトリア調のダンスホールの色あせた栄光の中で培われたと思う。

どこが一番落ち着きますか？
海辺はいつも安らぎを与えてくれるけれど、今の故郷はロンドン。ロンドンを離れる度に、早く戻って人々を観察しながらその町並みを歩くことを心待ちにするんだよ。

opposite: Let's Go!, 2004
overleaf: scenes from The World of Boo, 2005
pp.26-27: On the Beach, 2005

chris long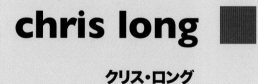

クリス・ロング

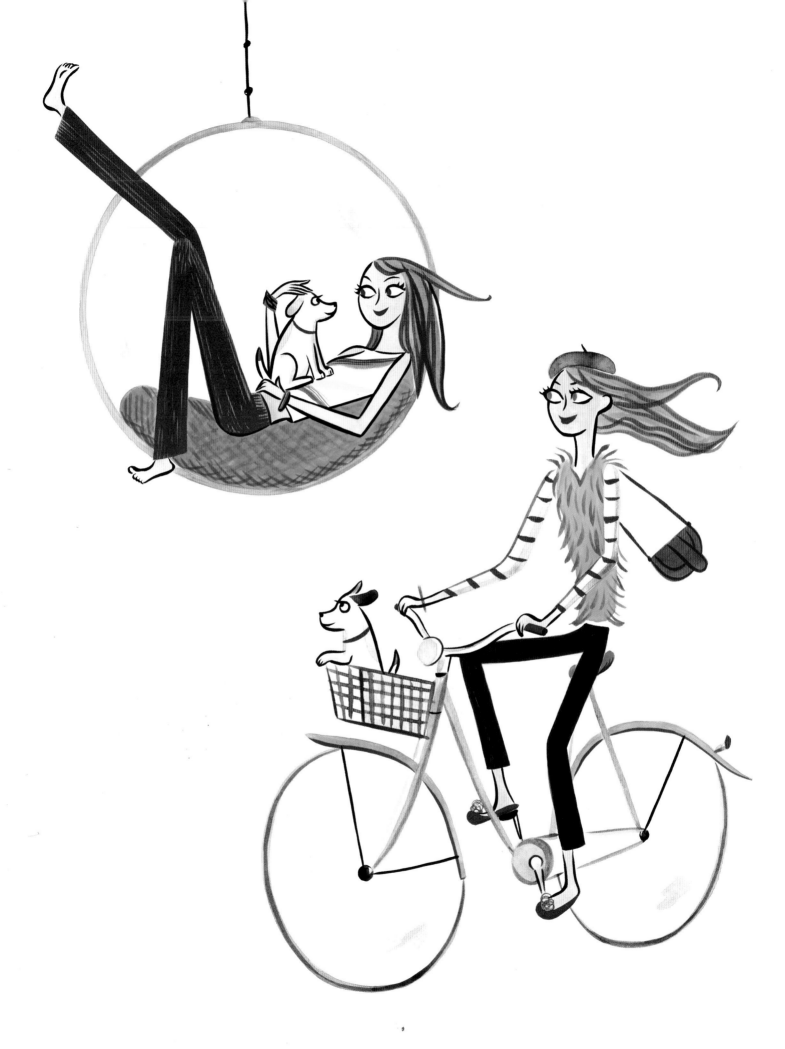

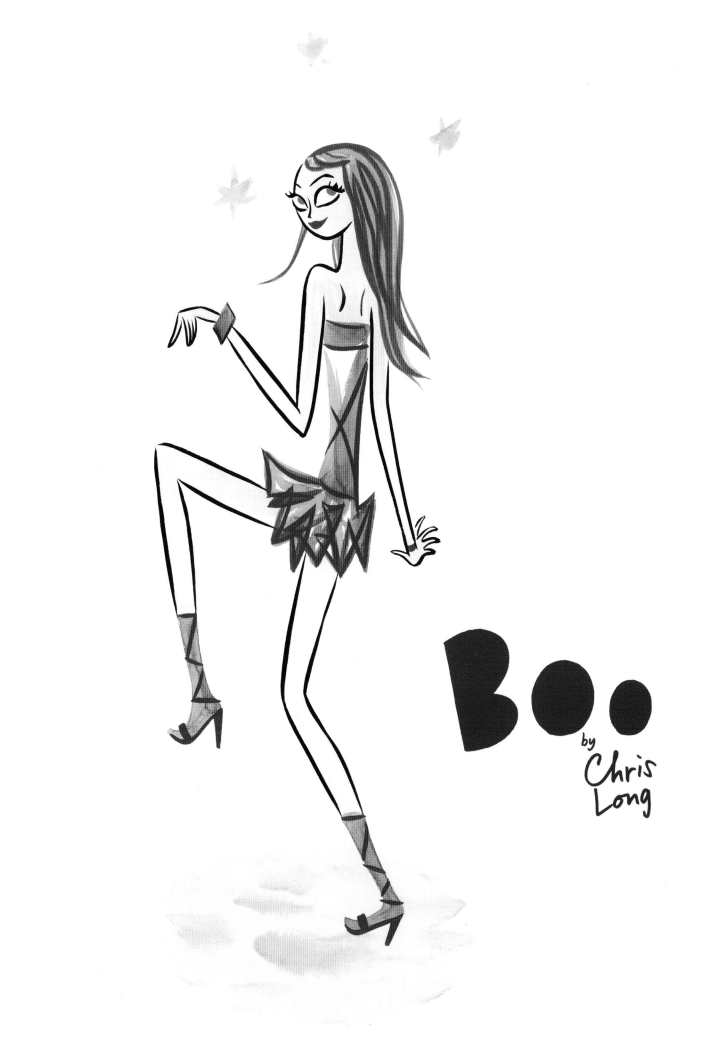

Boo
by
Chris
Long

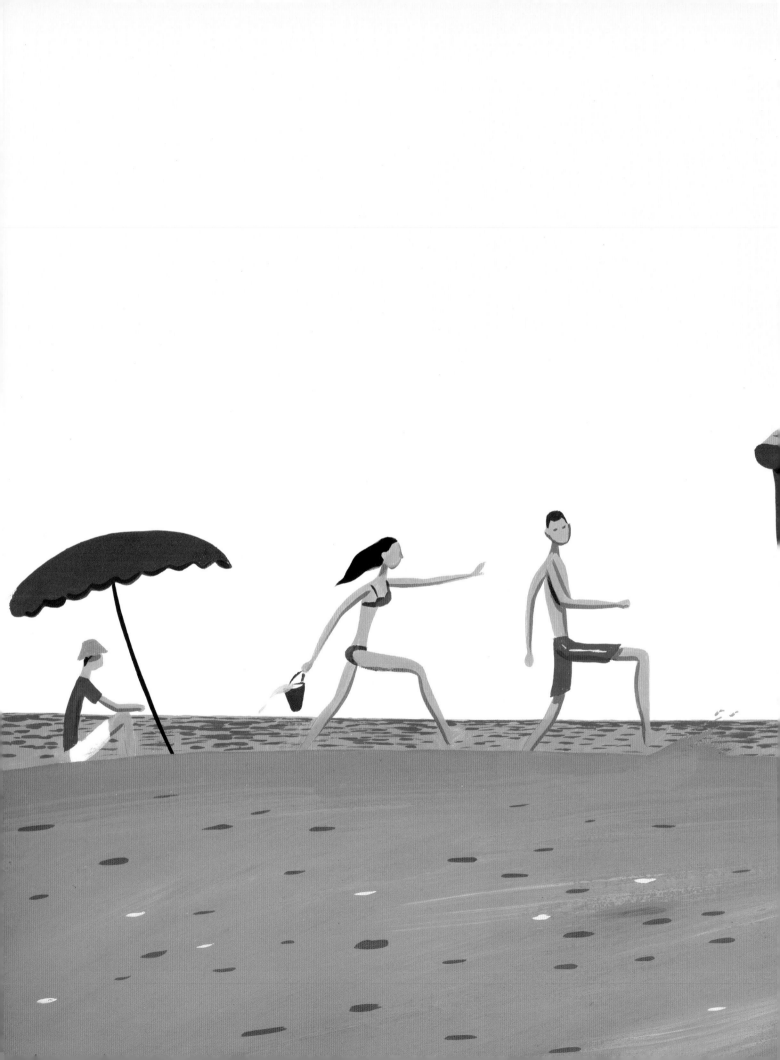

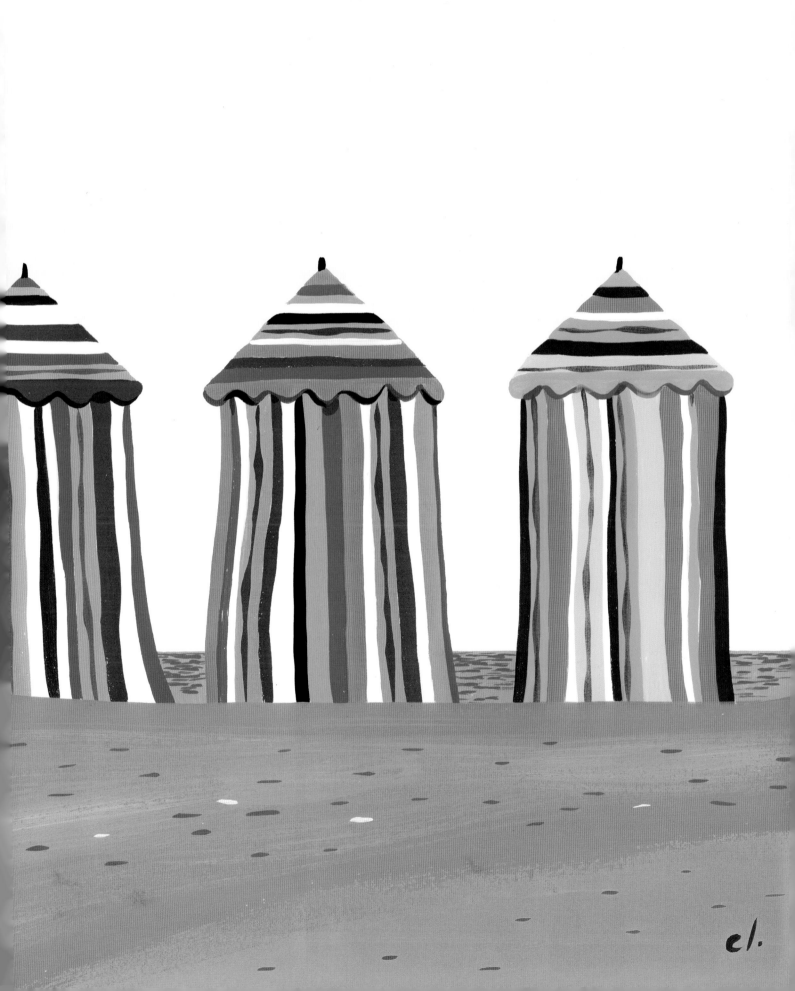

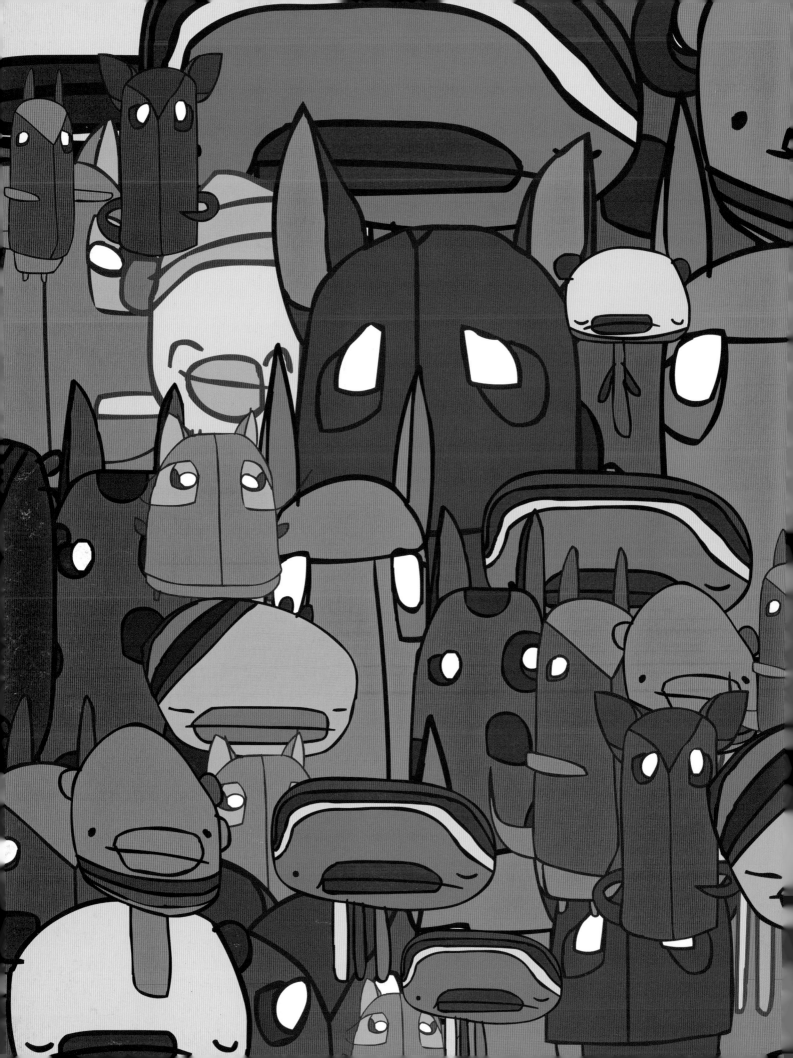

dynamo-ville
ダイナモ - ビル

What is your current dream project?
keith: I would love to do a television show. A variety-type show with puppets, cartoons, a crazy set, songs, and musical guests and famous actors. The show would take place on an island, and every week someone else would get stranded there. Then all of the characters would spend the whole time trying to figure out a way to get the guest rescued because they like their island better without movie stars or musicians, or people for that matter.
alisa: My dream project would be to create a theme park about dynamo-ville. It would have rides like the "serious sally does her homework" roller coaster. It would also have stage shows where the characters from dynamo-ville would sing and dance and encourage audience participation. And it would have a huge area of carnival games where you could spin wheels and toss beanbags to win special dynamo prizes. It would be a total blast!

What is your favorite time of the day? Why?
keith: I love the middle of the night/early morning. Like around 3-4 am. It's nice and quiet, and it feels like a dream even though I'm awake. It's also too late to get a good night's sleep, so it makes the next day really strange. It's also when I'm most creative.
alisa: My favorite time of day changes with the seasons. In spring it's when the sun is warmest at mid-day where you can see the little buds and the sun feels very warm and everything is waking up and new. In summer it's late in the evening when it's cooled off but people are still out on the streets looking for summer fun. In fall it's late in the afternoon before the sun goes down when the leaves are crunchy and smell nice, it's warm but you need a sweater. In winter it's late at night after a beautiful snow fall. It's so nice when the snow is sparkly and crunchy under your feet and the air is crisp and the stars are out.

あなたのキャリアにおける具体的な夢を教えてください。
Keith：TV番組を作ってみたいな。ぬいぐるみが登場するバラエティ番組。マンガやぶっ飛んだセットや歌の中で、有名俳優やミュージシャンをゲストとして迎えるんだ。舞台はどこかの孤島で、毎週ゲストがそこに漂流してくる。そこで毎回ぬいぐるみのキャラクターたちがどうやってゲストのために助けを呼ぶか色々試行錯誤するんだ。だって彼らは映画スターやミュージシャン（というより人間）に自分たちの島に住んでほしくないからね。
Alisa：私の夢はdynamo-villeのテーマパークを作ること。そこには「まじめなサリーが宿題を片付ける」ジェットコースターとかいった名前の乗り物がたくさんあるの。もちろん、dynamo-villeのキャラクターたちが歌って踊って観客にも一緒に参加してもらえるようなステージもあるのよ。それに、輪投げとかのミニゲームが楽しめる大きなゲームエリアもあったりして、絶対楽しい！

一日のうちで一番好きな時間はいつですか？
Keith：僕は真夜中から早朝にかけての時間が大好き。午前３－４時頃。とても静かでいいし、起きているのに夢の中みたいなんだもの。それに、今更寝てもぐっすり眠れない時間だから、次の日とても奇妙に感じるんだ。僕が最もクリエイティブになる時間でもあるんだ。
Alisa：一日で一番好きな時間は季節によって変わる。春だったらお日様が一番暖かいお昼時。柔らかなお日様の日によって小さなつぼみが開き始め、すべてが新しく起きだすの。夏はやっぱり夜。すっかり涼しくなってはいるのだけど、みんなが夏の楽しみを求めて街を漂っている時間。秋になると午後の遅い時間、日が落ちる前。落ち葉がざくざくしていい匂いがして、まだ暖かいんだけどでもセーターは必要。冬で一番好きなのは深夜、美しい雪が降った後。足の下の雪がきらきらざくざくしてて、空気がキンとして空には星が出ているの。

this page: untitled, 2004
p.30: untitled, paper dolls, 2003
p.31: untitled, 2004

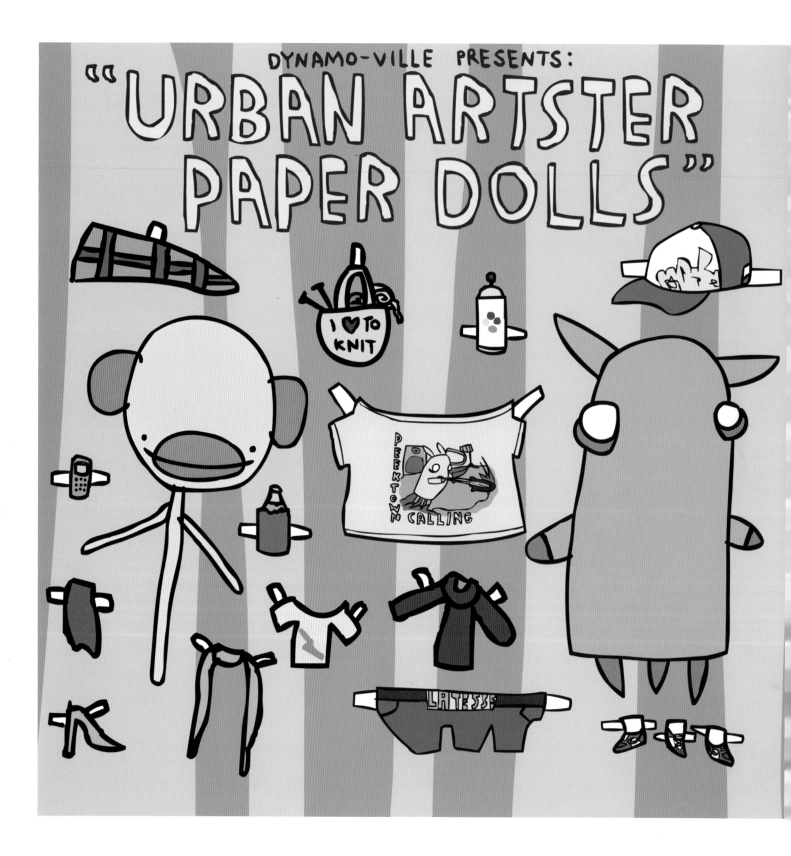

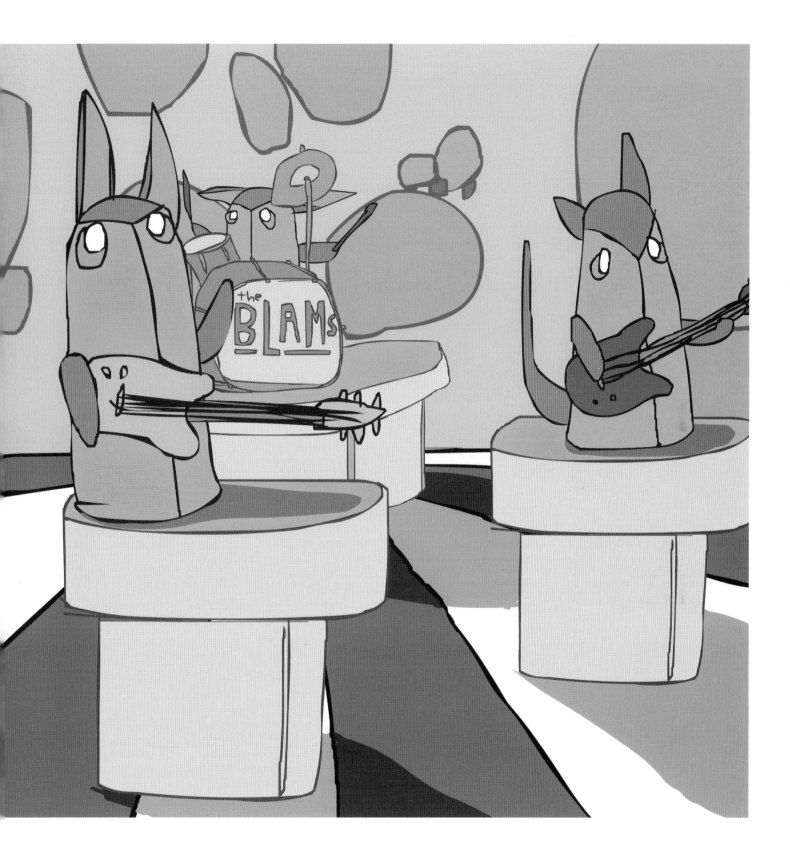

erotic dragon
by miho sadogawa
エロティックドラゴン

What are you visually inspired by?

Inspirations, or hints, for creation are everywhere in this world. But I, in particular, often draw inspiration from Asian cultural heritage and traditional arts, contemporary youth culture as conveyed by manga and animation, and turn-of-the-century European artists such as Klimt.

Favorite movie?

I love film, it's incredibly difficult to single out a favorite movie. I love all the animated movies by Mamoru Oshii, and I am such a Derek Jarman fan that I own all of his movies that are currently available. In addition, I am not usually into fantasy stories, but I admit that The Lord of the Rings series is amongst my many favorites.

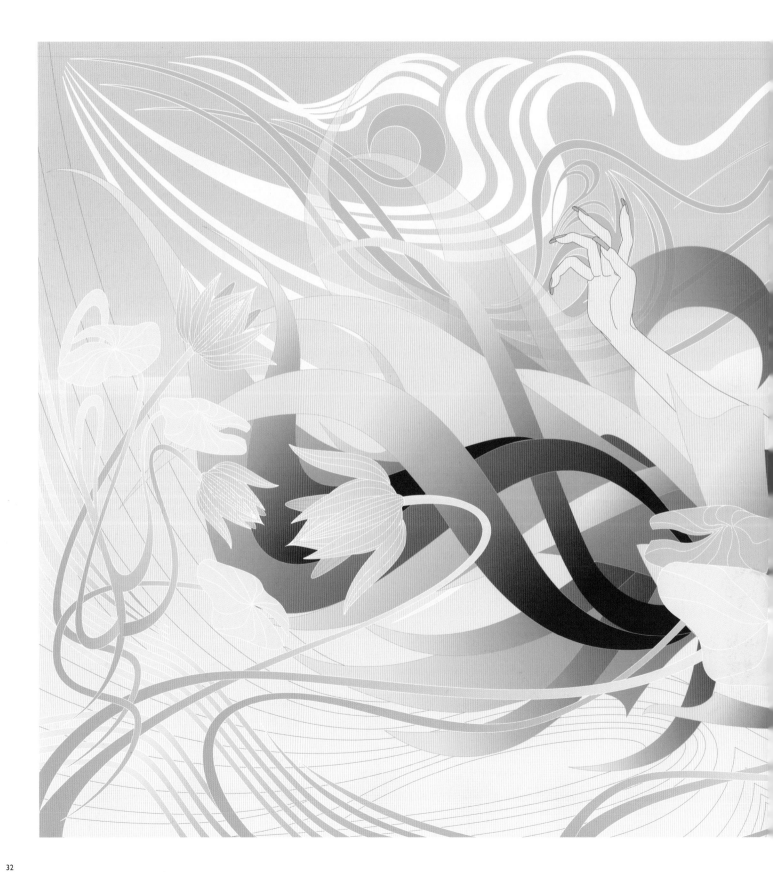

this page: Navigator of Paradise, 2004 (Maxalot)
p.34: 山人 (Yamabito), 2004
p.35: Lai Lai 3D poster, 2004 (Dub Project/Alpha Points)

あなたのヴィジュアル的なインスピレーションの源は何ですか？

創作のために有益なインスピレーションや、あるいはヒントになりうるものは世界のどこにでも落ちていると思います。ただ、私の場合、とくに、アジアの歴史文化や伝統芸術から現代のマンガやアニメーションを初めとするユースカルチャー、それに、クリムトなどの19世紀末ヨーロッパの美術作家たちの作品から得る事が多いです。

一番好きな映画は何ですか？

映画を見るのはとても好きなので、どれか一つを選ぶのはとても難しいですね。押井守監督のアニメーション映画はどれも大好きですし、デレク・ジャーマン監督の映画も、発売されているDVDソフトを全部そろえてしまうくらい好きです。それと、もともとファンタジーものは苦手なのですが、実はThe Lord of the Ringsは私のお気に入りの一本です。

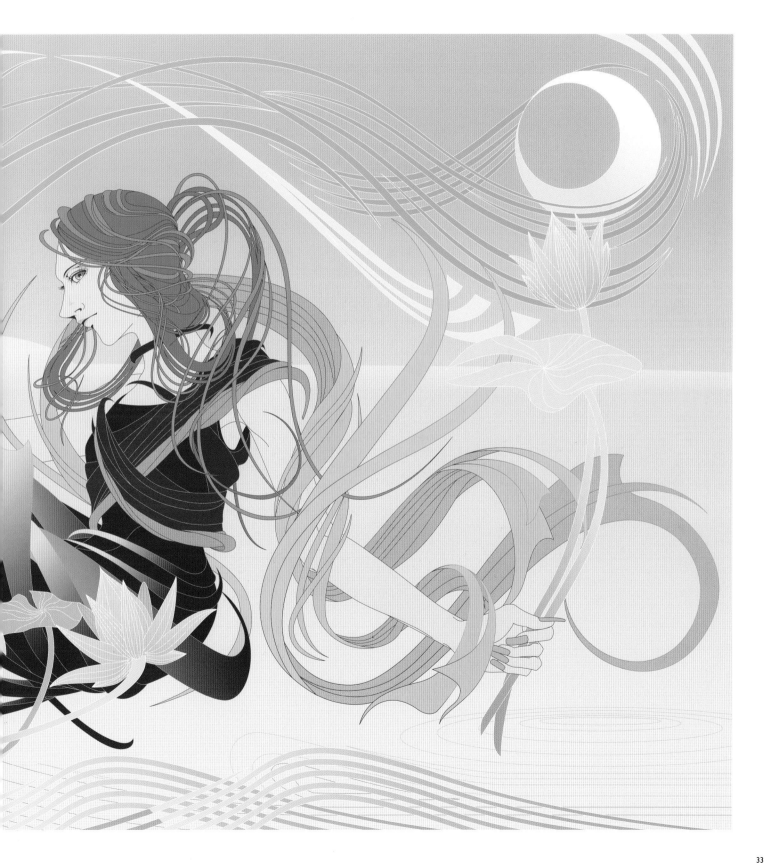

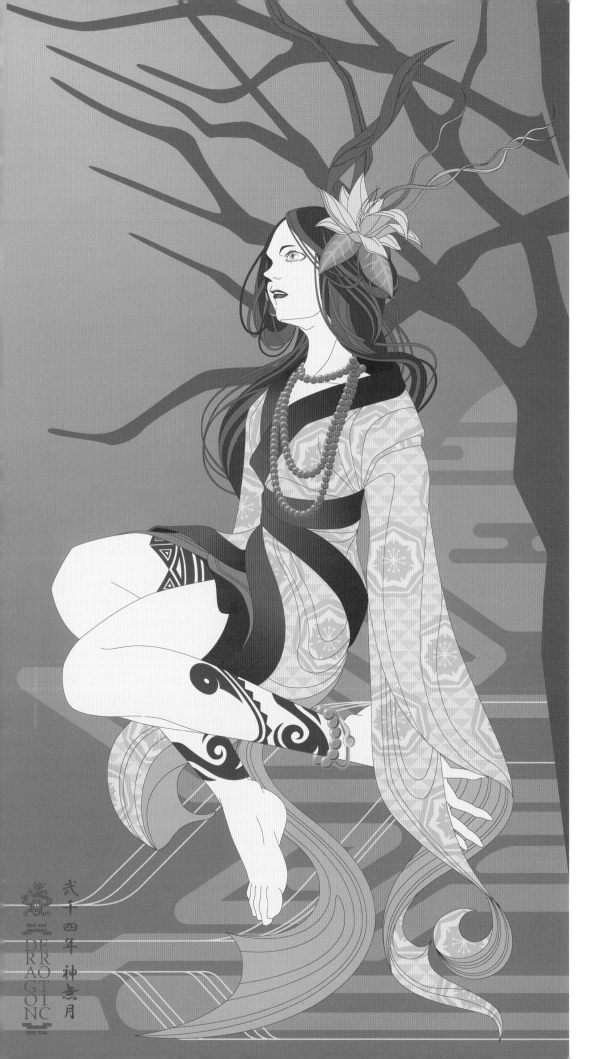

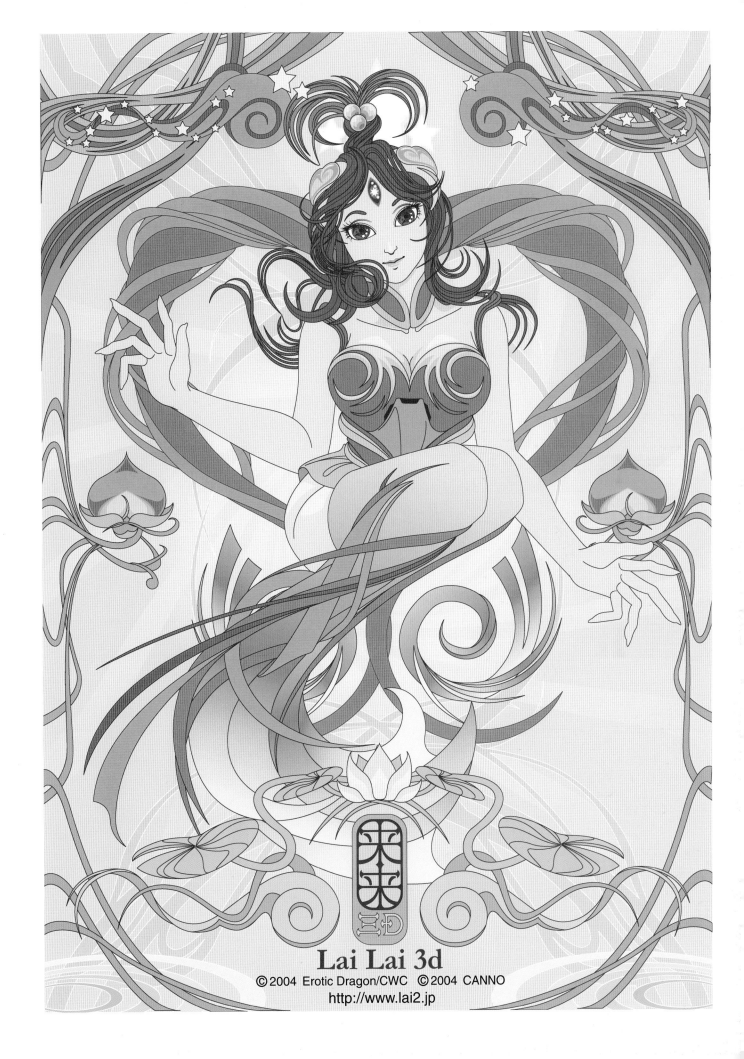

Lai Lai 3d

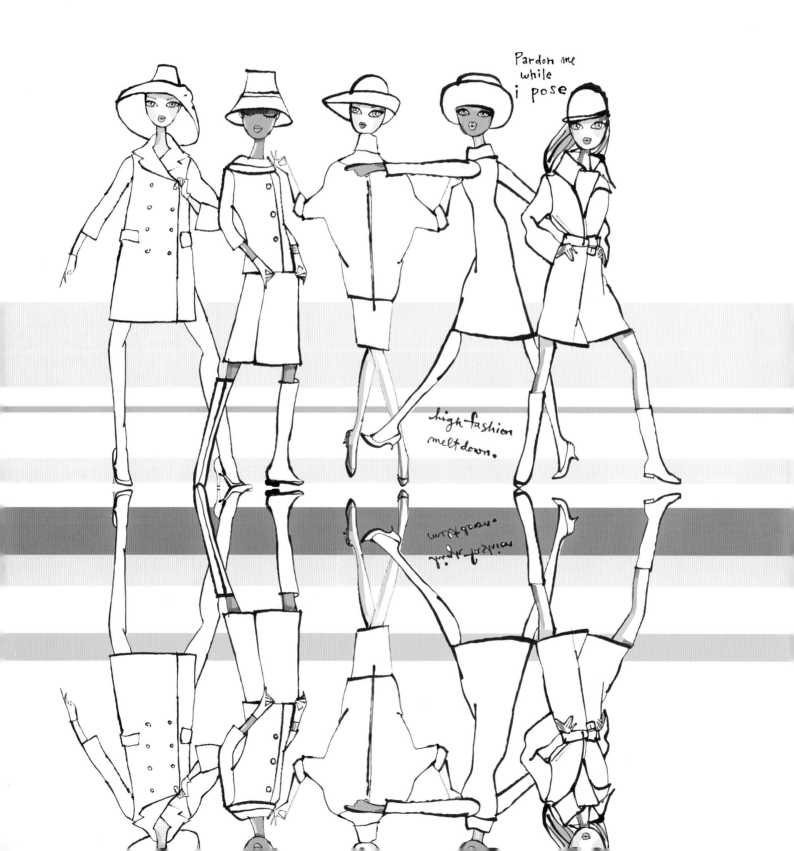

jeffrey fulvimari

ジェフリー・フルビマーリ

What is "fashion" in your context?
Fashion to me is just the art of dressing yourself. Everyone does this, since we all wear clothes.
You can do it on a budget, or, if you can afford, with the finest fabrics the world has to offer.
No one really has any special advantage in this realm, since it requires personal style and creativity.
I was taught by one of my professors that dressing is like painting for people who don't paint or draw.
And some people like minimal dressing, muted colors, and, you know, just like a t-shirt and jeans,
while some people like the peacock method. It should be fun, and not an iron-clad rulebook or prison sentence.
I always say that fashion is only a bad thing when we forget the person wearing the clothes
is more important than the clothes themselves.

Favorite color?
I love all colors. It's very hard to pick a favorite.
I used to always want to wear blue when I was a kid, but my mom would always buy brown clothes for me,
to match my hair and eyes. I think in my work my trademark color is magenta, so perhaps that is my favorite.

あなたにとって、「ファッション」とは？
僕にとってファッションとは、自分に服を着せるアートにすぎない。誰でもやっていることだよね、服は毎日皆着るものだから。
限られた予算で楽しむこともできるし、世界で一番豪奢な服や生地を楽しむのもいい。
必要なのは個人的なセンスと創造力であって、それ以外の有利不利、というのはないんだ。
ある教授に、「ファッションとは、絵を描かない人が絵を描くということだ」と教わったことがある。
ミニマルなファッション、地味めの色やTシャツとジーンズが好きな人もいれば、クジャクのように着飾るのが好きな人もいる。
ファッションとは楽しむものであって、絶対に守るべきルールもないし刑罰でもない。
僕がいつも言うのは、ファッションが悪いものになるのは、
「服を着る人の方が服より大事だってことを忘れた時だけだ」ってこと。

一番好きな色は？
色はすべて好き。一つ選べって言うのはとても難しいね。
小さい時はいつもブルーが着たかったけれど、母親はいつも僕の髪と目の色に合わせて茶色い服を買ってくれた。
僕の作品に関して言えば、トレードマークカラーはたぶんマジェンタなので、これが一番好きな色かもしれない。

this page: untitled, 2005
overleaf: blossom girls, 2005
p.40: bikini girls, 2004
p.41: only one me, 2004

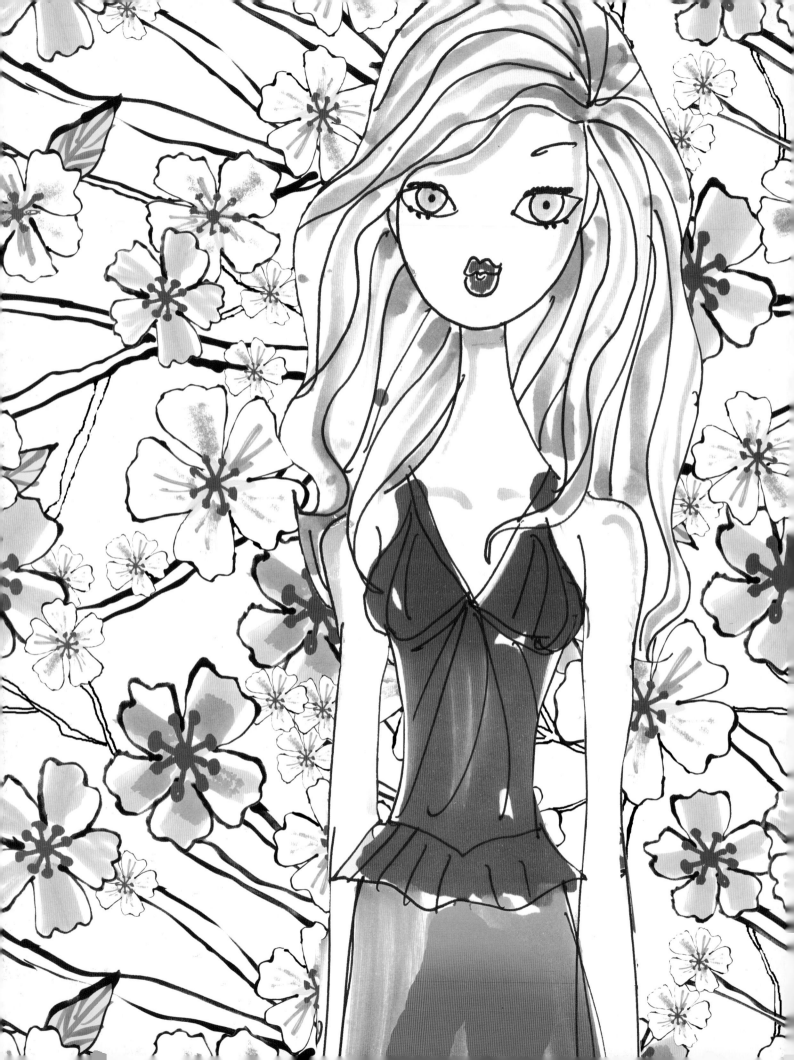

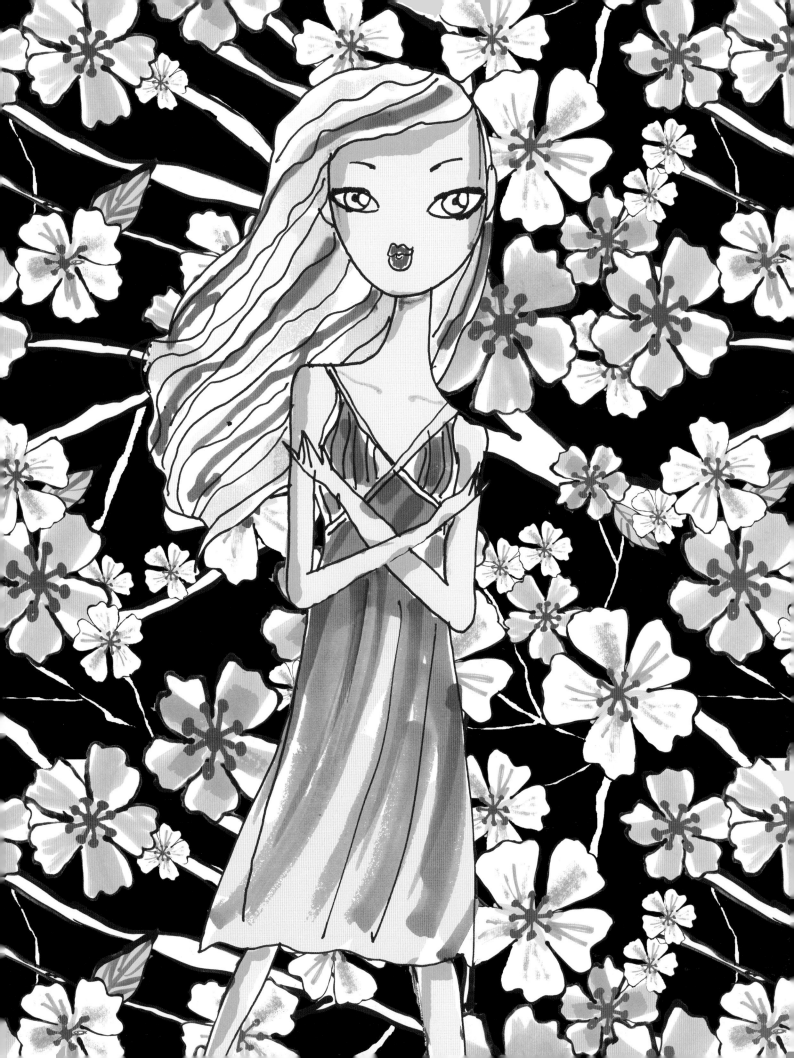

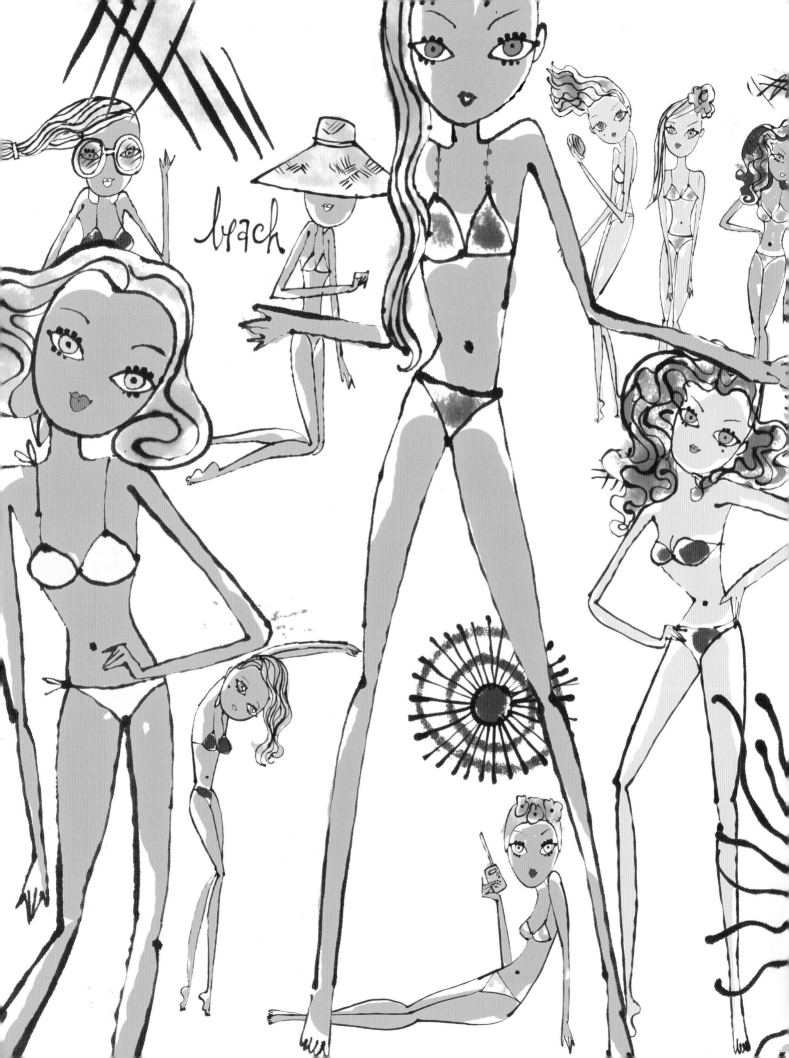

beach

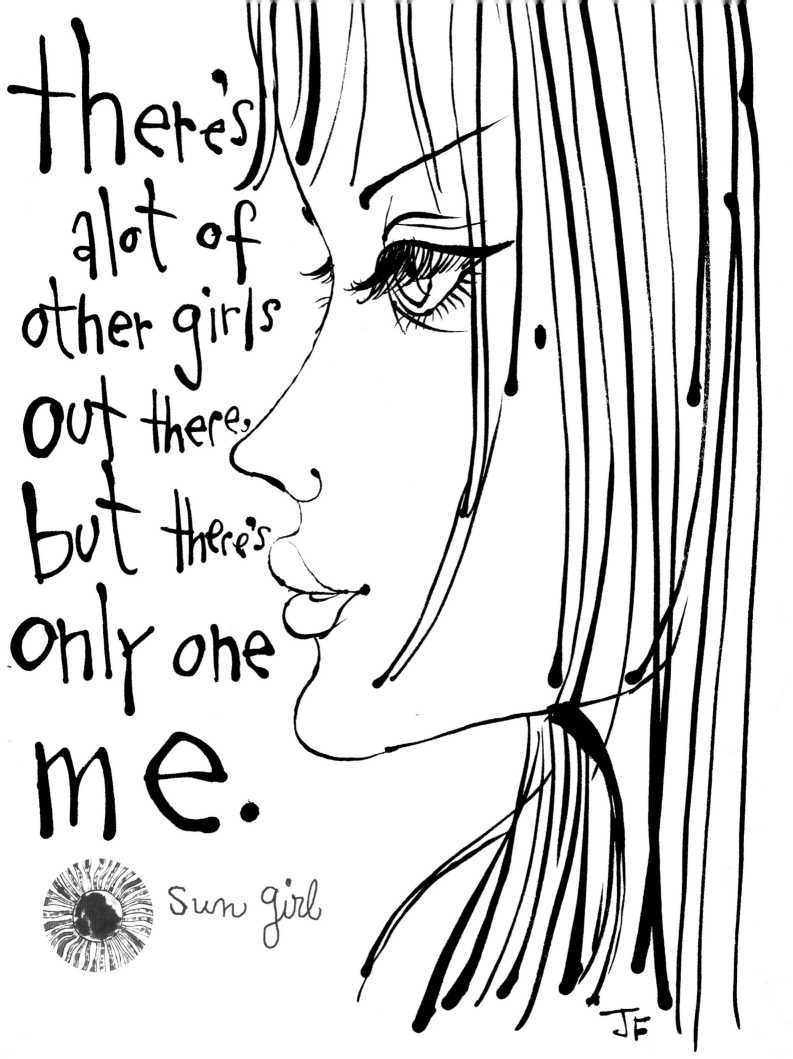

there's a lot of other girls out there, but there's only one me.

Sun girl

JF

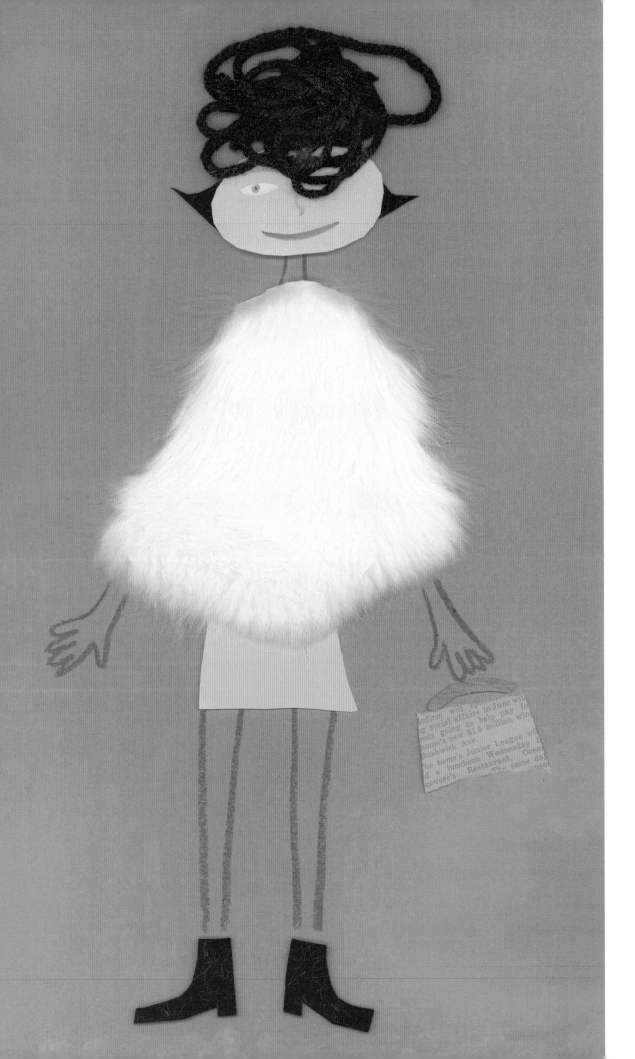

jessie hartland

ジェシー・ハートランド

What kind of music inspires your artwork?
I'm listening to Django Reinhardt a lot these days.
It's complex, but not so much that it's distracting.

What was the last book you read?
I last read *Lady with a Spear* by Eugenie Clark, 1951.
It's about an ichthyologist who traveled around the world doing research.
Read it if you like FISH.

あなたのアートは、どんな音楽にインスピレーションを得ていますか？
最近はよく Django Reinhardt を聴いている。
とても複雑な音だけれど、気が散るほどではないから。

一番最近読んだ本について教えてください。
一番最後に読んだのは、
Eugenie Clarkの1951年の著作「Lady with a Spear」。
研究のため世界を旅する魚類学者の話。
魚が好きな人は読むべき。

this page: untitled, 2004 (Safeway Select)
opposite: Flight of furry fancy, 2004
overleaf: the feather district,
from *Clementine in the City* (Viking Children's Books, 2005),
written and illustrated by the artist

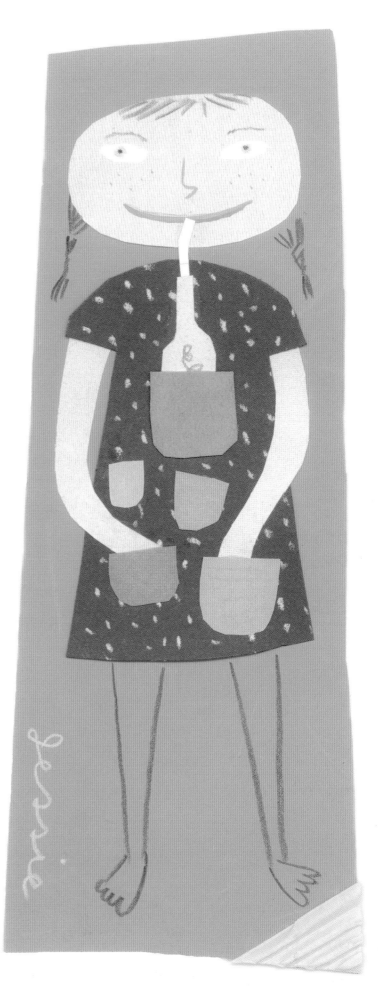

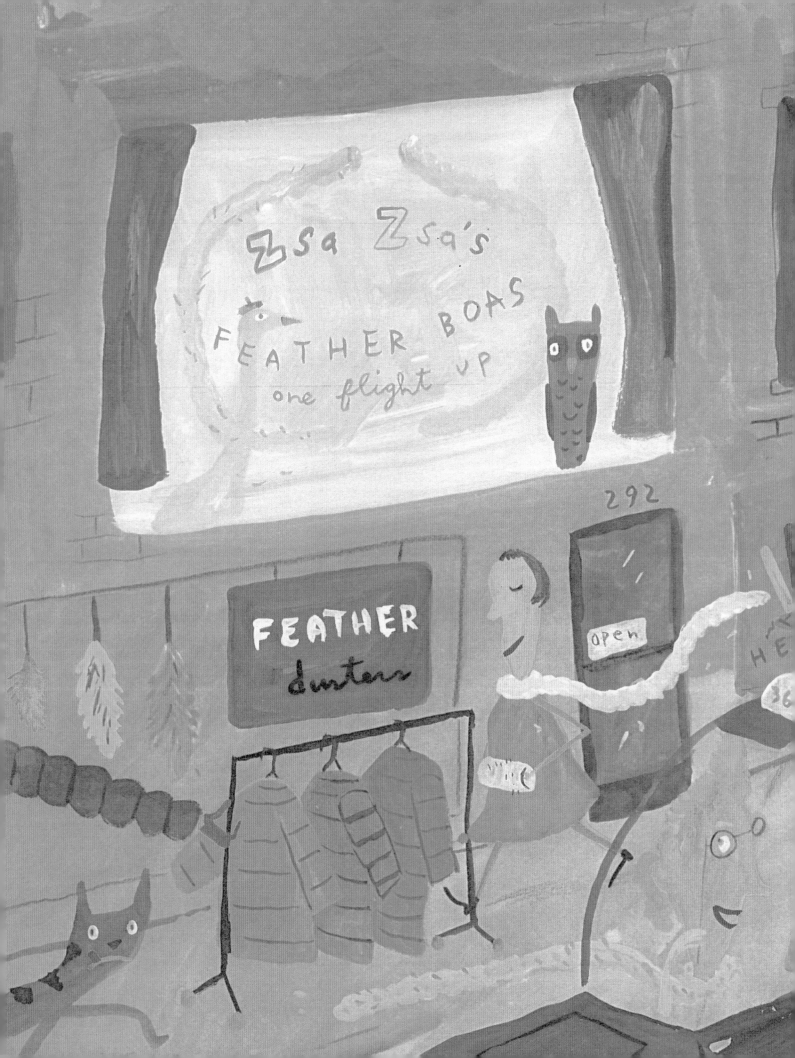

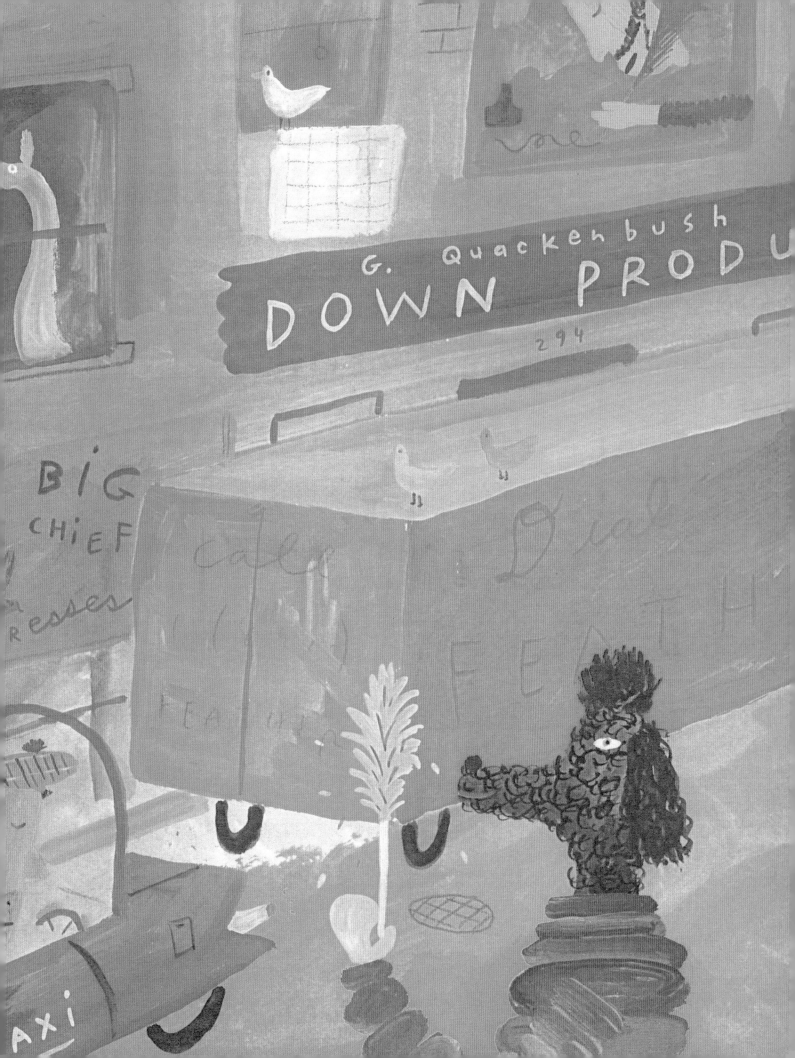

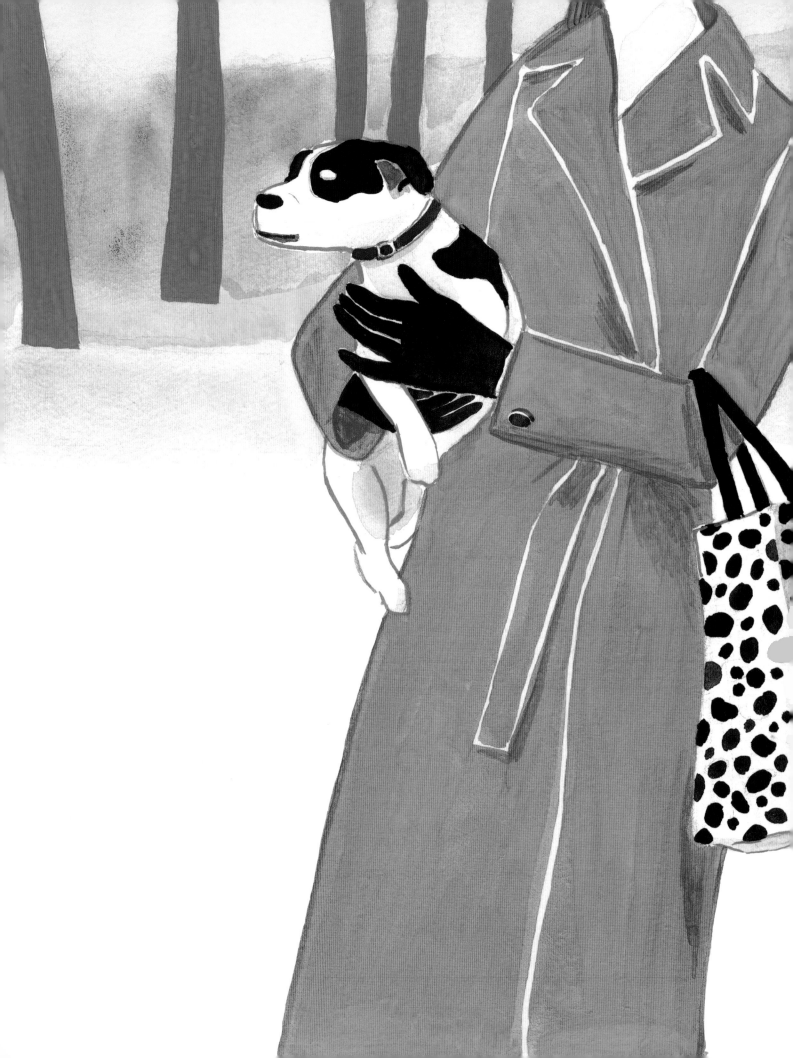

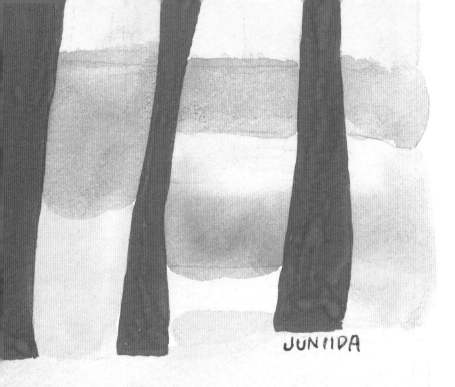

Did you attend art school?

When I was preparing for the entrance exam for Tama Arts University, I attended cram school in the evenings in addition to the hours spent during the day at a specialized arts high school—so I certainly did my fair share of endless sketching and space compositions. But it's true that the more you practice and the better your sketches become, the more they look the same. I realized this somewhere along the way and went back to my own drawings. All the practice wasn't for nothing, though—it did give me the ability to grasp space and composition.

What is your favorite memory in your childhood?

The summer of 1964, back when I was in third grade—I would love to relive that summer if I could. I spent the day picking edamame and corn with my grandmother, then would go out with my friends to play by the riverside...I would be so hungry by dinnertime that I even came to love green peppers which I loathed until that summer.

美術学校で学びましたか？
もし学んだのであれば、それは有意義な経験でしたか？

いやってほど学びました。高校が芸術高校で夜は予備校、一浪して多摩美ですからいわゆる受験デッサン、平面構成は死ぬほど描きました。しかし受験生のデッサンは上手くなればなるほどみんな同じになるんですね、それはヤバイと気が付いて自分の絵に戻りました。でも、空間を把握する力は付いたと思います。

子供の頃の一番好きな想い出を教えてください。

1964年小学3年生の夏休み、帰れるならあの日に帰りたいです。
信州のおばあちゃんと枝豆、トウモロコシを刈り入れて、友だちと河遊びと缶蹴り、夕飯が待切れないほどお腹ペコペコ、嫌いだったピーマンが大好きになった夏でした。

jun iida

飯田淳

this page: untitled, 2004
overleaf: untitled, 2004

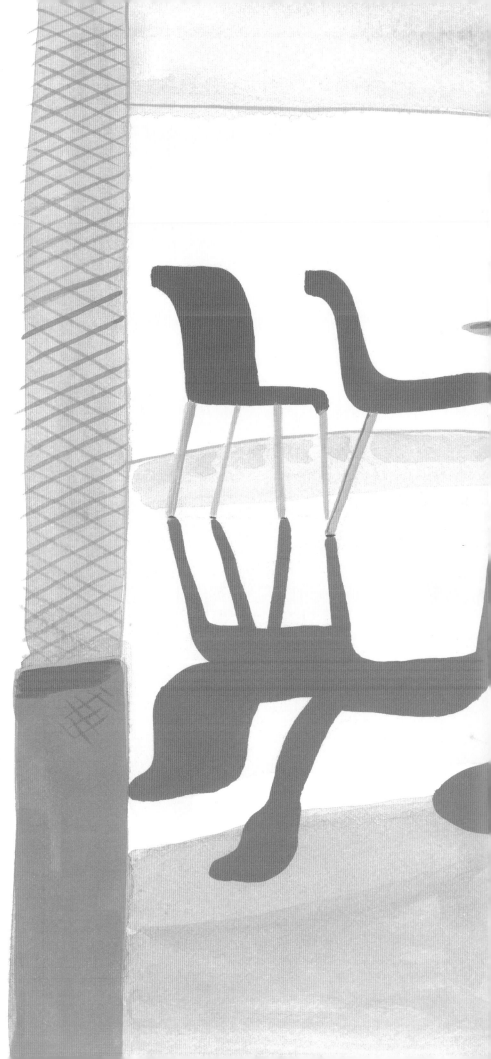

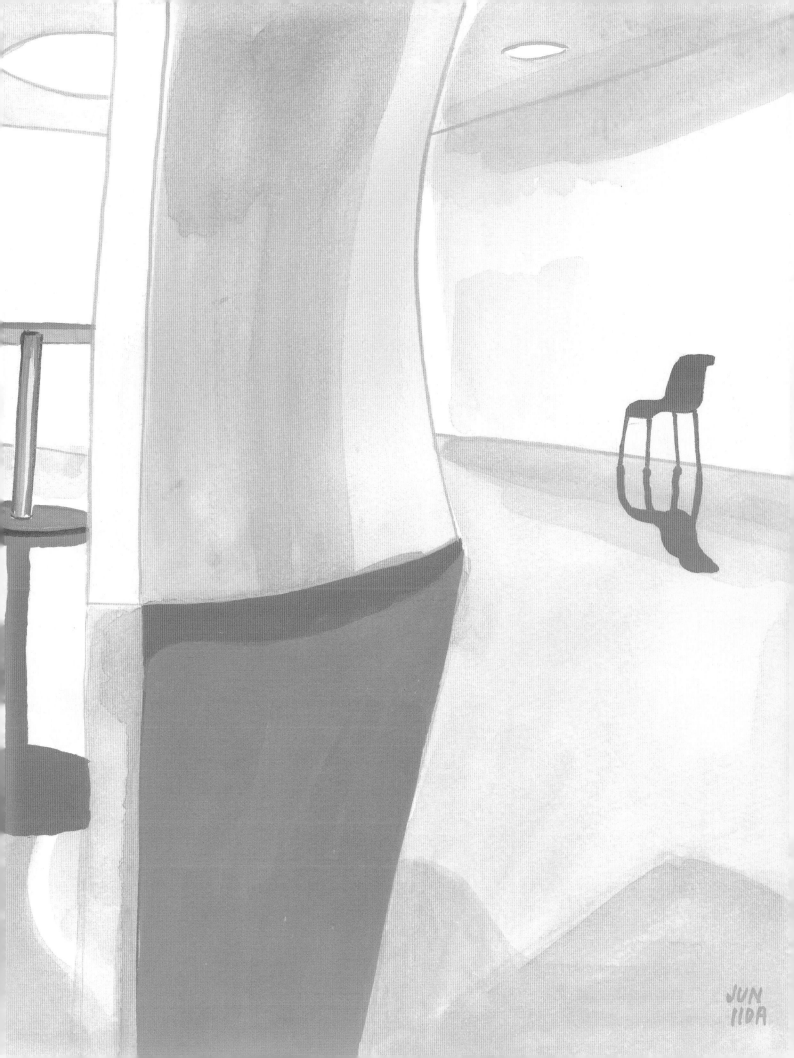

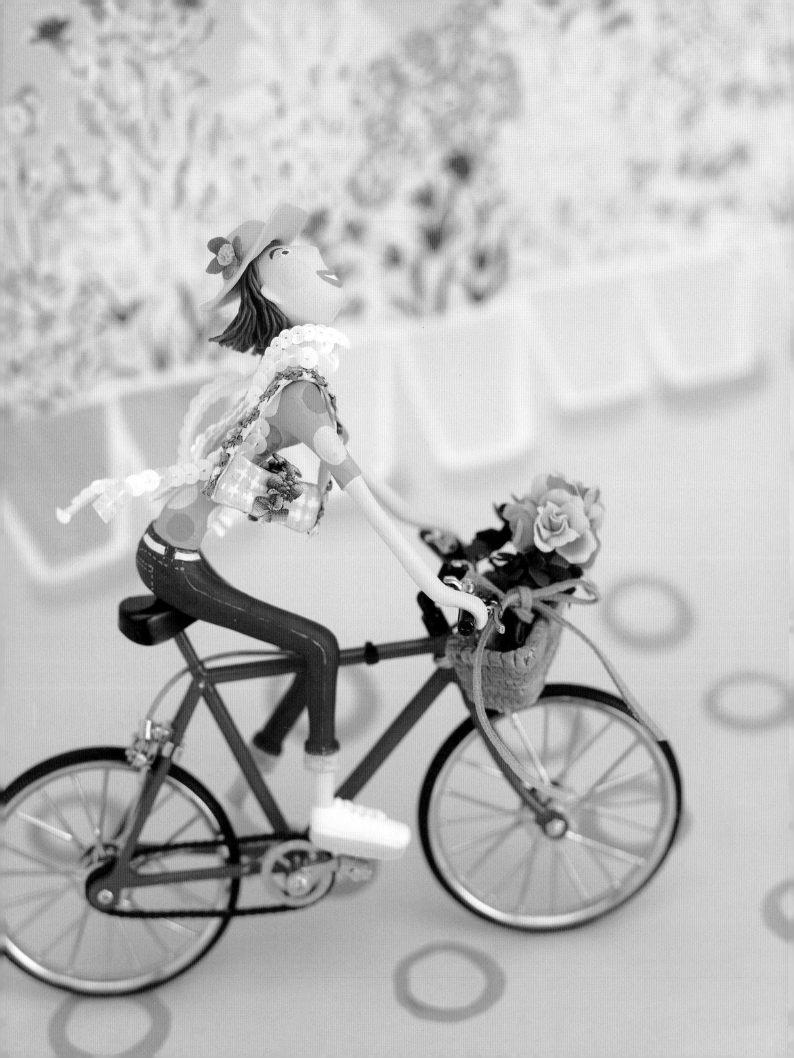

kacchi

カッチ

What about your work appeals to others? What about it appeals to you?
I always wish to create works that convey the day-to-day story of people.
I create work with the hope that it will make people happy,
that they will sympathize with it, thinking "yeah, that happens."
People have told me that they were cheered up by my work.
That to me is the highest praise, and the ultimate source of my happiness and energy.

What are your special skills other than illustration?
HAWAIIAN DANCE

あなたのアートの何が見る人を最も惹きつけるのだと思いますか？
私は、いつも、人をテーマに日常のstoryを感じるような作品を作りたいと思っています。
私の作品を観てくれた人達が、こういう事ってあるよねなんて、共感してくれたり、
楽しい気持ちになってくれたらいいなと思い制作しています。
Kacchiの作品を観て元気になれたよって言われる事があります。
それは私にとって最高に素敵な褒め言葉で、私に元気とエネルギーを与えてくれるのです。

イラストレーション以外で、あなたの得意なことを教えてください。
ハワイアンダンス

opposite: Sweet wind, 2004
overleaf: STAGE, 2001 (Paul Smith Japan)

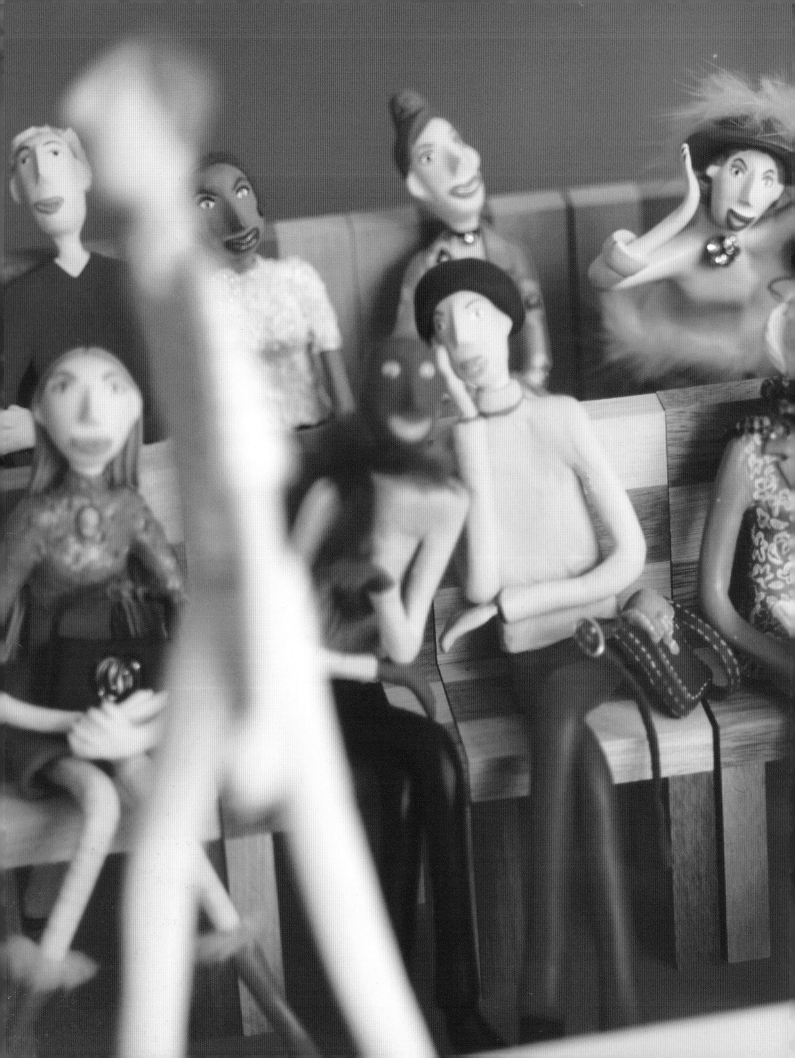

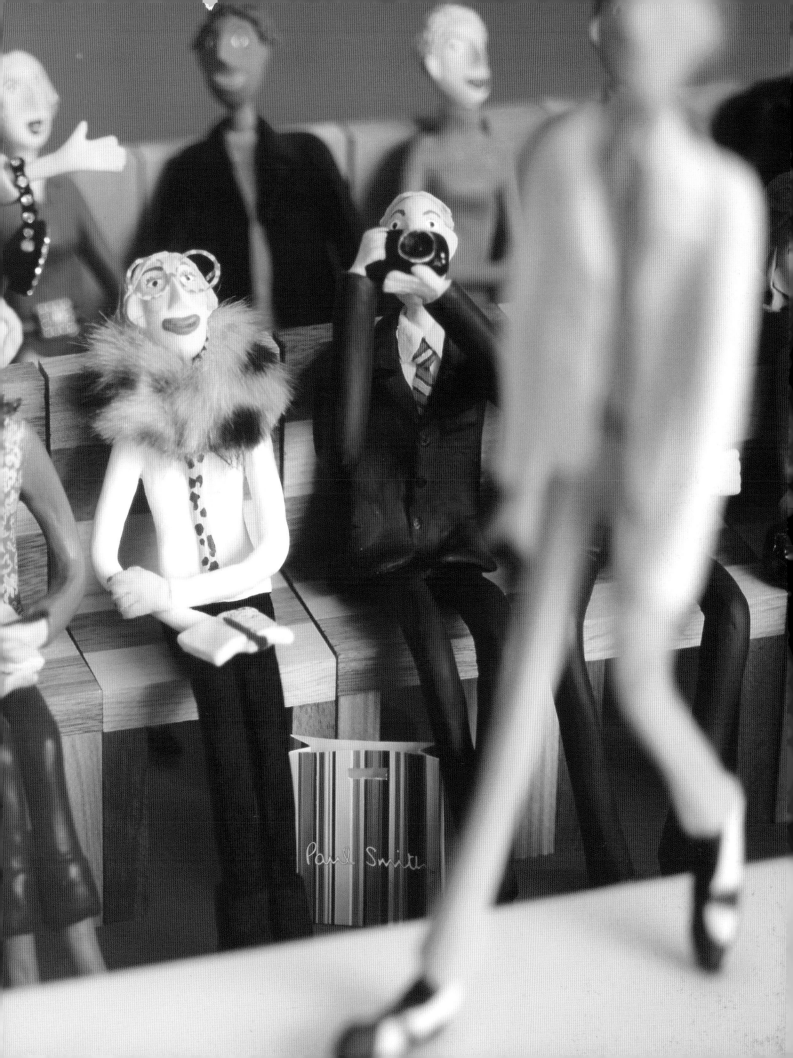

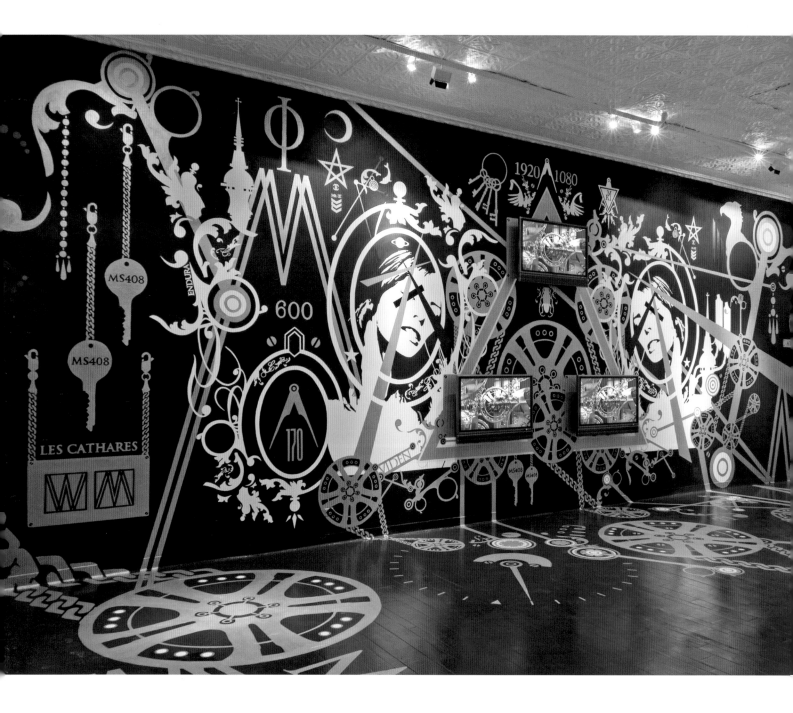

kenzo minami ケンゾー・ミナミ

What is "fashion" in your context?
"Fashion" is simply something which captures the essential nuance of the times and manifests it in any medium (of course, not just in garment form). Fashion becomes essential to everyone on earth (especially if you are any type of artist or designer) just because of the fact it's there—either you follow it, battle against it, or completely ignore it...in any situation, we all are affected by it as a pivotal point of reference.

Do you thrive on chaos or order?
Or something in between?
Neither chaos nor order. The key for me is that the state is in the process of change. I thrive on the shift from chaos to order, or vice versa. Any state that is completely static, I do not care for.

あなたにとって、「ファッション」とは？
ファッションとは端的に言えばその時代のエッセンスや感触を捉えるものであって、それはどんなメディアで具現化されてもファッションだと思う。（衣服での表現だけがファッションではないということ）誰にとってもそうだけど、特にアーティストやデザイナーにとってはファッションはなくてはならないもの。そこにあるというだけの理由でね。従ってもいいし、反抗してもいいし、全く無視してもいいけれど、何にしろ、僕らは重要な尺度であるそれに多かれ少なかれ影響されているんだ。

カオスと秩序、あなたはどちらの状態に活力を得る方ですか？
どちらでもない。僕にとって重要なのは、変化の過程にいるということ。だから、僕が一番うまくやれるのはカオスから秩序へ、もしくは秩序からカオスへ移行する過程の中でなんだ。静止した状態というのには興味がない。

this page: CODEX 408, mural painting and video installation, 2004 (The Aquos Project by SHARP)
overleaf: Guernica MMV, 2005 ("Remastered" exhibition)
pp. 58-59: DDM, 2005 (Bonus Magazine, "Fight" issue)

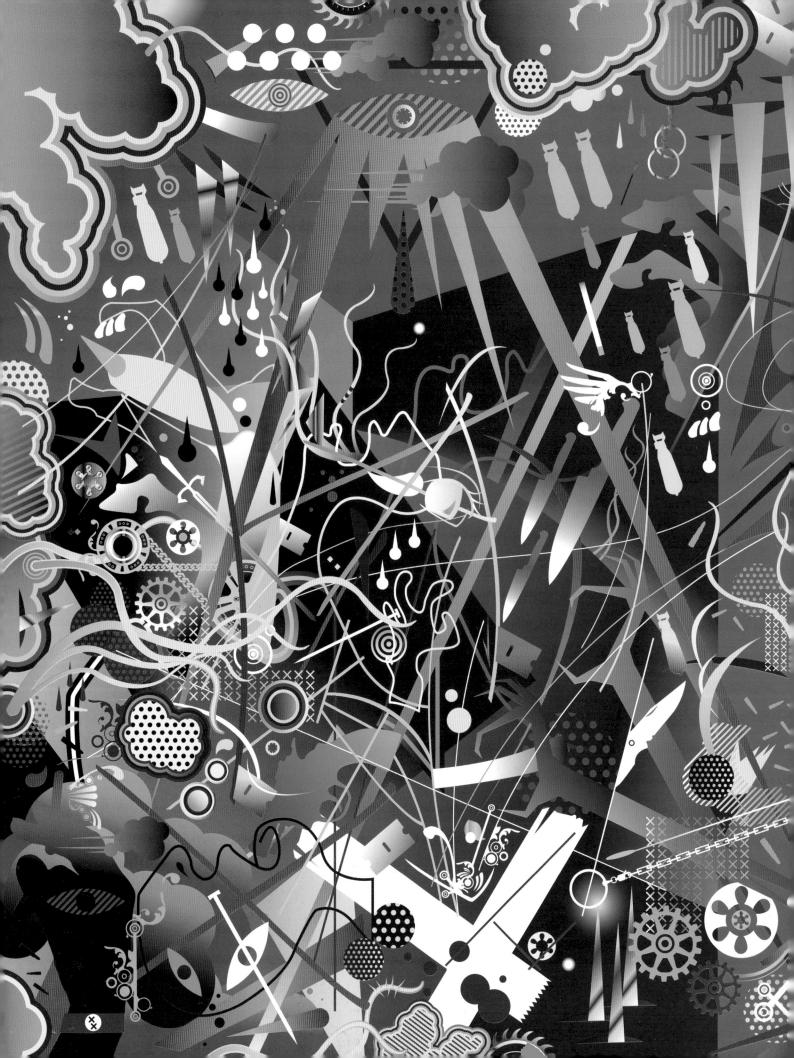

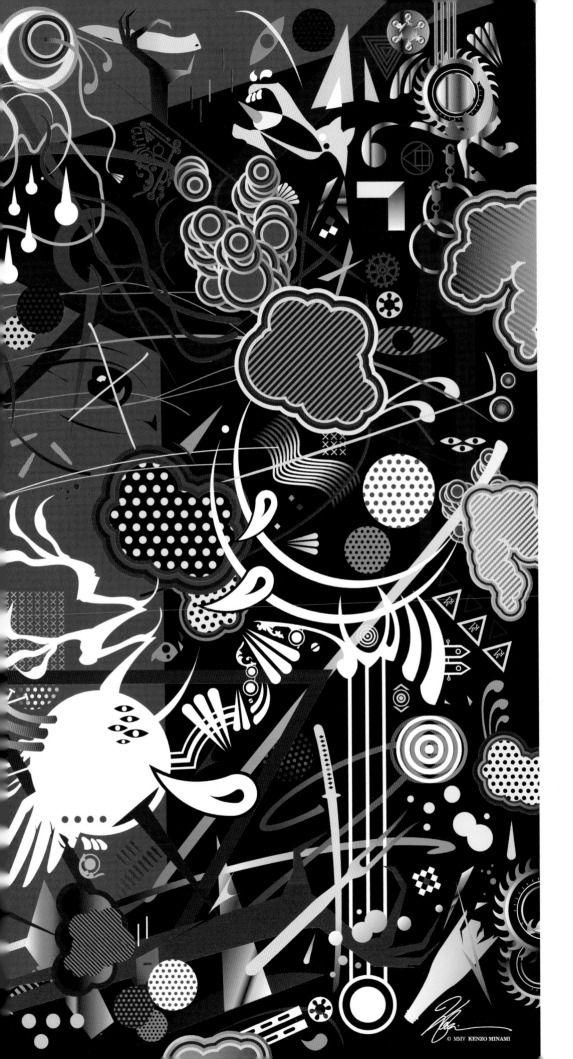

© MMV KENZO MINAMI

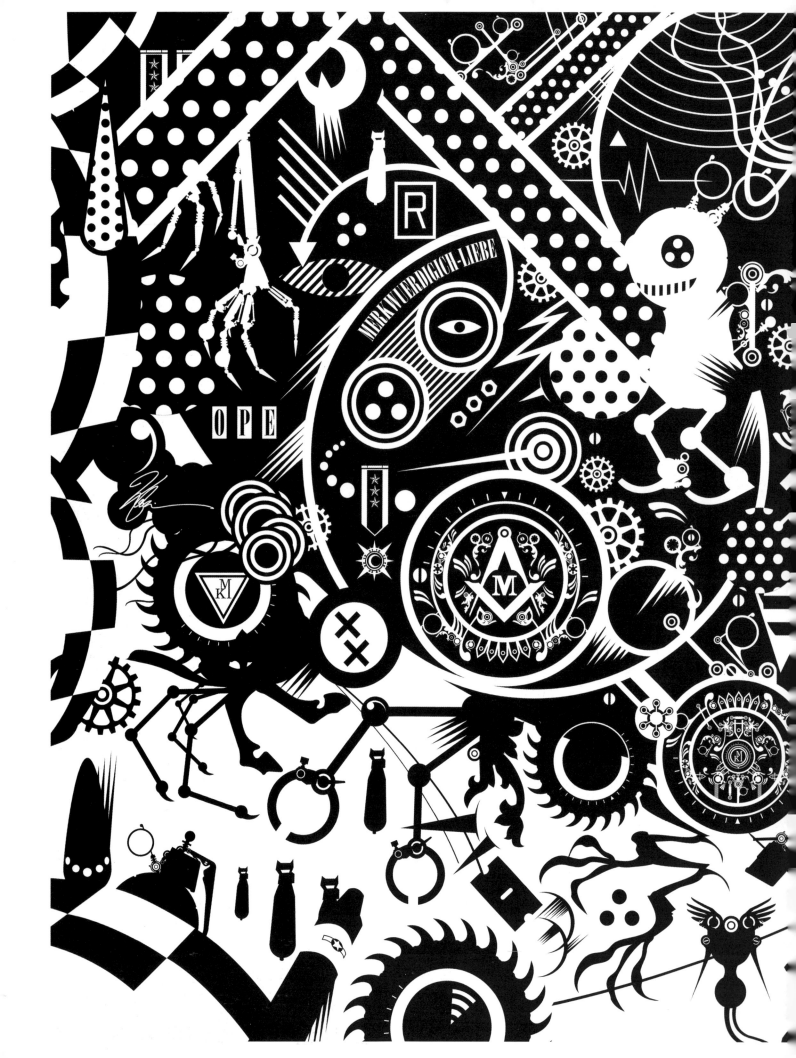

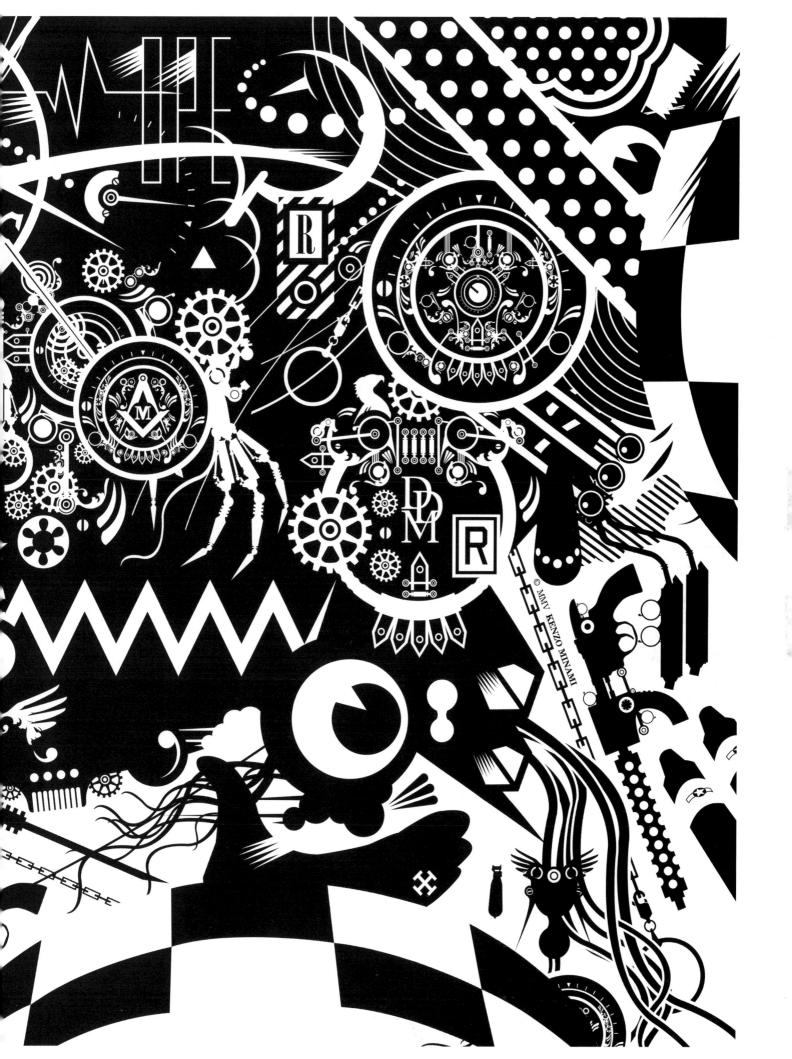

© MMV KENZO MINAMI

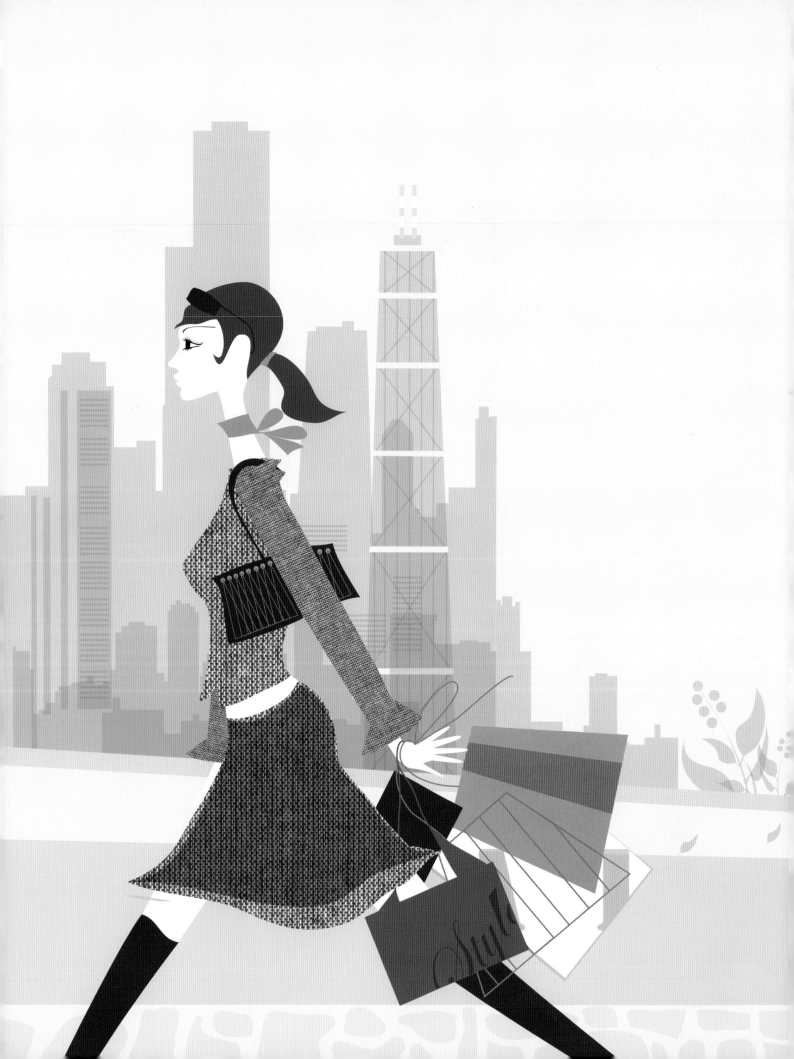

■ LULU*
ルル

What is your current dream project?
I have a story in mind, in which I would love to see my illustrations move and dance, a phantasyworld with lots of flowers. Also I would love to collaborate with a friend from Switzerland who I adore for his amazing work, he inspires me and my work every day. I cannot tell the whole story, because then there would be no more surprise...

If you could magically possess any one superpower, what would it be and why?
The superpower would be collecting all bad moods and turning them into kindness. Maybe all humans have the power to collect their feelings and bundle them to make electricity out of them—this power would help all sad humans to be just happy and gentle and give them the electricity they need in their happy households…

あなたのキャリアにおける具体的な夢を教えてください。
実は今考えがあって、お花がたくさん咲いているファンタジーワールドの中で私のイラストレーションが動いて踊っているの。ぜひスイスに住んでいる私の友人とコラボレートできたらなと思ってるわ。彼は本当に素晴らしいものを作っていて、彼は私と私のアートに常にインスピレーションを与えてくれる。
楽しみが減ってしまうからこれ以上は言えないけど・・・

もしあなたに超能力が与えられるとしたら、どのような力が欲しいですか？
世の中の不機嫌を全部優しさに変えてしまう超能力が欲しい。もし、世界中の人間に自分たちの嫌な気持ちを集めて電気に変えてしまう力があったらどうだろう？この力で、悲しんでいる人を楽しく穏やかな気分にすることができるし、彼らのハッピーな家で使う電気も供給することができるようになるわ。

this page: untitled, 2004 (BAILA)
opposite: untitled, 2004
overleaf: it is just a simple gooseflesh, 2004
(online art project: tocame)

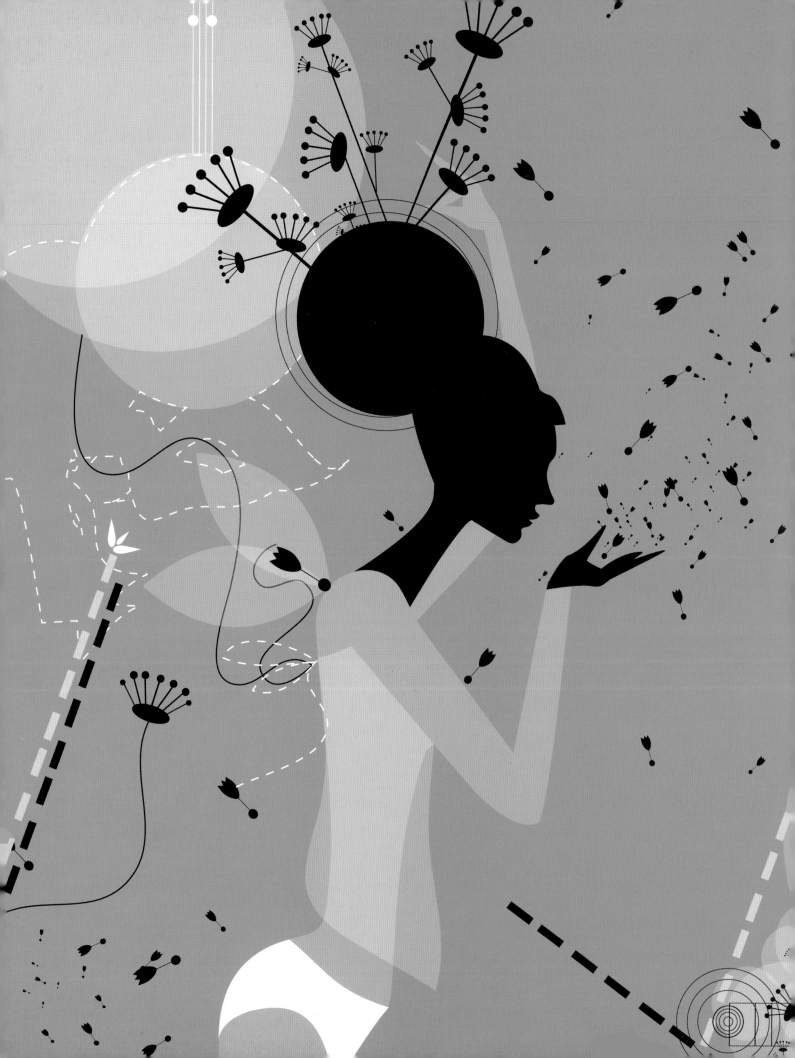

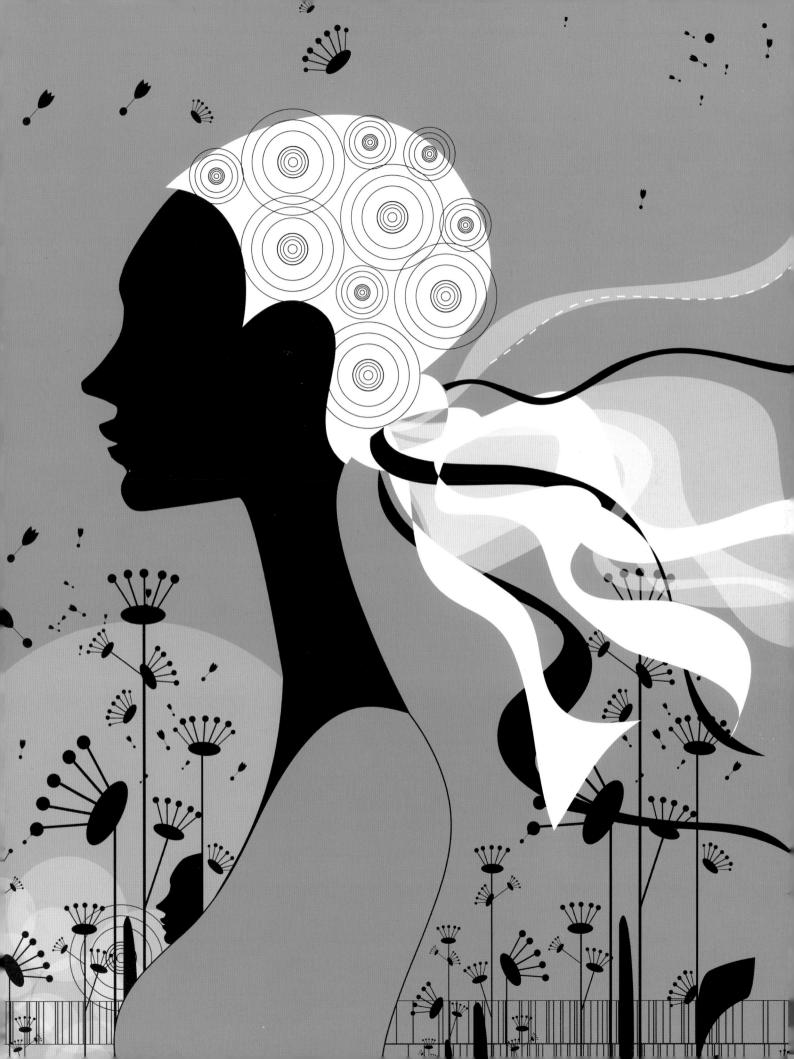

marcus oakley

マーカス・オークレー

What are your sources of visual influence?
My work as an artist and illustrator has many influences including my childhood, the countryside, nature, music, my travels and the aesthetic beauty of the architecture, fashion, graphics and typography of the 1970's.

What kind of music inspires your artwork?
Mostly I listen to music from the 1970's, it's a rarity if most days I don't play a Beach Boys song or album. I think the Beach Boys' music is very magical, it's the combination of melody and harmony and good vibrations that keeps me listening to them, but when not listening to the Beach Boys I also spend time listening to Pentangle, James Taylor, Lee Hazelwood, Fairport Convention, Neil Young, Fleetwood Mac, Kris Kristofferson, ELO and Vashti Bunyan.

What is your favorite piece of clothing that you own?
A lambswool jumper that was my grandfather's.
Do people say jumper in the U.S.?

ビジュアル的なインスピレーションはどこから得ていますか？
僕の、アーティストとイラストレーターとしての作品は、いろんなものに影響されている。例えば、僕の子供時代、田舎風景、自然、音楽、旅行、そして1970年代の建築、ファッション、グラフィックやタイポグラフィの美しさ。

あなたのアートは、どんな音楽にインスピレーションを得ていますか？
1970年代の音楽をよく聴くよ。ビーチボーイズのアルバムをかけない日の方が少ないし（ビーチボーイズの音楽はとってもマジカルで、そのメロディとハーモニーと心地よいバイブレーションの絡み合いが耳を離れないんだ）、ビーチボーイズを聴いていない時は、Pentangle、James Taylor、Lee Hazelwood、Fairport Convention、Neil Young、Fleetwood Mac、Kris Kristofferson、ELO、Vashti Bunyanなんかをよく聴いているよ。

あなたの持っている服の中で、一番お気に入りのアイテムについて教えて下さい。
おじいちゃんからのお下がりのラムウールのジャンパー。
アメリカで「ジャンパー」って言う？

opposite: Owl Pattern, 2004
overleaf: things I find interesting, 2004/2005
p.68: The Captain & Tennille, 2005
p.69: Flower Pattern, 2004

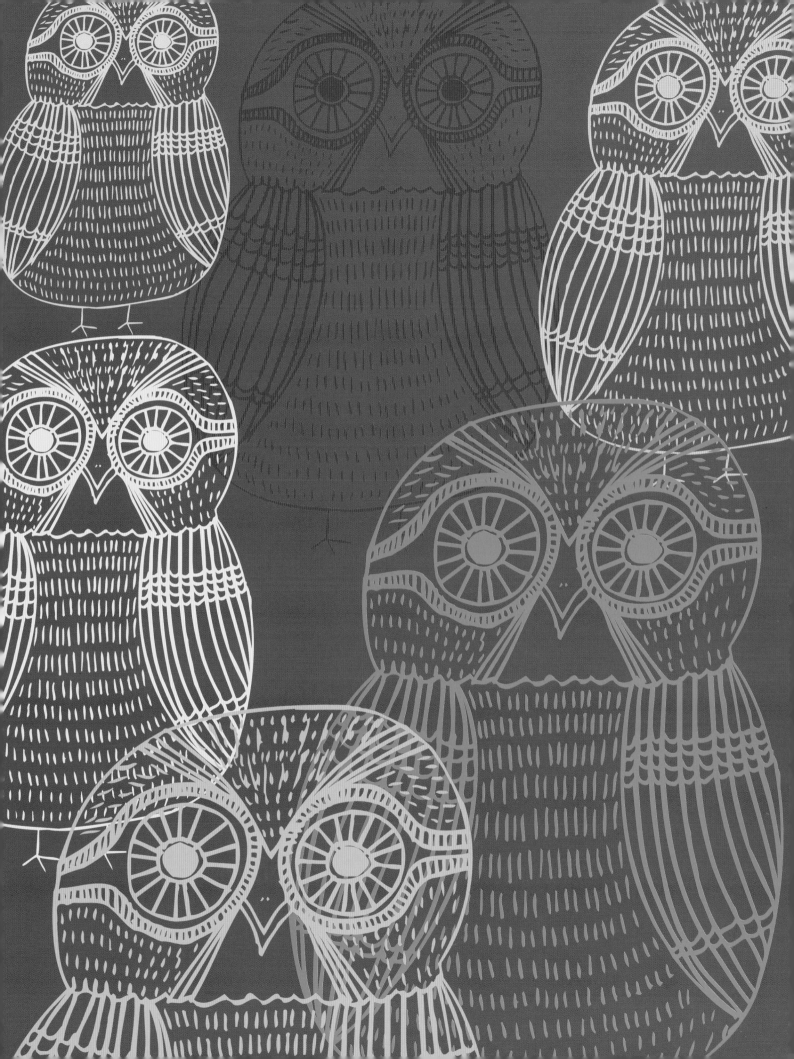

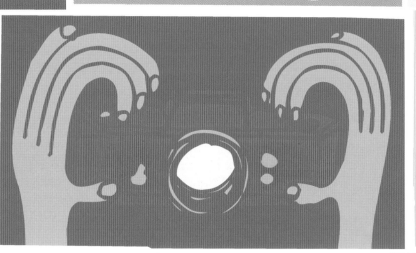
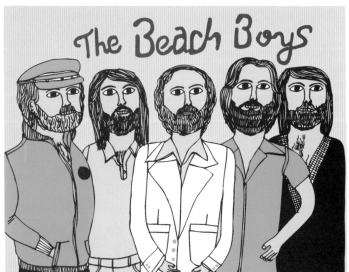

The Beach Boys

good humour

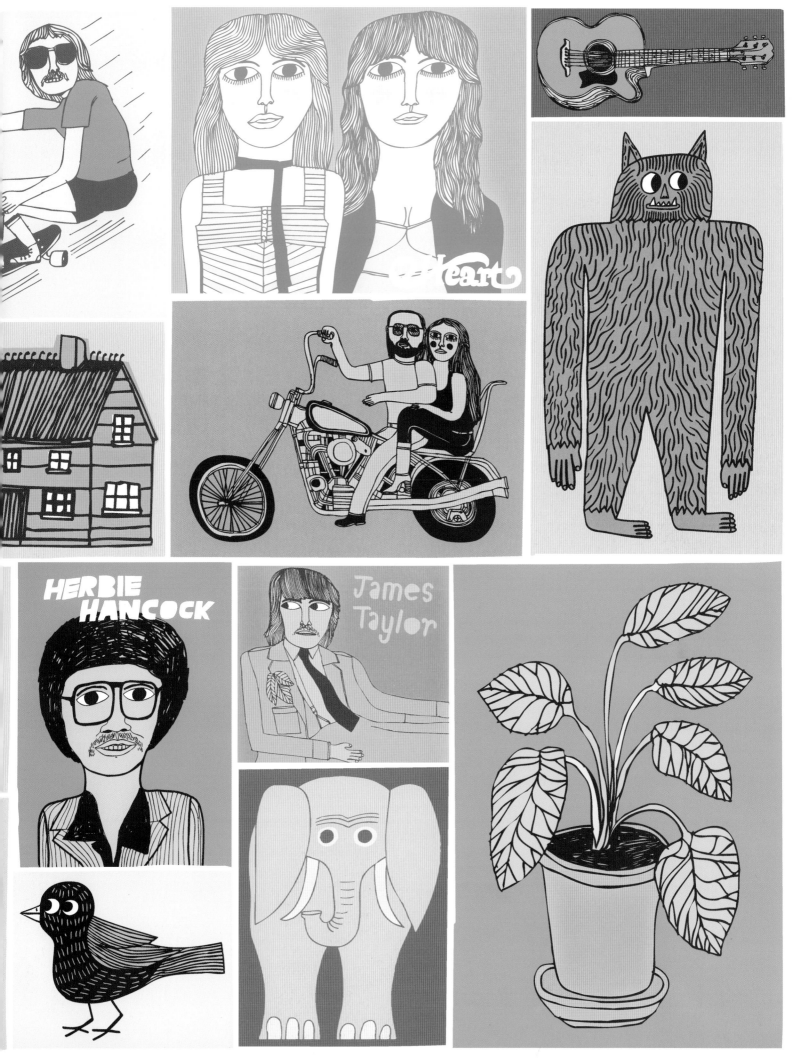

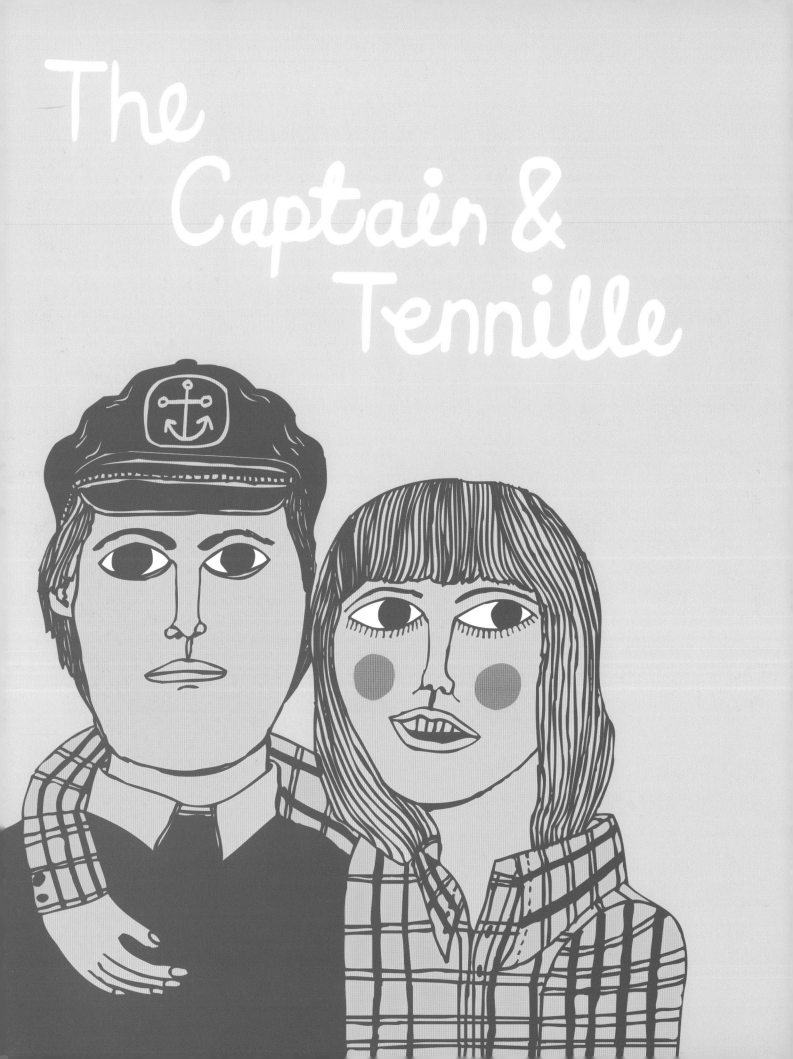

masaki ryo. ■ マサキリョウ

What is "art" in your context?
The morning after a day spent exercising or going out, in the moments after I have stopped my alarm but doze off without being able to leave the bed, I feel an inexplicable languid sense of pleasure. It may be just me, but a work that can give me the same sense of pleasure is "art" for me. When I behold a work I like, I feel the languid sense of pleasure slowly building up from within. It is not rational. When the work is something that I have created, the pleasure intensifies.
And this feeling grows on you. Yes, it's an addiction.
I will most likely seek out and create "art" for the rest of my life, to bask in this subtle sensation. Hm? Perhaps all creators do the same...!?

Black or White? Why?
Black.
The universe is a jet-black abyss. There you find "life." Countless stars are born, then die, and from their dust are born new stars. There also exist planets that bear life like Earth. On the other hand, there is the black hole, which swallows all. Black is mysterious. I am enchanted by mystery. Since I was a child, I have always loved gazing up at the stars. It is so mystical that it sends shivers down my spine..."What is the universe?" "Where is the universe?" "What will happen to the universe?" "What is outside of the universe?" "What was here before the universe existed?"...when I let my mind wander around the universe, I am able to forget the trivial things in life. And I come to realize that I exist as such a tiny presence in this vast universe. I suddenly feel at ease.
Once in a while I want to gaze at the stars out in the country...the skies in Tokyo are too bright.

あなたにとって、「アート」とは？
めいっぱい遊んだり体を動かしたりした翌朝、目覚まし時計を止めた後もそのままベッドから出られずにウトウトしている時、何とも言えない"気怠い快感"を感じる。極めて個人的な見解かもしれないが、その感覚に似た快感を味わえる作品が僕にとっての「アート」。お気に入りの作品を見つけてそれを眺めると、ある種そういう"気怠い快感"がじーんと体の中からわいてくる。それは理屈ではない。気に入った作品を自分で制作できたとき、その快感はより心地よくなる。そしてこのような感覚はたまらなく癖になる。
そう、中毒だ。
おそらくこの先一生涯「アート」を探し続け、創り続けていくのだろう。このビミョーな感覚を味わうために。・・・ん？ 世のクリエーターって皆そうなのかも・・・！？

黒か白だったらどっちですか？
黒。
宇宙は漆黒の空間。そこには"生"がある。無数の星が生まれ、死に、その塵からまた新しい星が生まれる。地球のような生命を宿す惑星も存在する。またその反面、全てを飲み込むブラックホールがある。
黒は神秘的。神秘的なものには心惹かれる。子供の頃から満天の星空を眺めるのが好きだった。
ゾクッとするほど神秘的だから・・・。
「宇宙って何？」「宇宙ってどこにあるの？」「宇宙ってこの先どうなるの？」「宇宙の外側ってあるの？」「宇宙が存在する前は何だったの？」・・・宇宙について考えると、つまらない細かいことなど忘れることができた。そして、あまりに莫大な宇宙に、とてもちっぽけな自分が存在することに気づく。
気持ちがスーッと楽になった。たまには田舎で夜空を見上げたい・・・東京の夜空は明るすぎるから。

opposite: untitled, 2001
overleaf: untitled, 2004
pp. 74-75: untitled, 2004 (Caspari)

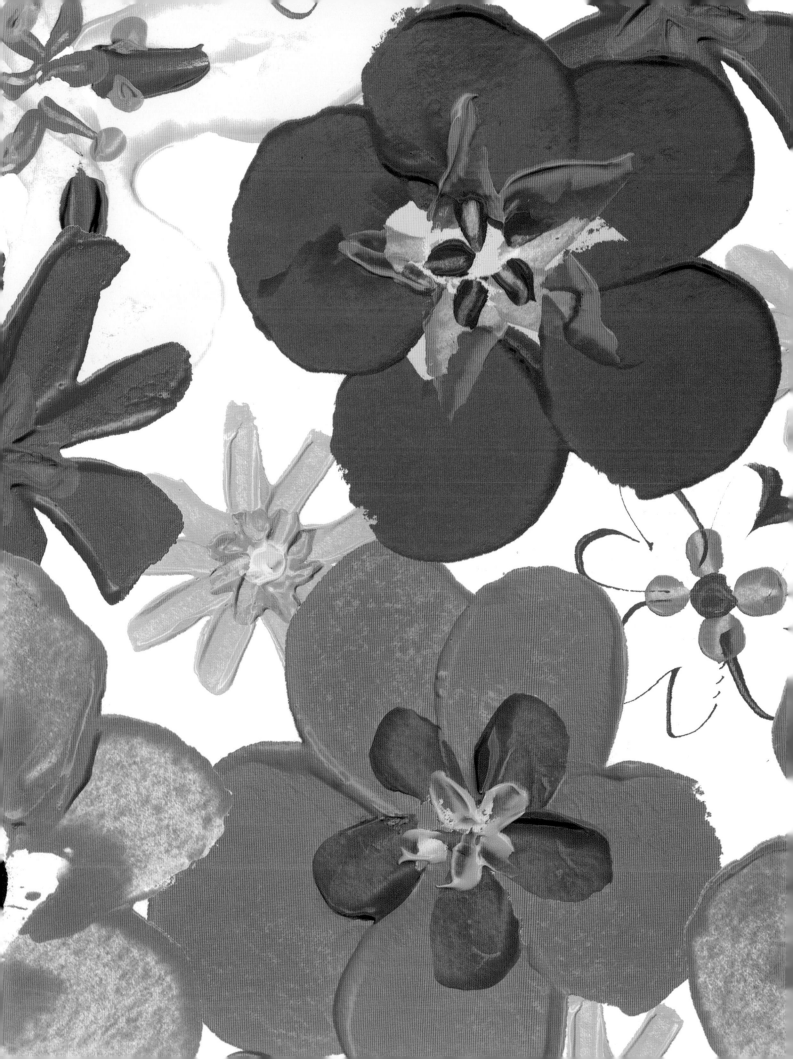

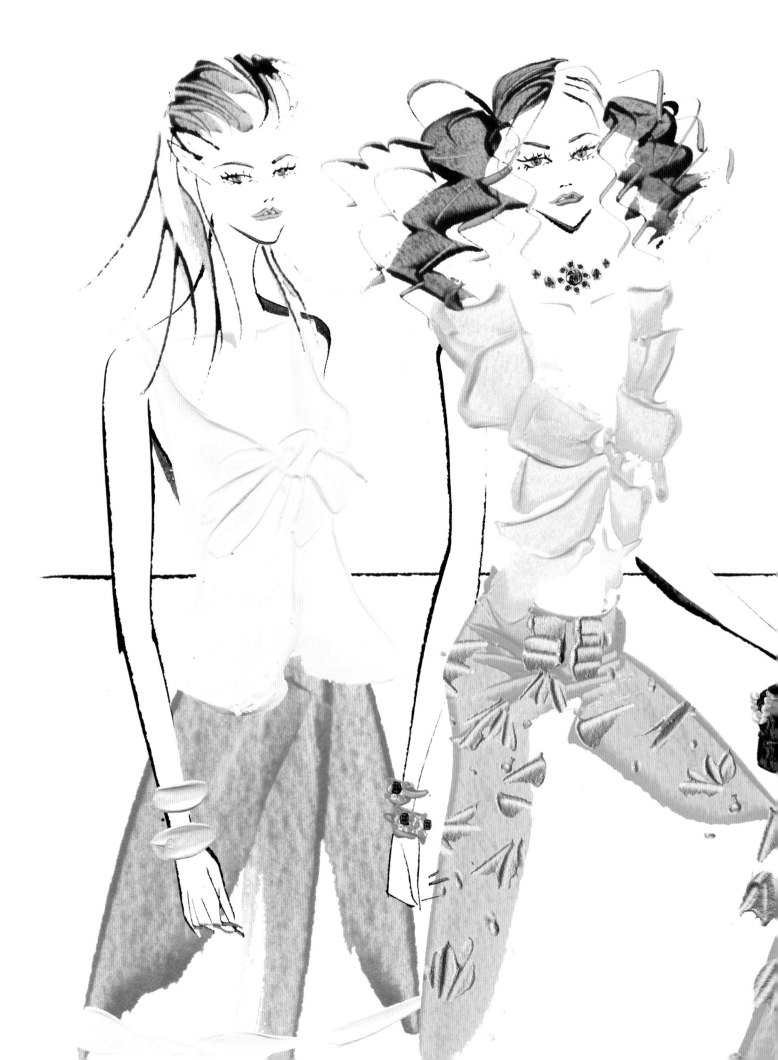

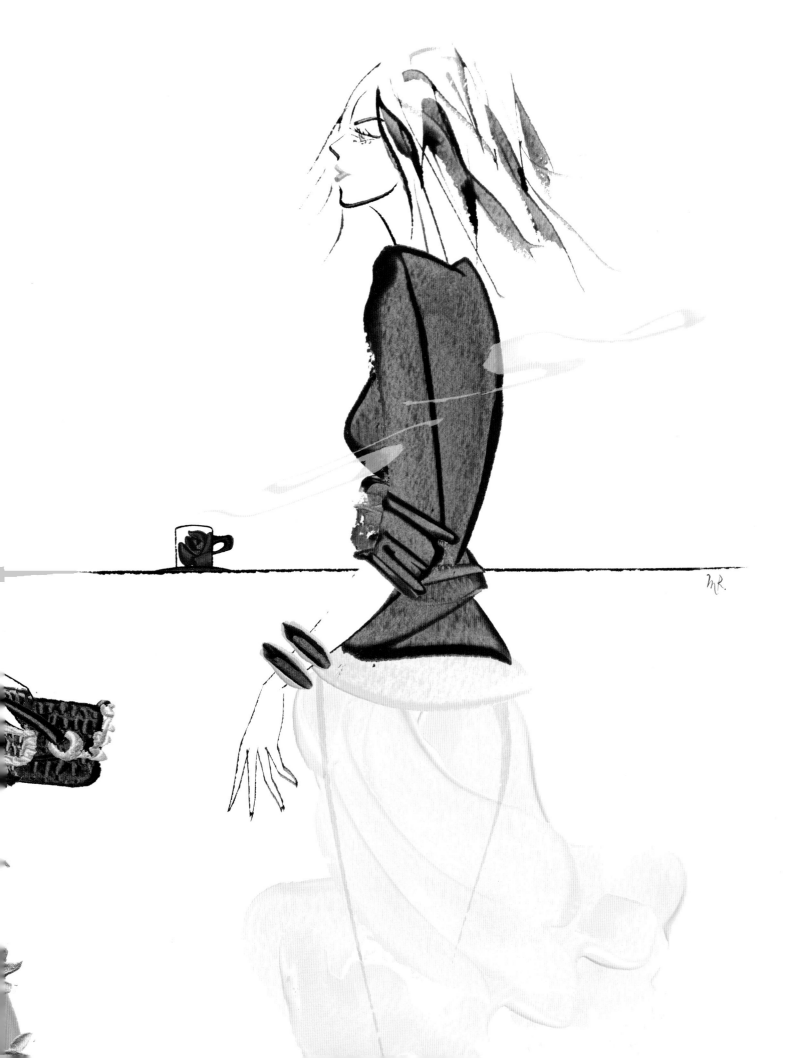

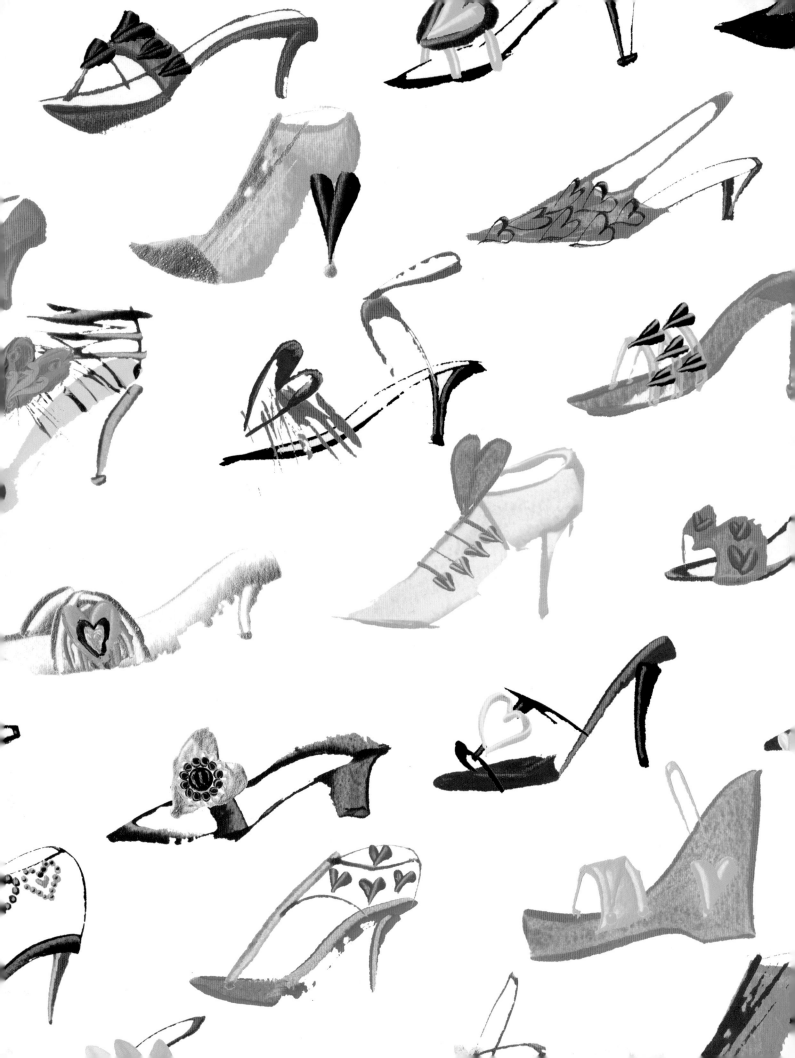

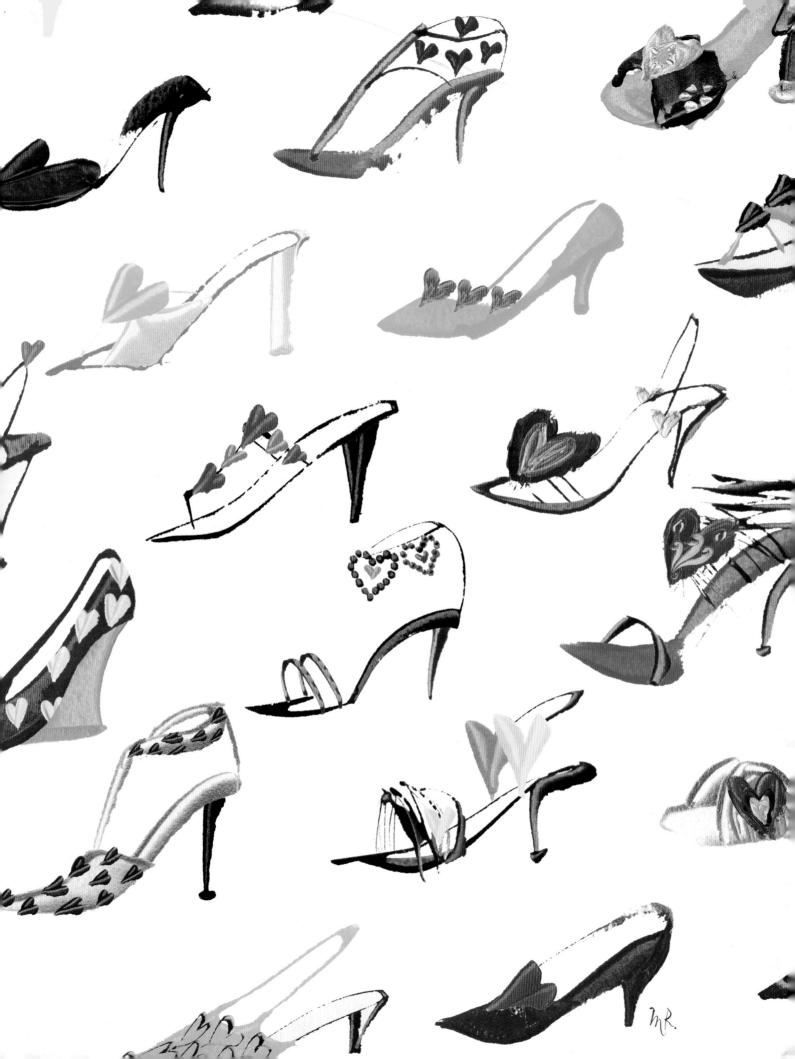

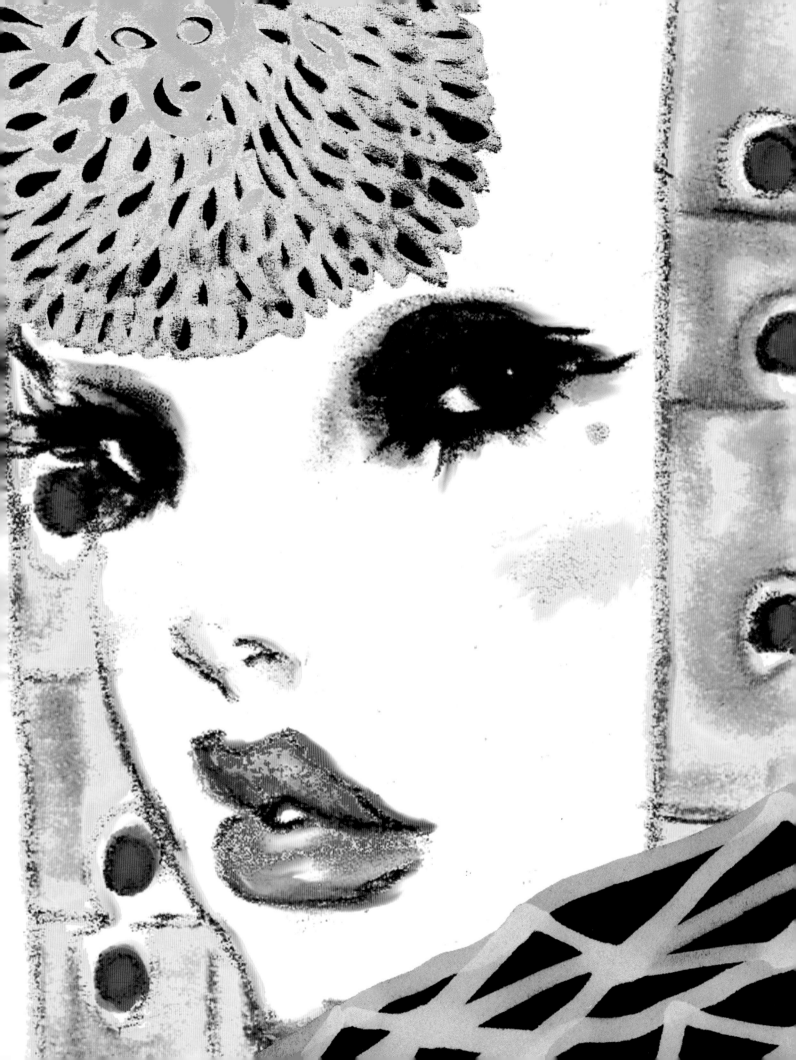

What is "art" in your context?
The key to an alternate universe.

What do you consider to be an artist's societal role?
The founding of a new culture.

What about your art is most appealing to others? To you?
I will quit when I really find out.

What is your favorite time of the day?
Time I spend with my family.

If you could bring one person back from the dead just to hang out with you and let you bask in their utter and complete genius for a day, who would it be and why?
Shiko Munakata (world-renowned 20th-century Japanese painter).
I want to sit down and talk with him, it doesn't matter what about.

Change the world in 5 steps. What would those steps be?
1. Complete ban of arms
2. Restrictions on new development
3. Comprehensive program to increase green space
4. Elimination of all national borders
5. Unite the earth as one country

あなたにとって、「アート」とは？
異次元への鍵

アーティストの社会的役割とは、どういうものだと考えますか？
新しい文化創造

あなたのアートの何が見る人を最も惹きつけるのだと思いますか？
本当にわかったらやめる。

一日のうちで一番好きな時間はいつですか？
家族との時間

もし誰か一人、その人のあふれる才能に直にふれるためだけに一日だけ生き返らせることができるとしたら、誰を生き返らせますか？
棟方志功。なんでもいいから話してみたい。

あなたに「世界を5つのステップで変えなさい」という課題が与えられたとしたら、どんなステップで世界を変えますか？
1　武器の完全な廃止と禁止
2　開発の制限
3　完全なる緑化
4　すべての国境廃止
5　地球を一つの国とする

this page: himalia 囁き光線, 2004
p.78: ananke 黙想的な如意輪, 2004
p.79: io 偏愛慕情, 2004 / europa 雷光スタイル百科, 2004

masayuki
ogisu

小岐須雅之

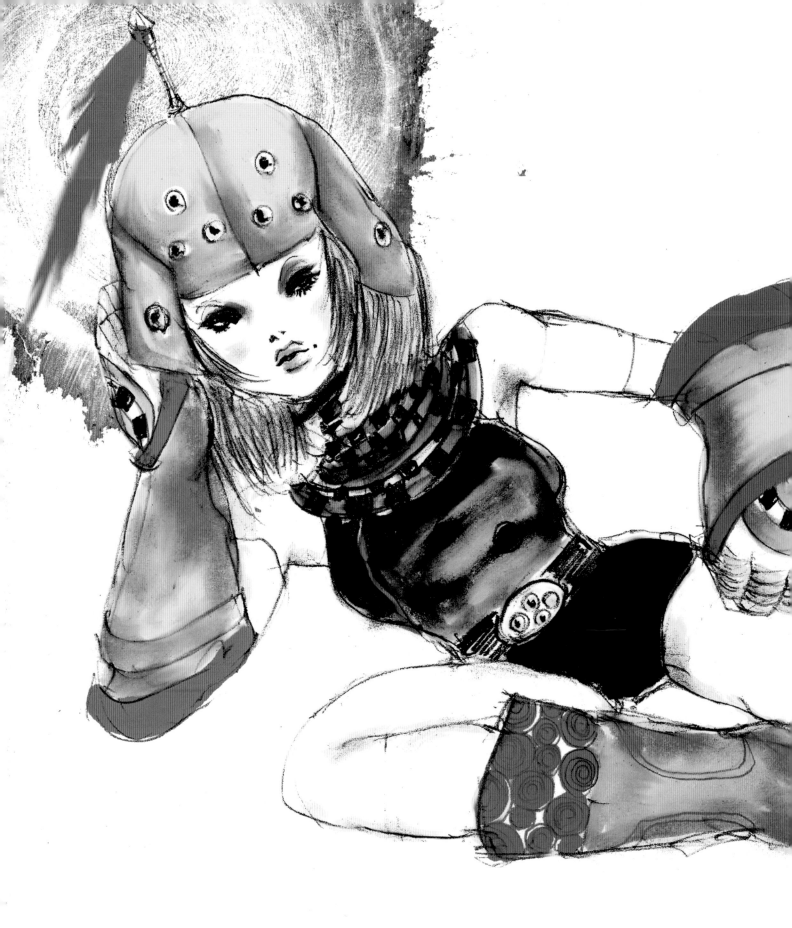

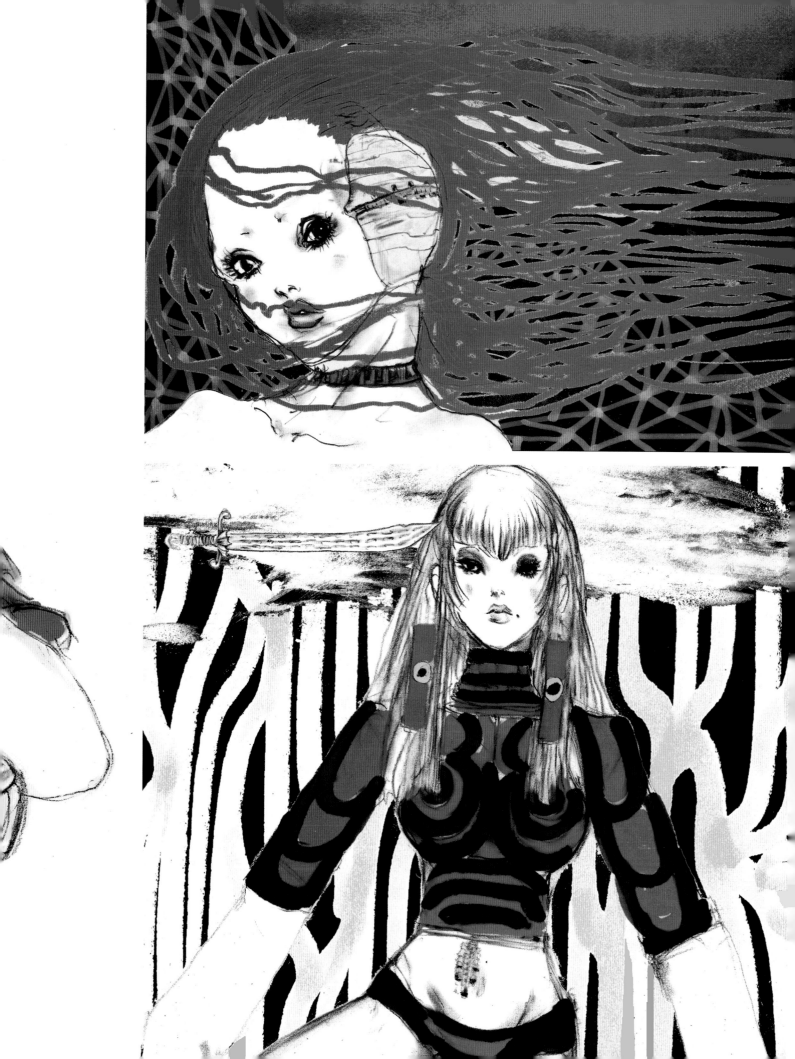

What kind of music inspires your artwork?
I love music generally and listen to it when I'm working all the time, unless I've got to think really hard about something (but then that doesn't happen very often). I don't know that it influences my artwork specifically but it's more like it's the spiritual food that gets me excited and then I do good art (well some of it's good).

What is your current dream project?
I am very much interested in animation, I would love to make a short film and eventually a feature or series. But to be honest there's not much that I don't want to do—huge sculptures, toys, clothes, miscellaneous merchandise, video games…and I'm working on it all—scrapbooks full of plans and schemes.

What is your specialty besides being an illustrator?
I am a practicing multimedia artist—by that I mean I am actively creating paintings and sculpture as well as some installation work. I am one of 5 partners of the Riviera Gallery in Brooklyn (www.seeyouattheriviera.com) and spend all my spare time promoting or creating art in one way or another.

あなたのアートは、どんな音楽にインスピレーションを得ていますか？
音楽は大好きだし、仕事してる時はだいたいいつも何か聞いている。深く考えなきゃいけないとき以外はね（あんまりそういうこともないんだけど）。聴いている音楽が僕の作品に具体的にどういう影響を及ぼしているかはわからないよ、まあ言うなれば心の栄養素だね。いい音楽が僕をエキサイトさせ、その結果いい作品が生まれるんだ（まあ、少なくともいくつかはいい作品が生まれる）。

あなたのキャリアにおける具体的な夢を教えてください。
アニメーションにとても興味があるんだ。ショート作品、いずれはフィーチャー映画かシリーズを作りたい。でも正直に言うと、やりたいことが多すぎてやりたくないことをあげる方が難しいよ。巨大な彫刻、おもちゃ、アパレルやマーチャンダイズ、TVゲーム・・・これらのプロジェクトはみんな僕のスクラップブックの中で進行中だよ。

イラストレーション以外で、あなたの得意なことを教えてください。
僕はイラストレーターとしてだけではなく、マルチメディアアーティストとしても活動している。どういうことかというと絵画や彫刻も作るしインスタレーションもやる。ブルックリンにあるRiviera Gallery（www.seeyouattheriviera.com）のパートナーの一人としても活動しているし、制作にしろプロモーションにしろ自由になる時間はすべて絶えず何らかの形でアートに携わっているよ。

matt campbell
マット・キャンベル

this page top: Greedy Gas Guzzlers "Skull 4x4," vinyl sticker, 2003
bottom: Greedy Gas Guzzlers "Sad Seal," T-shirt design, 2004
opposite top: Brownstone 4x4 Duplex, model kit collage, 2003
bottom: Hamburger Bandwagon Bandit, painted wood, 2003
p.82: from the American Dreamer series, "Tiger Lilly Girl" and "Christian Skinhead," 2005
p.83: Live Lovebats, 4color screen print, 1999

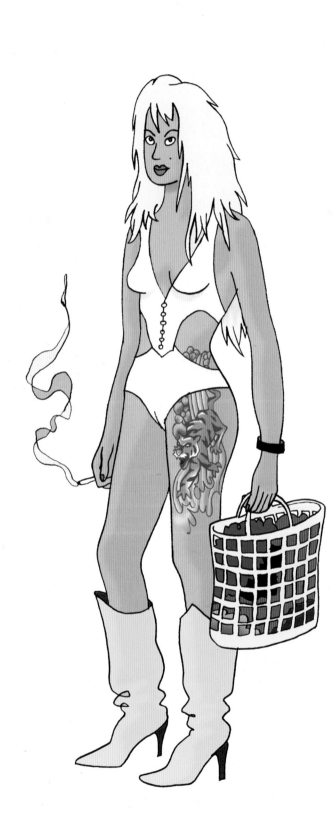
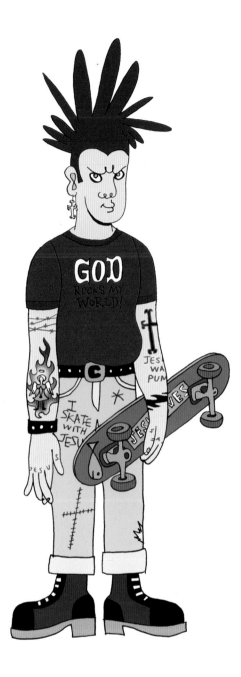

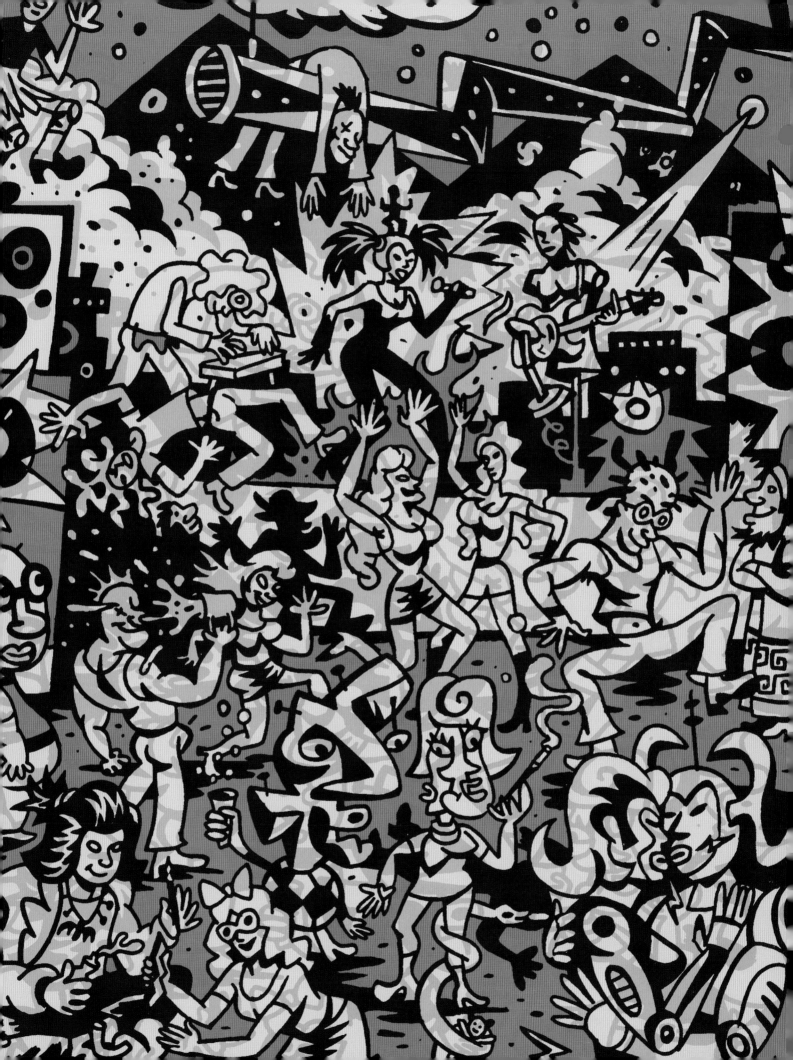

michael bartalos

マイケル・バルタロス

What are you visually inspired by?
I am enchanted and inspired by the work of Kurt Schwitters, Alexander Calder, Stuart Davis, Joan Miro, Isamu Noguchi, and the architects Herzog + De Meuron, among others.

Your favorite place in Japan?
Sakurajima, where kimono-clad ladies with parasols leave footprints in the ash that snows down from the active volcano towering dramatically nearby.

あなたのヴィジュアル的なインスピレーションの源はなんですか?
Kurt Schwitters、Alexander Calder、Stuart Davis、Joan Miro、Isamu Noguchi、そして建築家 Herzog + De Meuron などの作品にはいつも夢中にさせられ、インスパイアされている。

あなたが日本で一番好きな場所はどこですか?
桜島。
そこでは、着物をまといパラソルをさしたレディ達が、ドラマチックにそびえ立つ活火山から降りしきる火山灰の上に足跡を残していくんだ。

opposite: Savoir-Faire, 2003
overleaf: Four Trees, 2003
p.88: a la Mode, 2004
p.89: 29 Degrees North, 2004 (San Francisco Center for the Book)

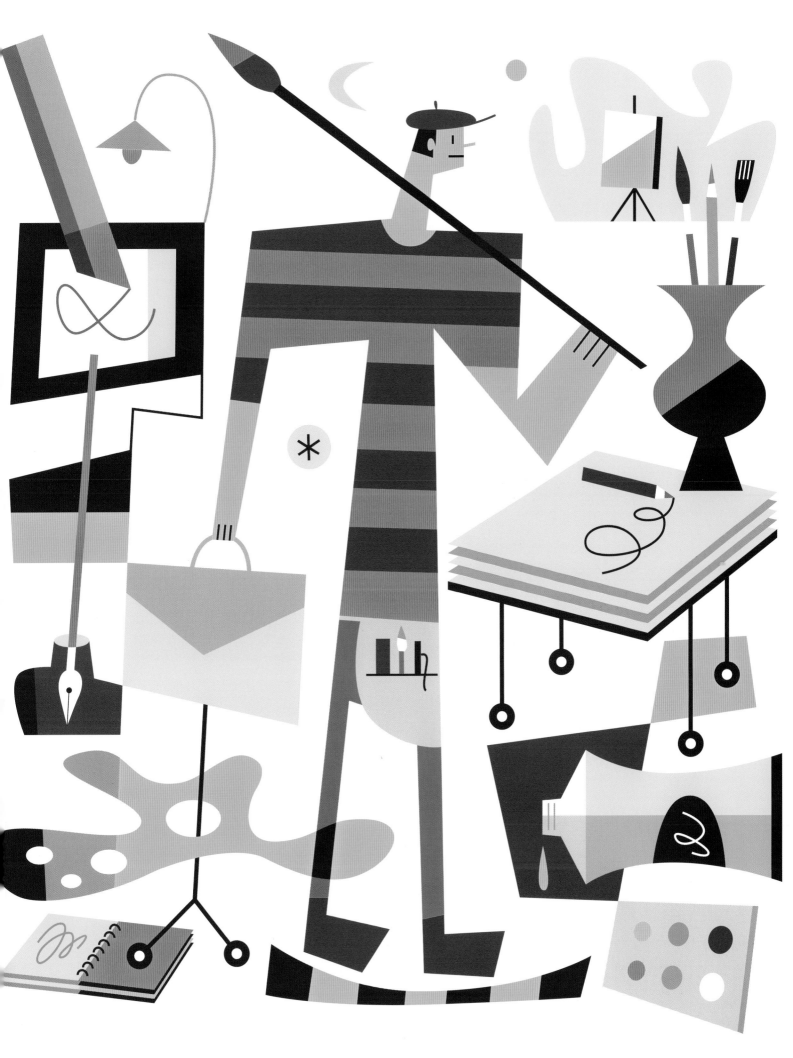

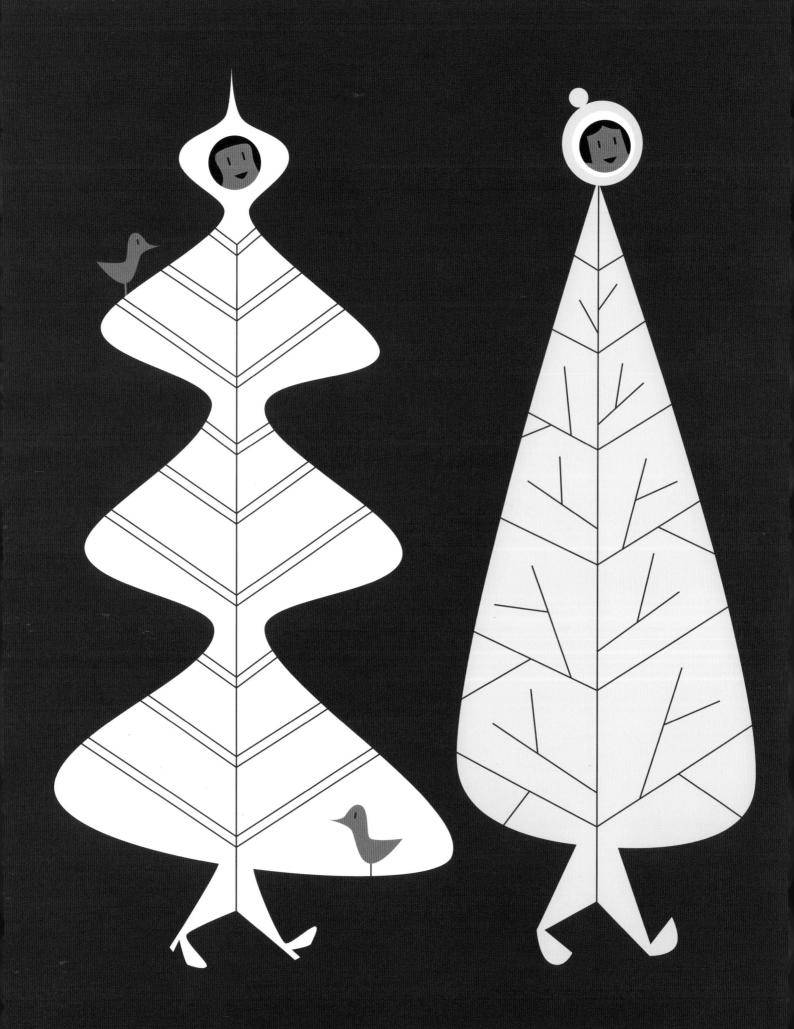

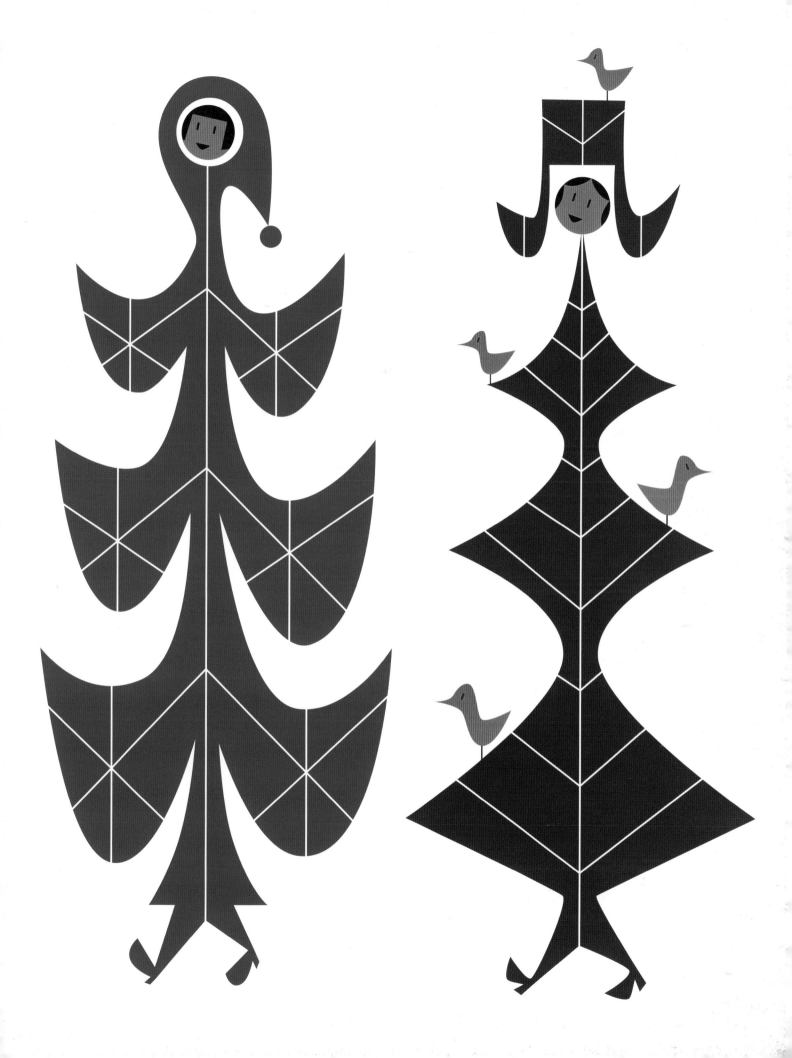

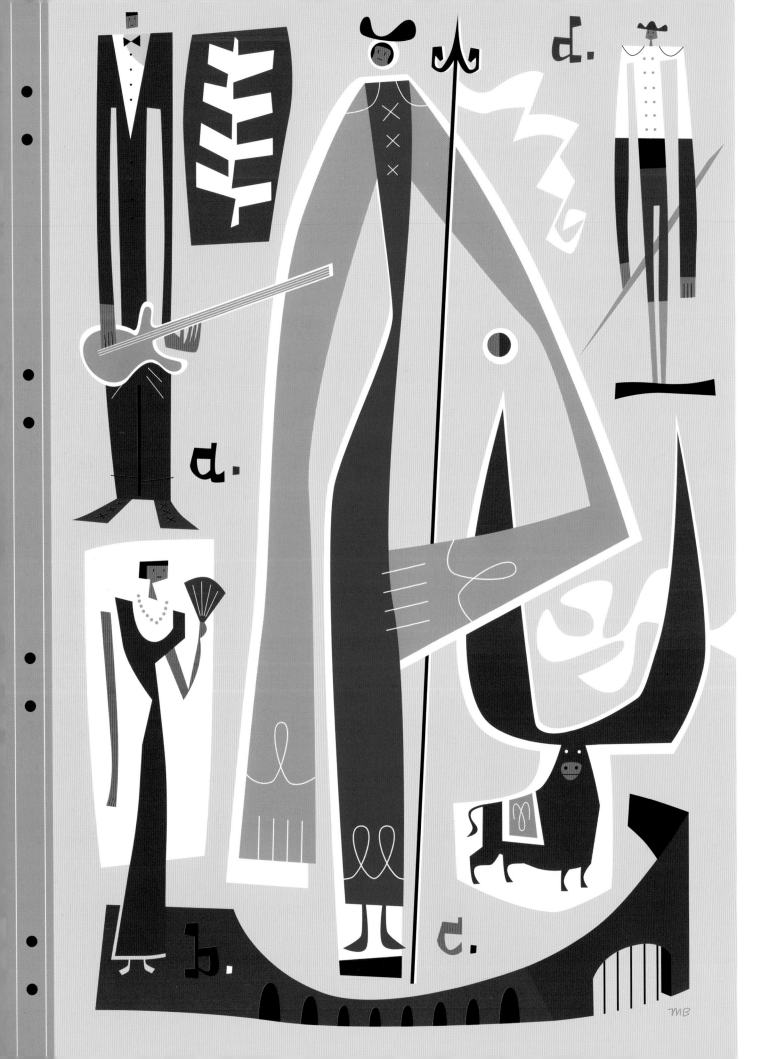

What are you visually inspired by?
People-watching more than anything. During my years in NYC
I got spoilt and I'm searching for something like it in Europe.

**What is the ideal environment you want to live and
work in?**
In a space flooded with light, friends and good coffee.

What is your current dream project?
I would love to find somebody, an animator I guess, who could
make my scribbled people move! It would be fantastic.

What do you trust?
Family and love. Everything else is secondary.

**Do you thrive on chaos or order? Or something in
between?**
I'm aiming for order but the result is definitely chaotic.

あなたのヴィジュアル的なインスピレーションの源はなんですか？
何よりも人間観察からインスピレーションを得ることが多いわ。
ニューヨークにいた頃は恵まれすぎていたから今はヨーロッパで
同じようなものを求めているところ。

**あなたが生活をするのに、理想の環境というのは
どういったものですか？**
光と友達とおいしいコーヒーに囲まれた場所で時間を過ごすのが理想。

あなたのキャリアにおける具体的な夢を教えてください。
私の落書きを動かしてくれる人と一緒にプロジェクトをしたい！
それができたら最高。

何を信じていますか？
家族と愛。ほかのものはすべて二の次。

カオスと秩序、あなたはどちらの状態に活力を得る方ですか？
秩序を目指してはいるんだけど結果はいつも明らかにカオティックね。

stina
persson

スティナ・パーソン

opposite: Modette, 2003 (This is a Magazine)
overleaf: Among the Stars, 2005 (MADAME Magazine, Germany)
p.94: Web, 2004 (JANE Magazine)
p.95: Taurus, 2005 (MADAME Magazine, Germany)

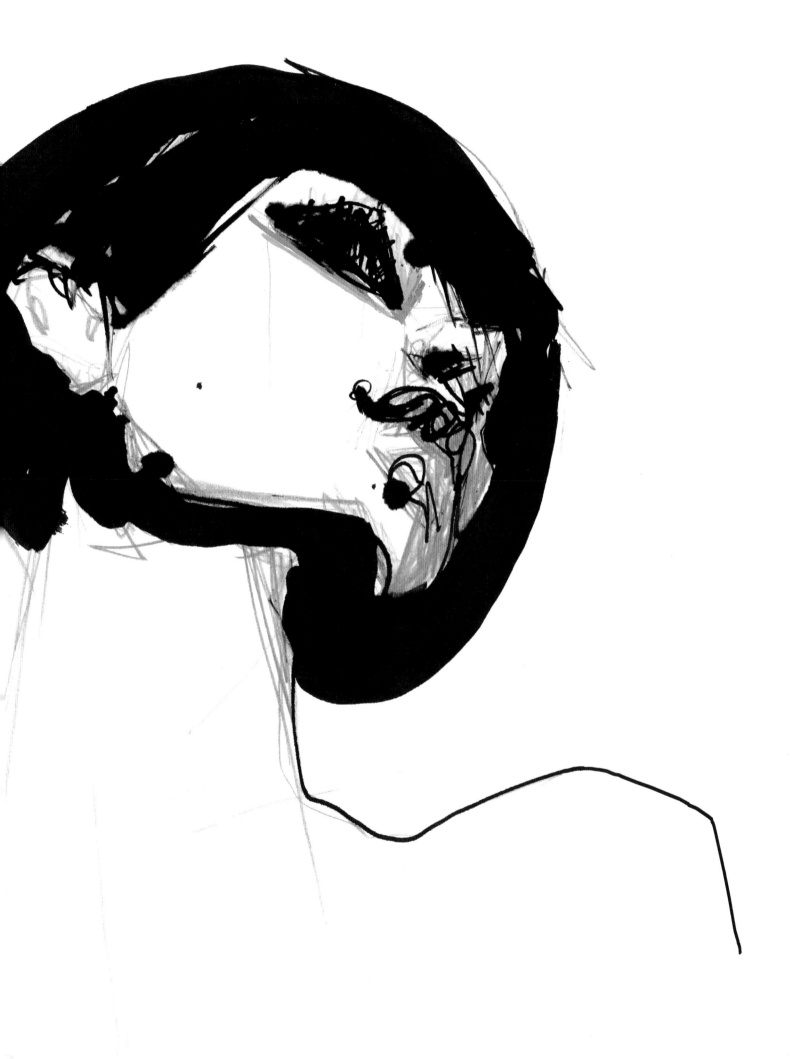

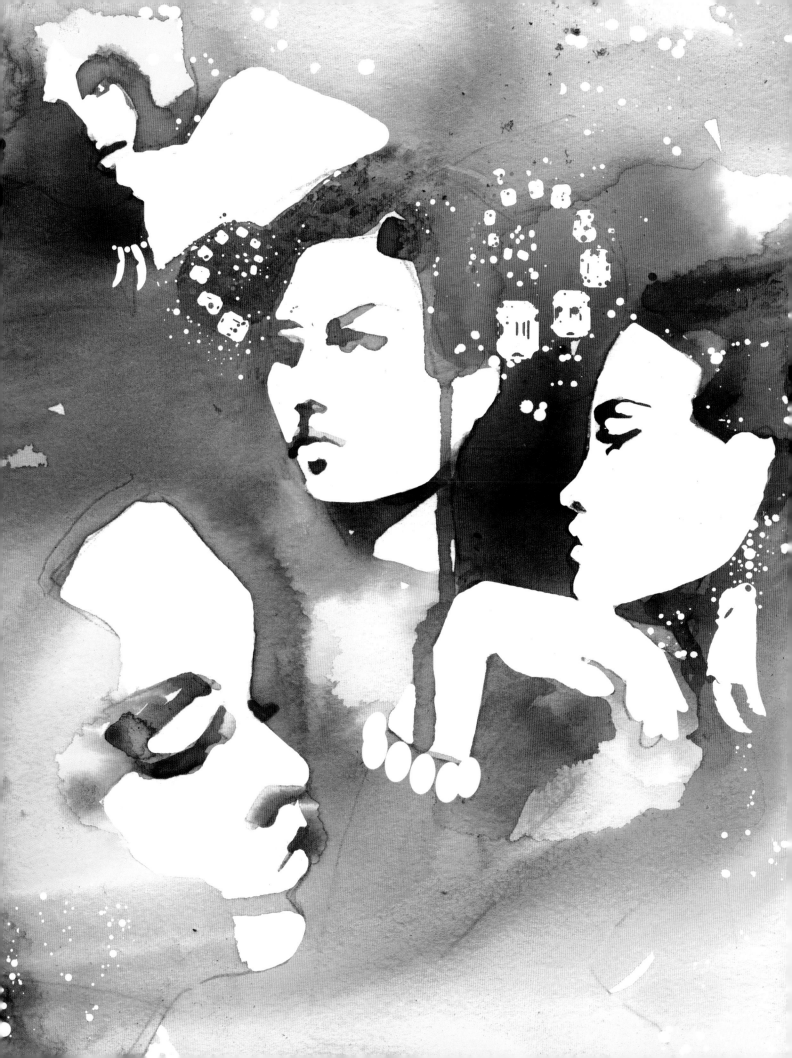

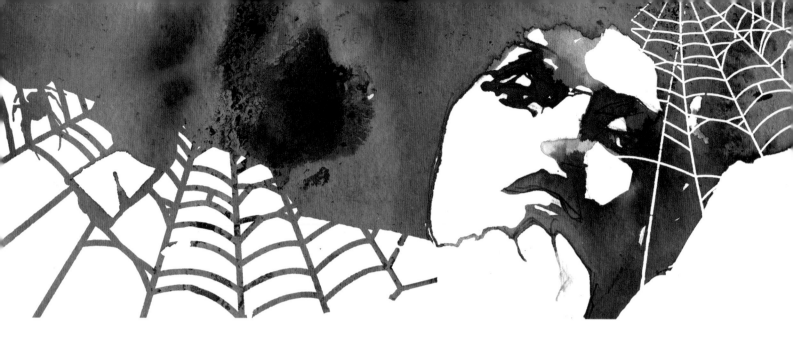

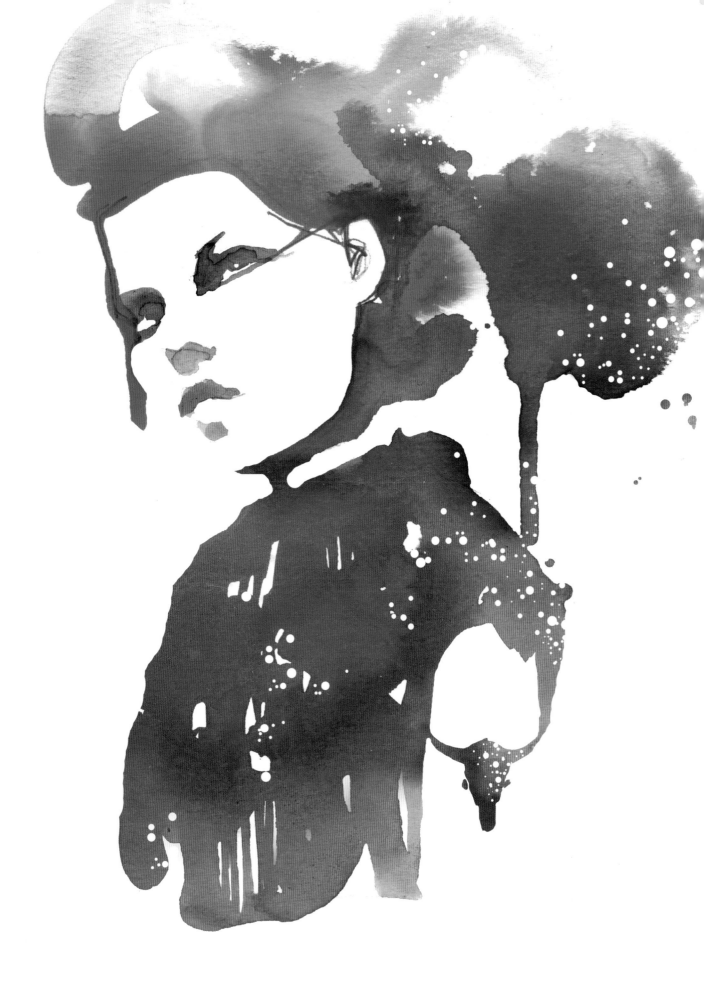

tina berning

ティナ・バーニング

How did your background affect your art?
My education was love and trust. My parents taught me that I can do whatever I want and as long as I put enough energy and patience into it, I will succeed.
There were only three things forbidden at home: talking during the news at 8, asking how long a car ride would take, and being bored. We were forced to occupy ourselves and later I understood that boredom is the opposite of creativity.

Who did you idolize as a teenager? Who do you idolize now?
I grew up with the illustrations of Heinz Edelmann (famous for "Yellow Submarine") in the supplement of my father's daily newspaper. Every Friday I was fighting with my sisters to get hold of that magazine first to cut out the illustrations and hang them on my wall. These illustrations made me want to become an illustrator and I still admire his work the most.

あなたの育った環境はあなたのアートにどのような影響を与えていますか？
私が両親から受けた教育は愛と信頼がすべてだった。私がやりたいと思ったことは何でもできる、と教えられたし、努力と忍耐さえ惜しまなければ必ず成功する、とも教えられたわ。そんな家庭で禁じられていたことはたったの3つ：8時のニュースの最中に話をすること、車で移動中に後どのくらいかかるか尋ねること、そして退屈すること。だから私たちはいつでも退屈しないように何かをしているように努めてたの。後になって退屈はクリエイティビティに相対するものだって気づいたわ。

子供時代に憧れた人、また今憧れる人は誰ですか？
父がとっていた新聞雑誌に載っていた Heinz Edelmann（彼の Yellow Submarineは有名ね）の作品を見て育ったのだけれど、毎週金曜日は姉たちよりも先にどうにかその雑誌を手に入れて、彼のイラストを切り抜いて自分の部屋の壁に貼るために必死だった。彼のイラストのおかげでイラストレーターになろうと思ったし、今でも一番彼の作品を尊敬しているわ。

this page: eitherway angel, 2004 (bilderklub.de)
overleaf: cancer, 2005 (Marie Claire UK) / magny cours, 2005 (RED BULLETIN magazine)
pp.100-101: travel, 2003 (qvest magazine)

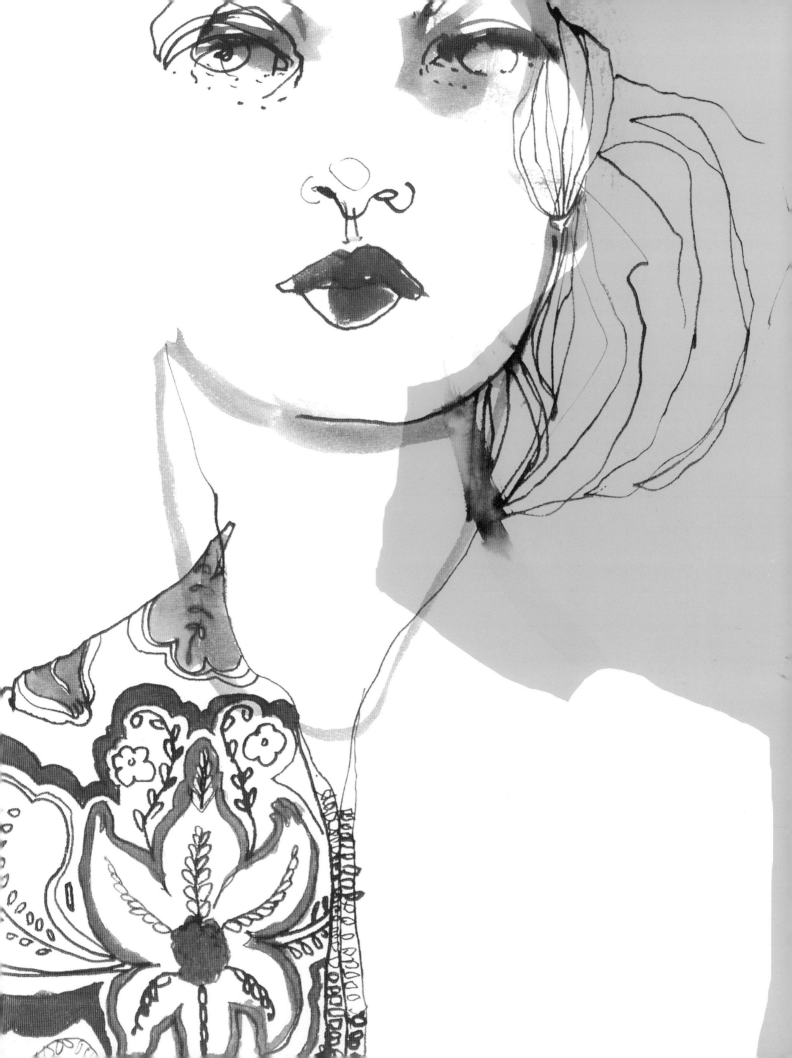

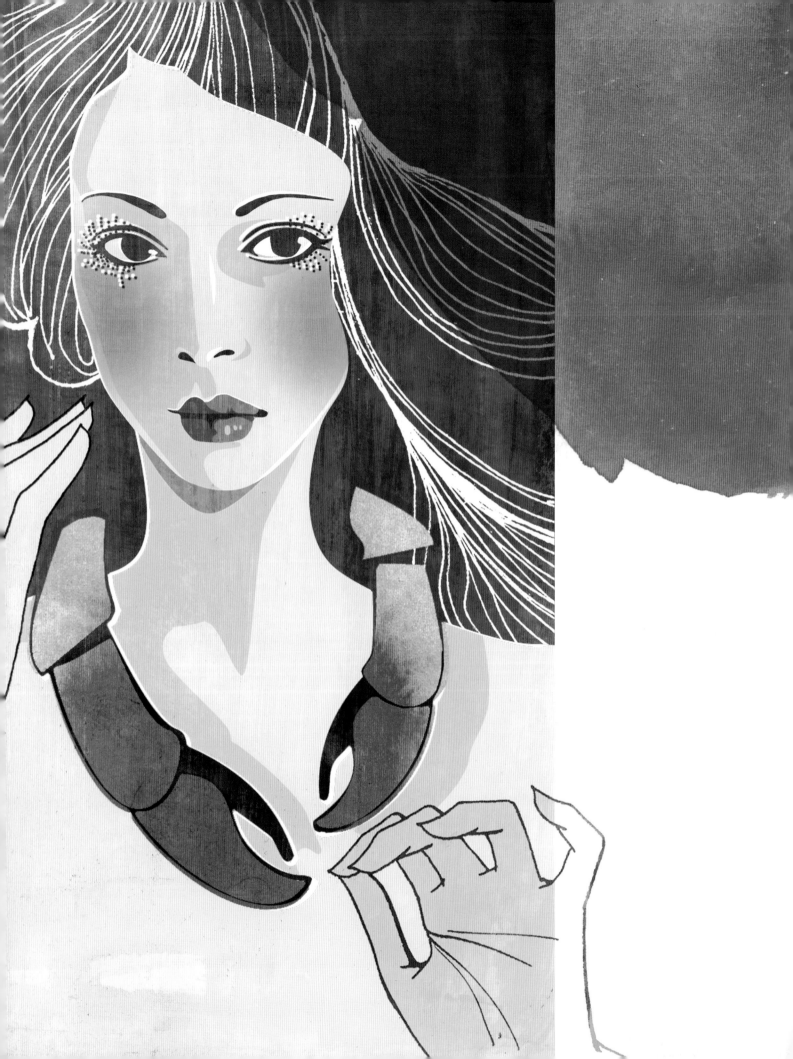

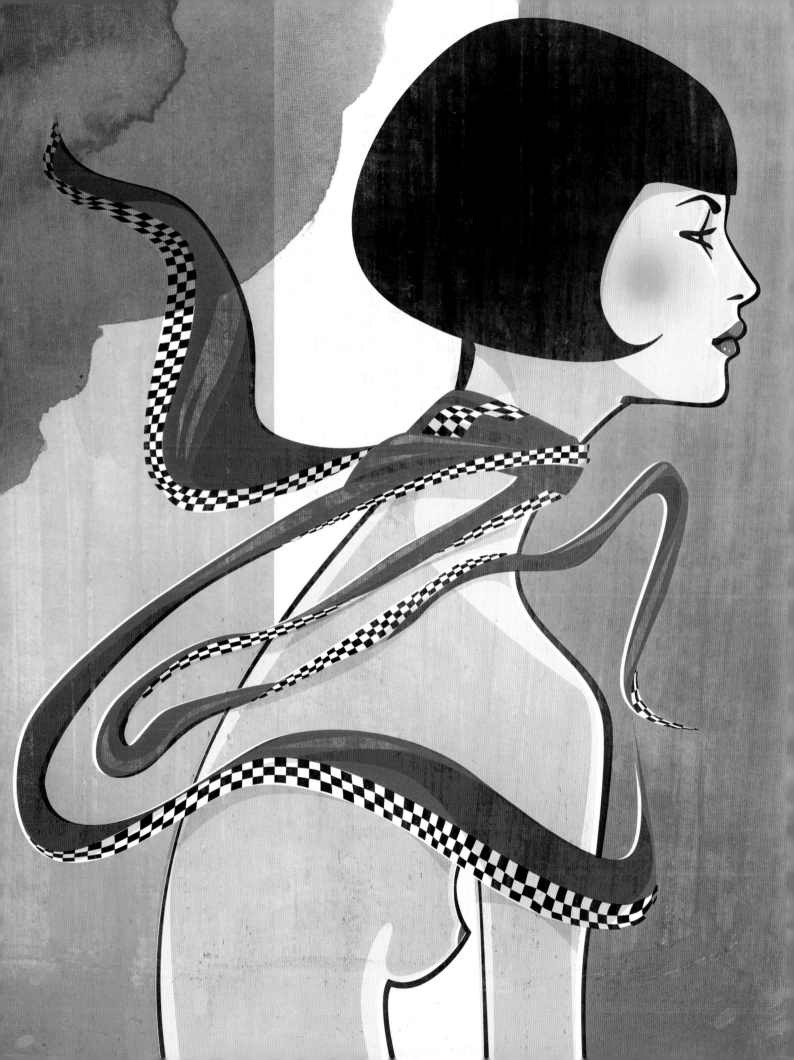

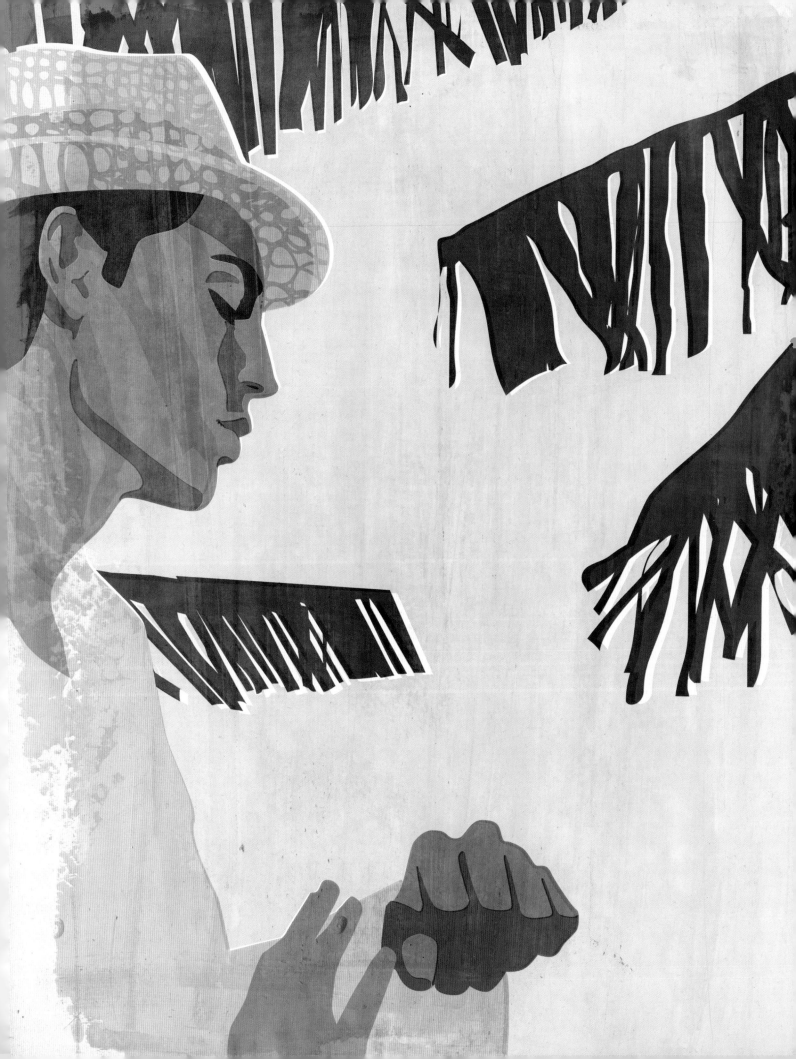

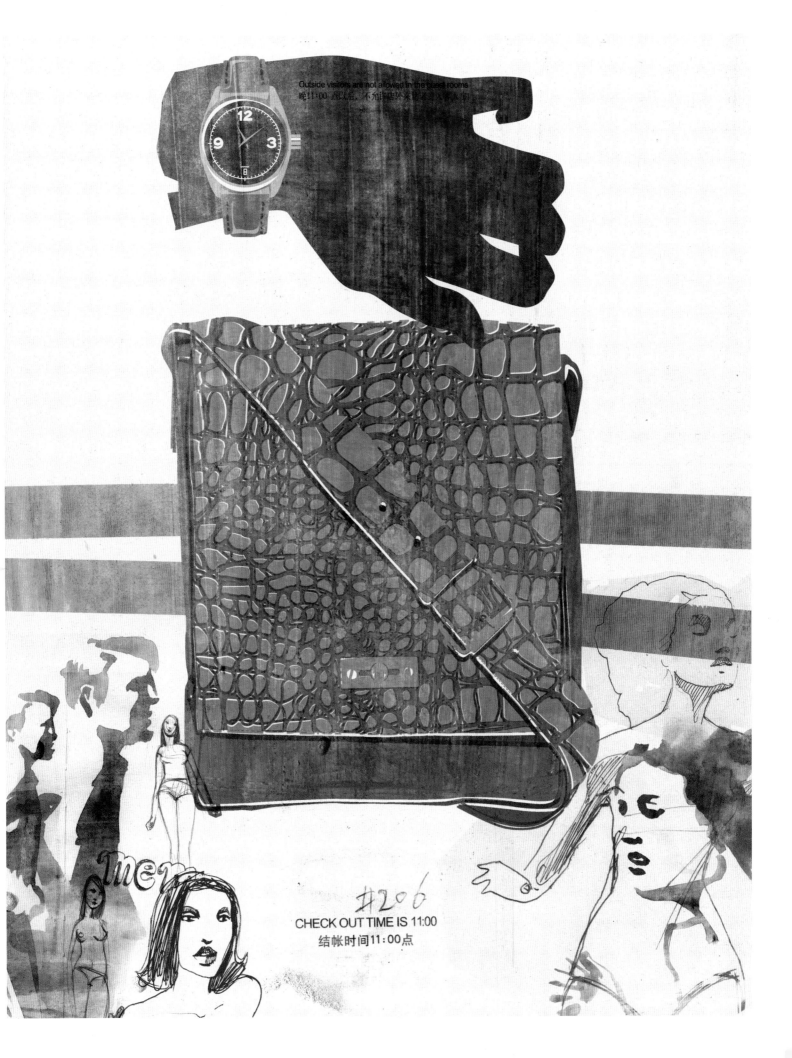

#206

CHECK OUT TIME IS 11:00

结帐时间11：00点

yuki hatori 羽鳥由紀

What are you visually inspired by?
The city and the people passing by. Late-night movies.

What was the last CD you bought?
Milton by Milton Nascimento.
My husband recommended it to me. Milton's earthy voice puts one at ease.

あなたのヴィジュアル的なインスピレーションの源はなんですか？
街や街行く人々。深夜の映画。

最後に買ったCDは何ですか？
Milton Nascimentoの「Milton」
夫の勧めで買いました。ゆったりとした大地のような声に癒されます。

this page: 牧場 (Meadow), 2001
p.104: untitled, 2004
p.105: untitled, 2004
pp.106-107: untitled, 2005

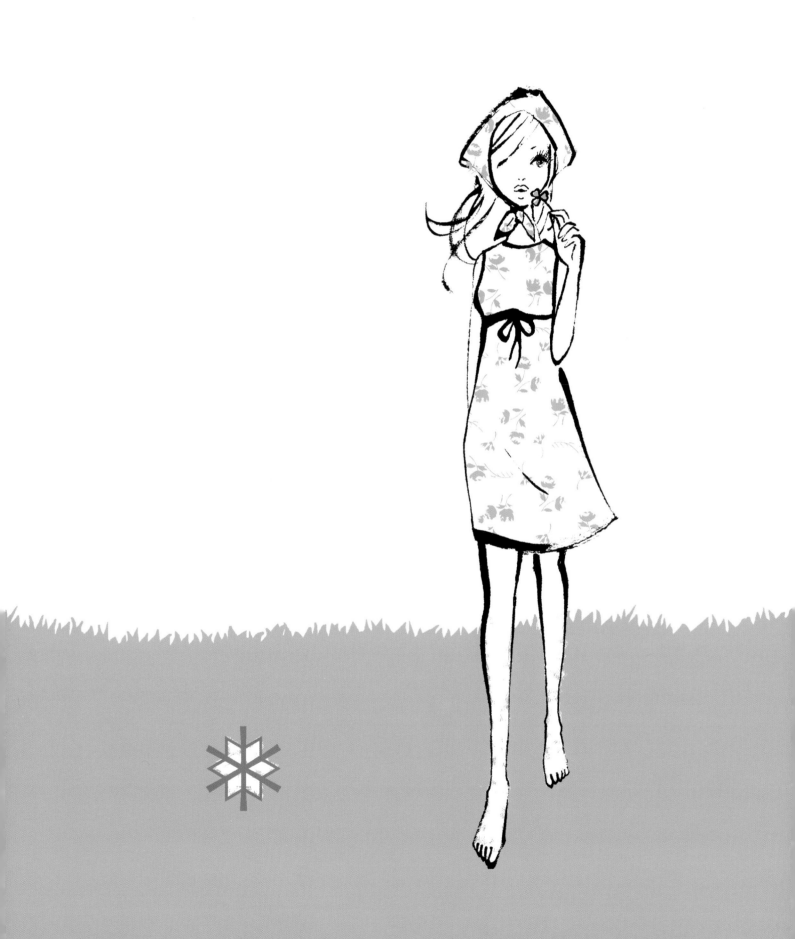

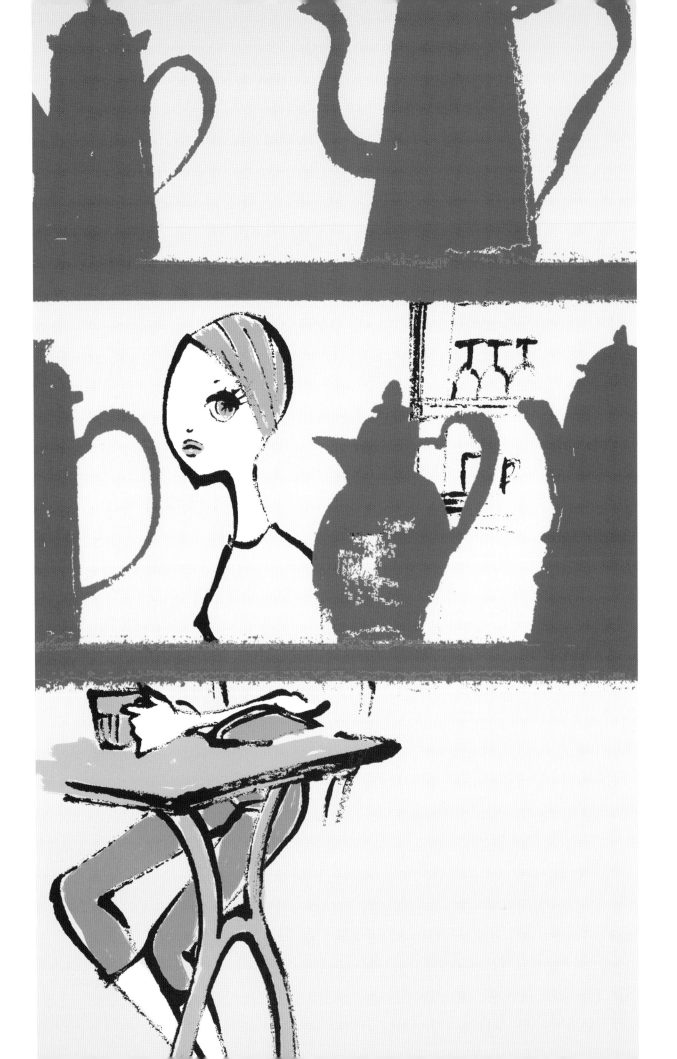

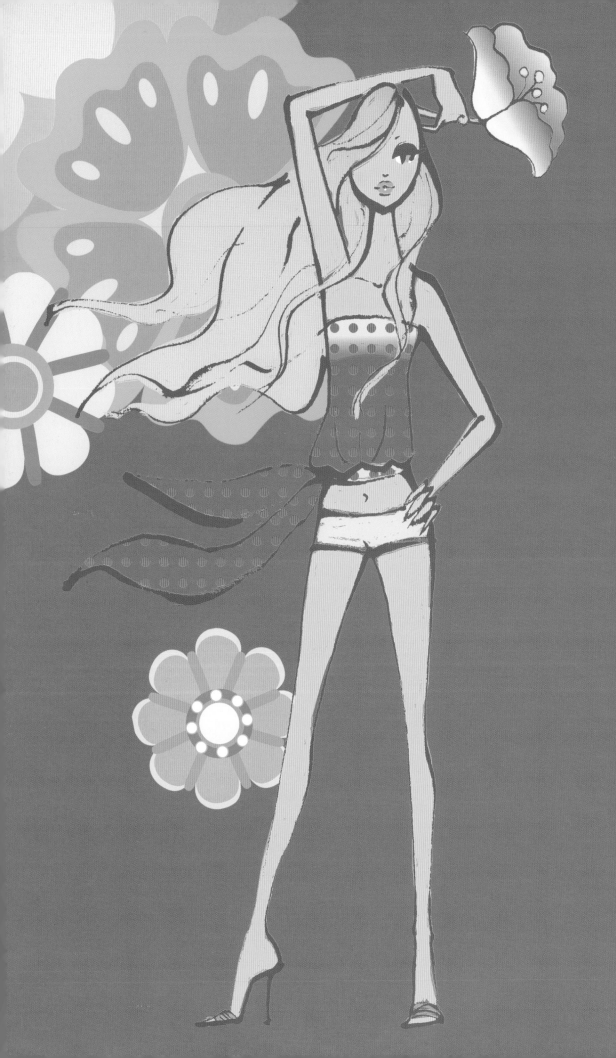

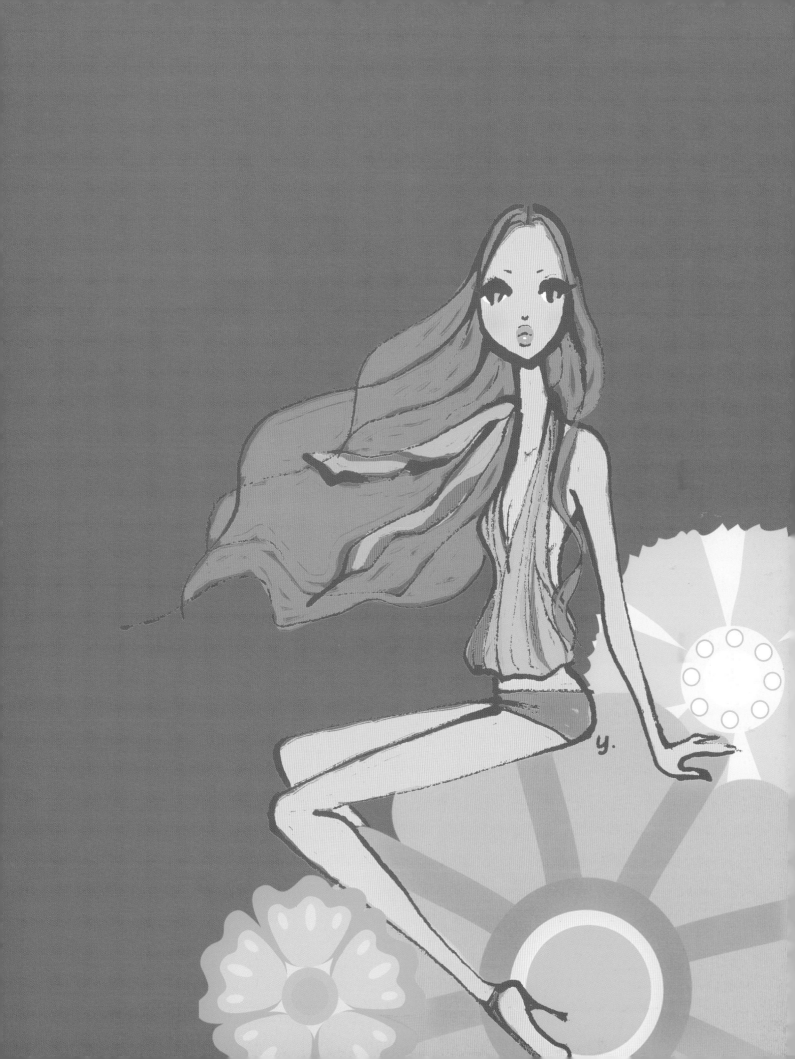

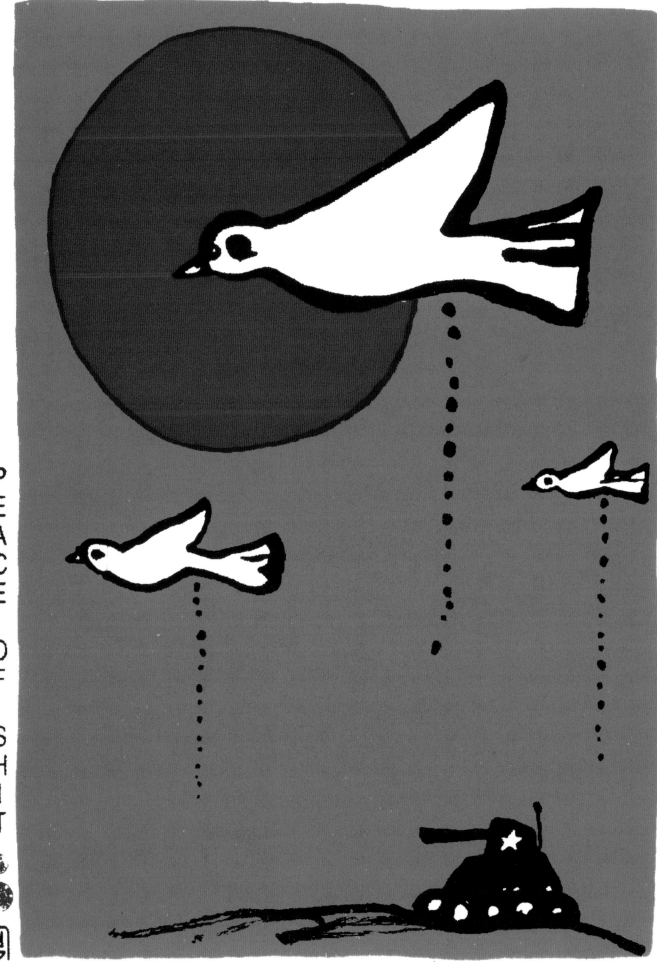

What do you consider to be an artist's societal role?
Messenger of inspiration, imagination and realization.

How does your background affect your art?
Of course EVERYTHING. I was brought up in an unconventional family, in a Japano-Western hybrid cultural environment. My life and art are deeply rooted in these childhood experiences. Thanks to that, I still occasionally see fairies.

Where do you draw your visual inspirations from?
Spots on the wall, and shapes of plants.

What is your current dream project?
<Publishing my picture journals>
My journals are records of all that I have gained from my travels and everyday life, through my six senses and expressed in my own personal voice. Through them I wish to promote human rights, a better environment and world peace.
<Picture books>
I want kids to continue to believe in things they can't see with their eyes.
<Gallery/museum exhibition>
Aside from my illustration jobs, I want to connect emotionally with others—reaching beyond race and age differences—through works that portray my inner self.

Favorite movie?
"Being There"
I wanted to marry Peter Sellers.
"The Seven Samurai"
I wanted to be a lover of Toshiro Mifune.
Personal favorite of late:
"The Life Aquatic with Steve Zissou"
Brilliant.

When you were a child, what did you want to be when you grew up?
Artist

アーティストの社会的役割とは、どういうものだと考えますか？
発想、想像、創造のメッセンジャー

あなたの環境は、あなたのアートにどう影響していますか？
of course EVERYTHING.
型破りな家庭環境と究極の和洋折衷文化で育った子供時代が、
ますます自分のlife/artに根ざしていると感じる。
そのおかげでまだ妖精が見えたりする。

あなたのヴィジュアル的なインスピレーションの源はなんですか？
壁のしみや植物のかたち

あなたのキャリアにおける具体的な夢を教えてください。
＊絵日記 (picture journal) 出版
旅や日常のlifeを六感全てで感じた個人の声を、人権、環境、平和に役立てたい。
＊絵本
子供たちが目に見えないものを信じ続けていけるようにしたい。
＊gallery/museum exhibition
illustrationの仕事の他に、個人的な内面を描いた絵が、人種や世代を超えた
別の個人の感情と繋がっていきたい。

一番好きな映画は何ですか？
「Being There」
Peter Sellersのお嫁さんになりたかった。
「七人の侍」
三船敏郎の恋人になりたかった。
でも最近のヒットは
「The Life Aquatic with Steve Zissou」
最高。

子供の時、大きくなったら何になりたかったですか？
アーティスト

opposite: Peace of Shit, 2002 ("Yo! What Happened to Peace!? " exhibition)
p.110: Patti Smith, 2004 (BarfOut!)
p.111: Boyd, 2004 (Boyd restaurant, NYC)
pp.112-113: NYC Subway, 2002 ("Travel Journal" exhibition)

 yuri

ユリ

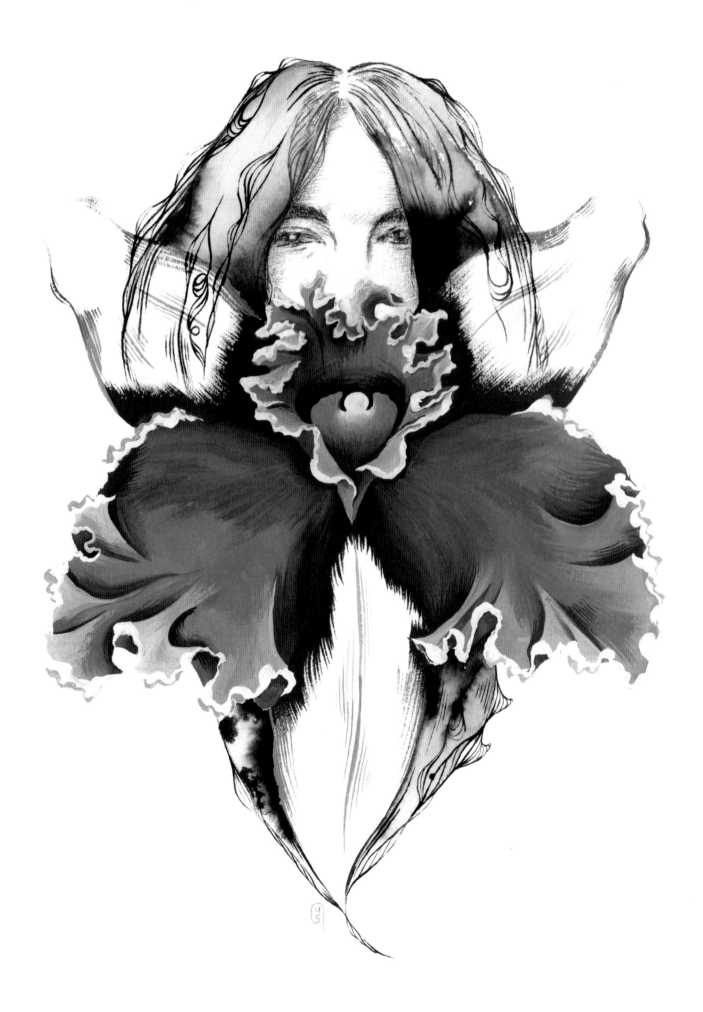

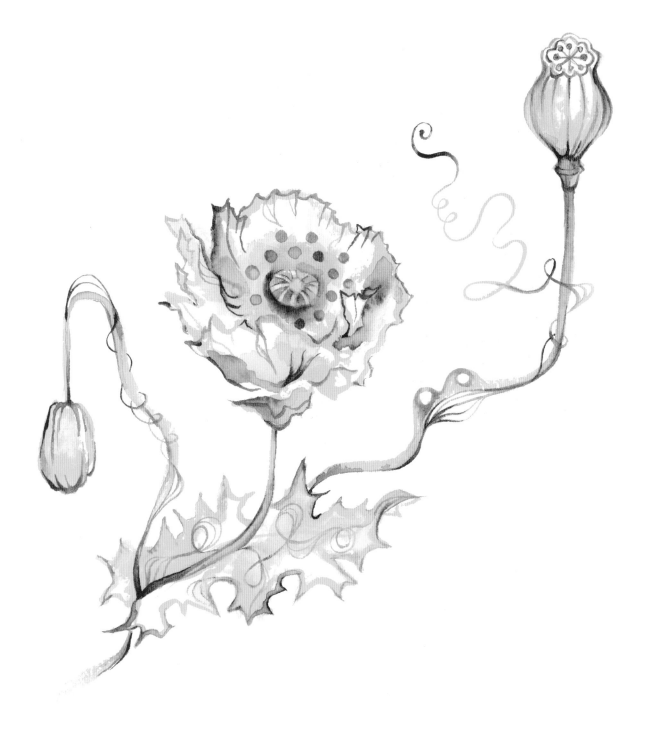

When I come back to New York from trave

The way is just get into a subway and be soaked in the
as I step into the subway, the vibes of NY infiltrate t
would see almost every ethnic group in the car. They are all di
from different backgrounds. But they all live in the same city,
the Yankees or Knicks won, sometimes low because everyone mou
but actually it's not. I know NY is one of the most warm hearted ch
faint and more than 6 hands were stretching out to support him. I
answer. I love subway performers. Some of them are amazi
and I love checking out people's fashion in the train car
I think I would still love to ride the subway even if
One day I have a limo and a chauffeur.

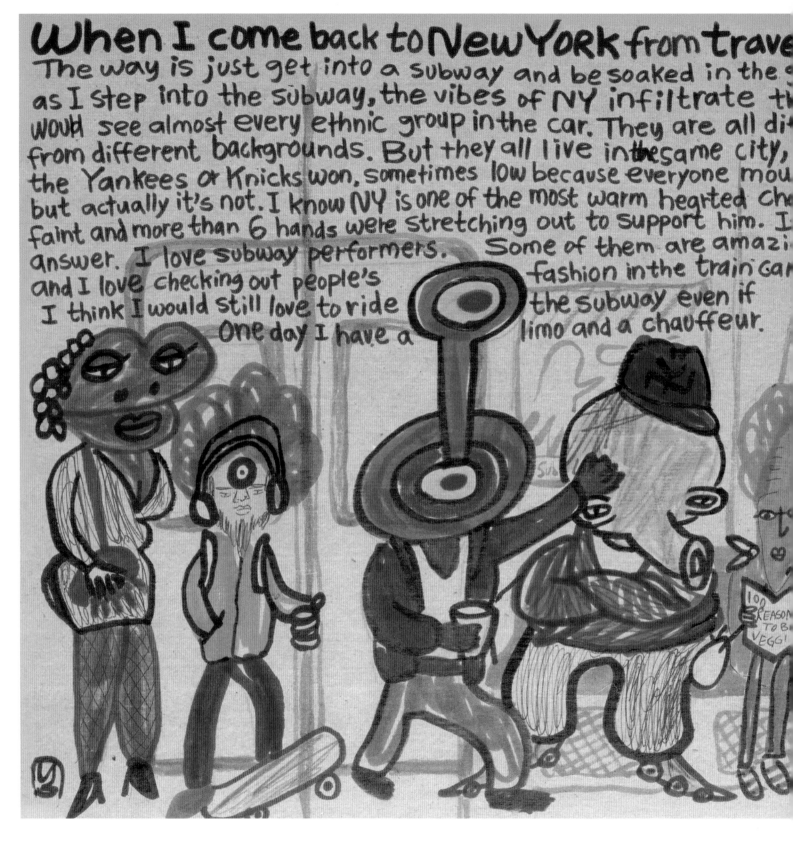

, I know how to put myself back in the NY groove. ne NY microcosmos. It is very strange but as soon me and I can feel like I am back. In the subway, you t types, from different races, from different religions and e same "NY attitudes". Sometimes energy is up because ur national tragedy. People say NY is such a cold blooded city city in the whole universe. I saw a homeless guy ▬▬ about to ebody shout to ask for direction, five voices would shout back the d some of them are terrible. I love Chinese "battery-one dollar" tribes,

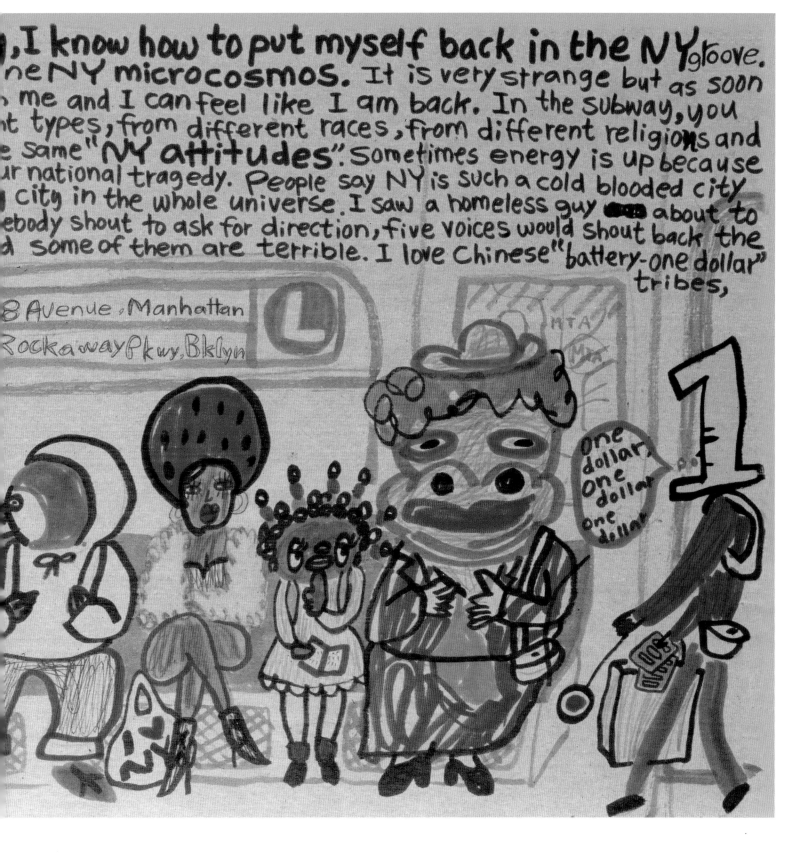

8 Avenue, Manhattan
Rockaway Pkwy, Bklyn

one dollar, one dollar, one dollar

us/asia

The artists in this chapter are represented in US/Asia by the CWC Group.
本章に掲載されているアーティストは、北米、及びアジア圏においてCWCグループがプロデュースしています。

What is "fashion" in your context?

Fashion is everywhere—on the street, in the house, in the stores, in work relationships...so it makes sense that the artist lives and draws fashion. And, with this perception of fashion, the artist introduces art into the house...

What about your art is most appealing to others? To you?

My art appears to others, I think, as a personal perception of color (maybe because of my first career as a stylist). I am very sensitive to color and forms. I love Bram van Velde (for the lightness of his colors) as well as the masters Vuillard, Bonnard (for their colored compositions) and Dufy (because he makes it look so easy which is so difficult to do!...). I like children's books too—the world of Bemelmans, of Tomi Ungerer or of Pierre Probst. I hope to keep the same enthusiasm for the future.

What is your current dream project?

My private life and my professional life are mixed. So, my professional life is the result of meetings... friends, exhibitions and so on... I never know exactly what my next projects will be (I have always had a bit of a carefree spirit!).

Favorite color?

I have no favorite color. I love all colors. It is, above all, a question of proportions...

P.S.

Did I forget the question of art school? I have no bad memories of art school. There I learnt to be curious, to learn to look around myself!...

あなたにとって、「ファッション」とは?

ファッションはどこにでもあると思うの。街の中、家の中、お店の中、仕事の中・・・だからアーティストがファッションと一緒に生き、ファッションを描くのも自然なことだと思うの。ファッションをそういう観点から見ると、アーティストはアートを家の中に上手にとりこんでいると思うわ。

あなたのアートの何が見る人を最も惹きつけるのだと思いますか?

私のアートに関して言えば、たぶん他人の目には個人的な色の捉え方を体現したものに映るんだと思う。スタイリストという昔の職業柄かもしれないけれど、色と形にはとても敏感なの。Bram van Velde の色の軽やかさは大好きだし、名匠 Vuillard やBonnard の構図の取り方なども尊敬しているの。Dufy も好きよ、本当は全然簡単じゃないのにいつもとても楽そうに全てをやってのけるから。Bemelmans や Toni Ungerer、Pierre Probst と言った絵本作家の作品も大好き。彼らのような積極性と希望を持って仕事をしていきたいと思うわ。

あなたのキャリアにおける具体的な夢を教えてください。

私のプロフェッショナルな生活と個人の生活は入り組んでいるから、お仕事と言うとさまざまな出会いの積み重ねにつきるわ。友達との出会い、展覧会・・・次のプロジェクトが何かなんて、いつもわからないわ(結構楽観的なところがあるのよ)。

一番好きな色は?

全ての色が好きだから、一番好きな色というのはないかも。
結局のところ、全てはバランスの問題だと思う・・・。

追伸

アートスクールの質問に答え忘れたかしら?アートスクールでの悪い想い出はないわ。そこで、好奇心を持ち自分の周りを良く見ることを覚えたのよ。

this page: Paris, 2005
overleaf: for Illustration à la Mode, 2005
pp.120-121: from Ropé collection

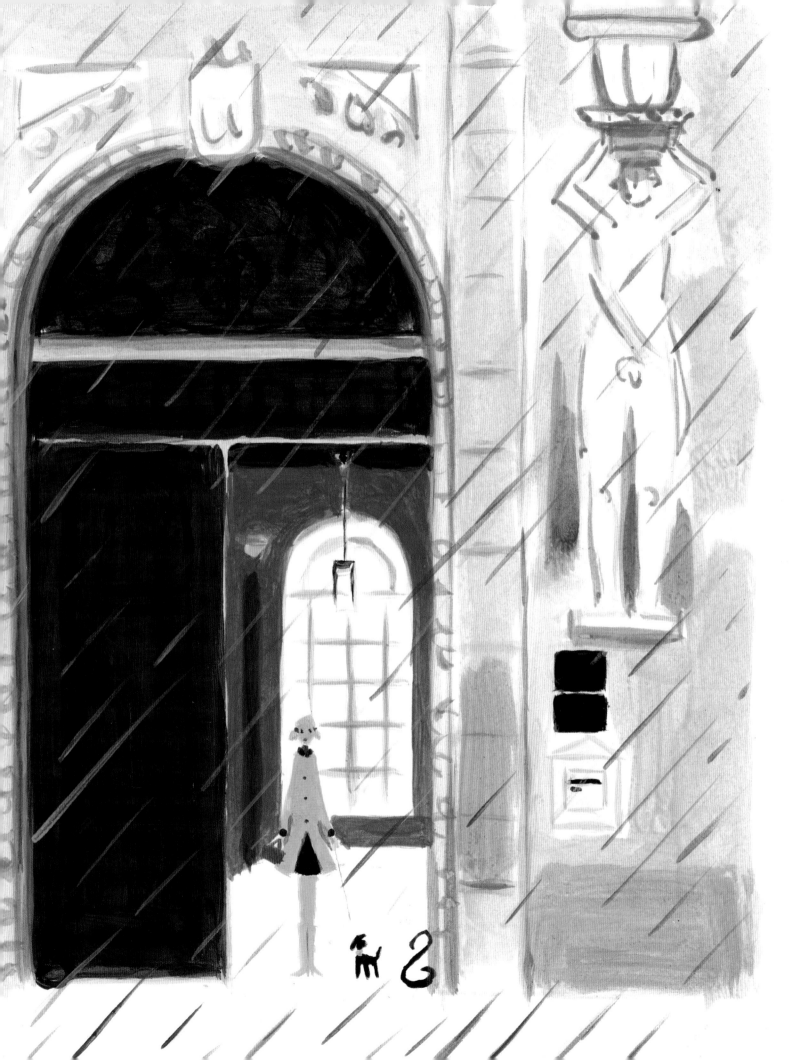

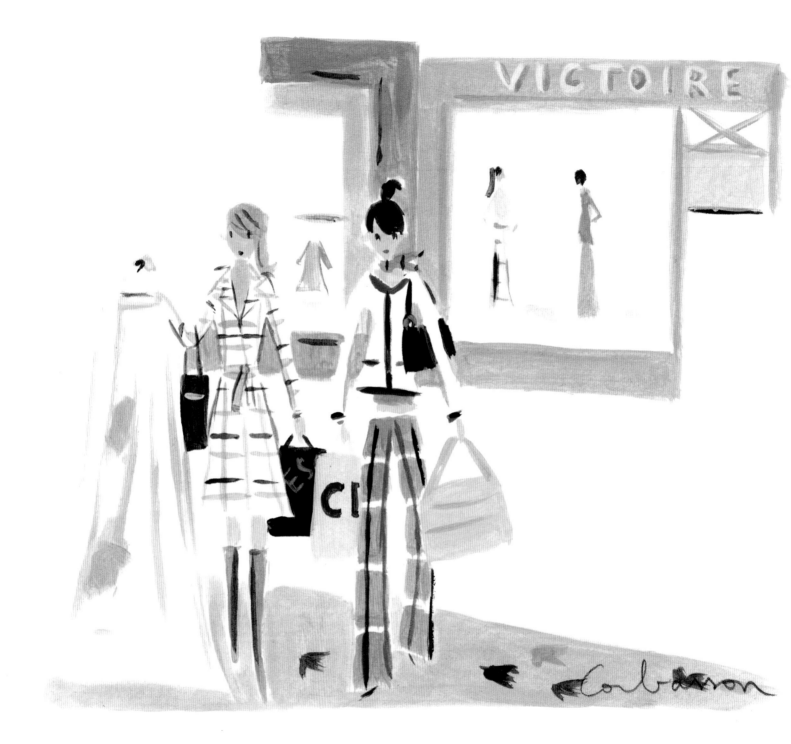

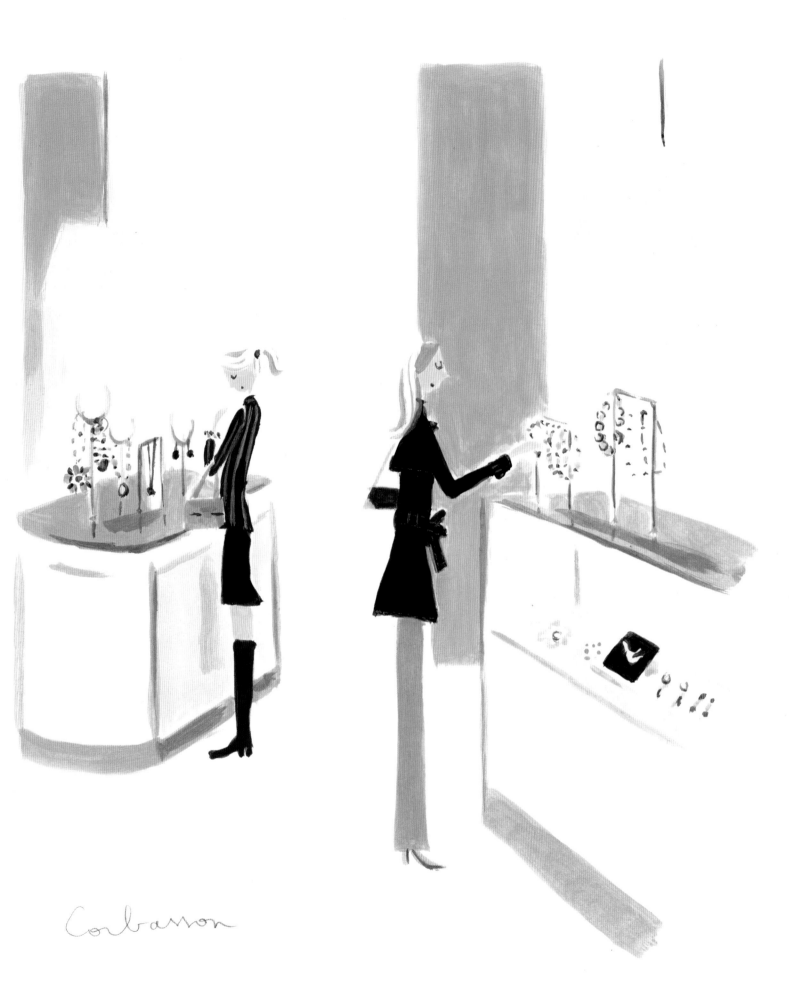

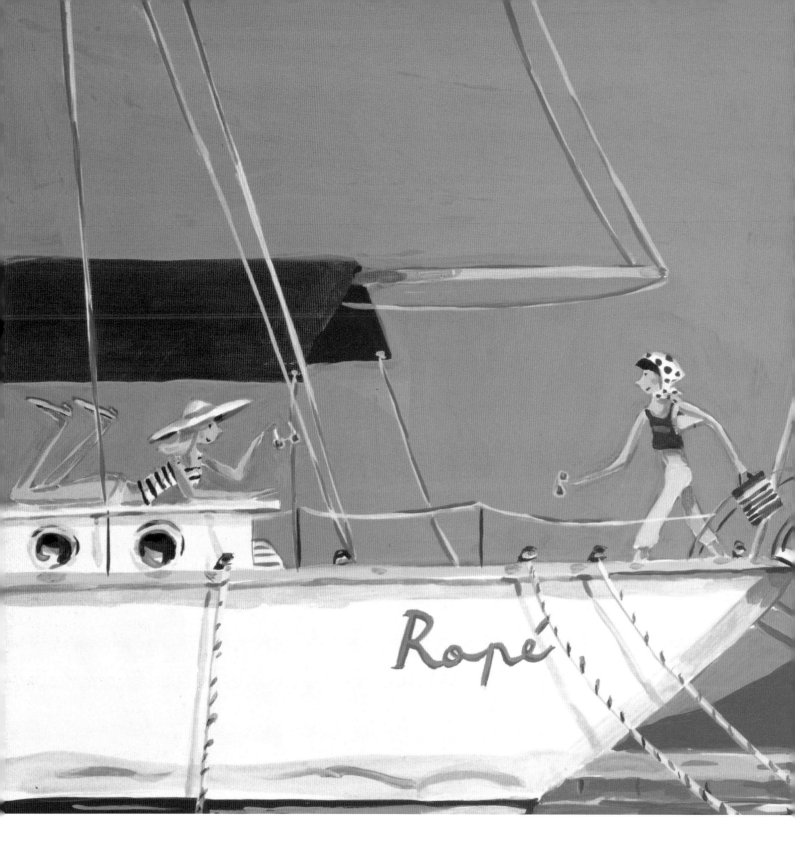

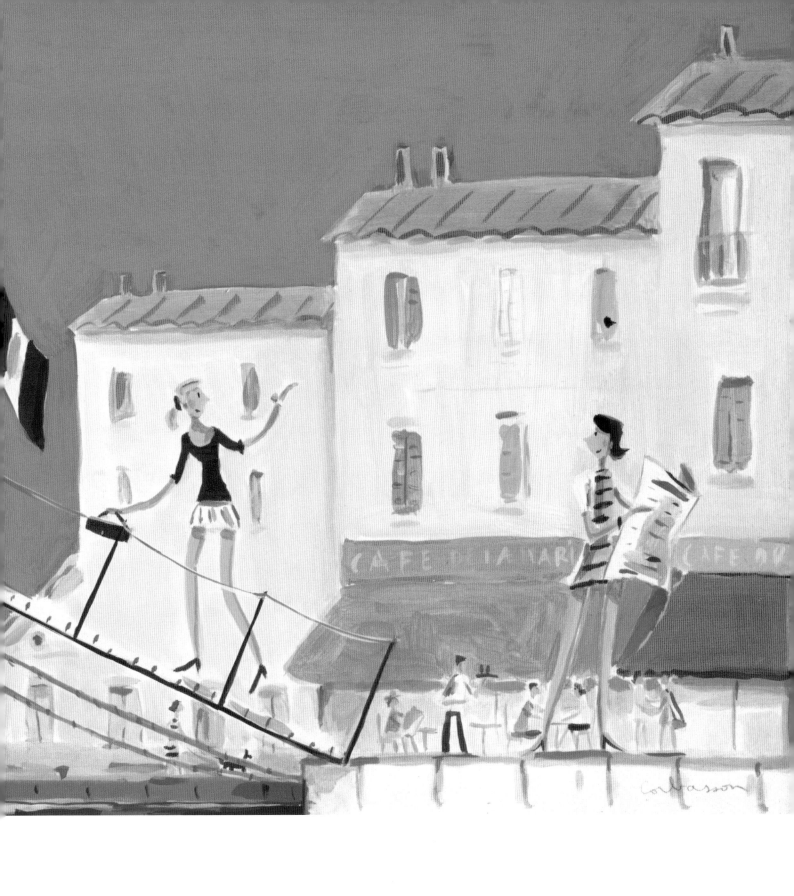

dovrat ben-nahum

ドヴラ・ベン・ナハーム

Did you attend art school? If so, was it worth it?
I had the great opportunity of attending the Illustration Department at the Royal College of Art in London, where I was given the tools to find my personal way of working.

What is your favorite memory from your childhood?
The first time I saw the world under the water at the Red Sea. The deep blue and the sense of no gravity was a bit like flying.

美術学校に通いましたか？
ロンドンのRoyal College of Artのイラストレーション科で学ぶというすばらしい経験に恵まれたわ。そこで自分独特のスタイルを確立するツールを与えられたの。

子供の時の一番印象的な想い出を教えてください。
紅海で生まれて初めて水面下の世界を見た時。深い青の色と無重力感のおかげで、空を飛んだように感じたわ。

this page: untitled, 1996 (Worldwide Fund for Nature, UK)
opposite: untitled, 1999 (Tomorrow Magazine)
p.124: untitled, 2004
p.125: untitled, 1996

Dovrat Ben-Nahum

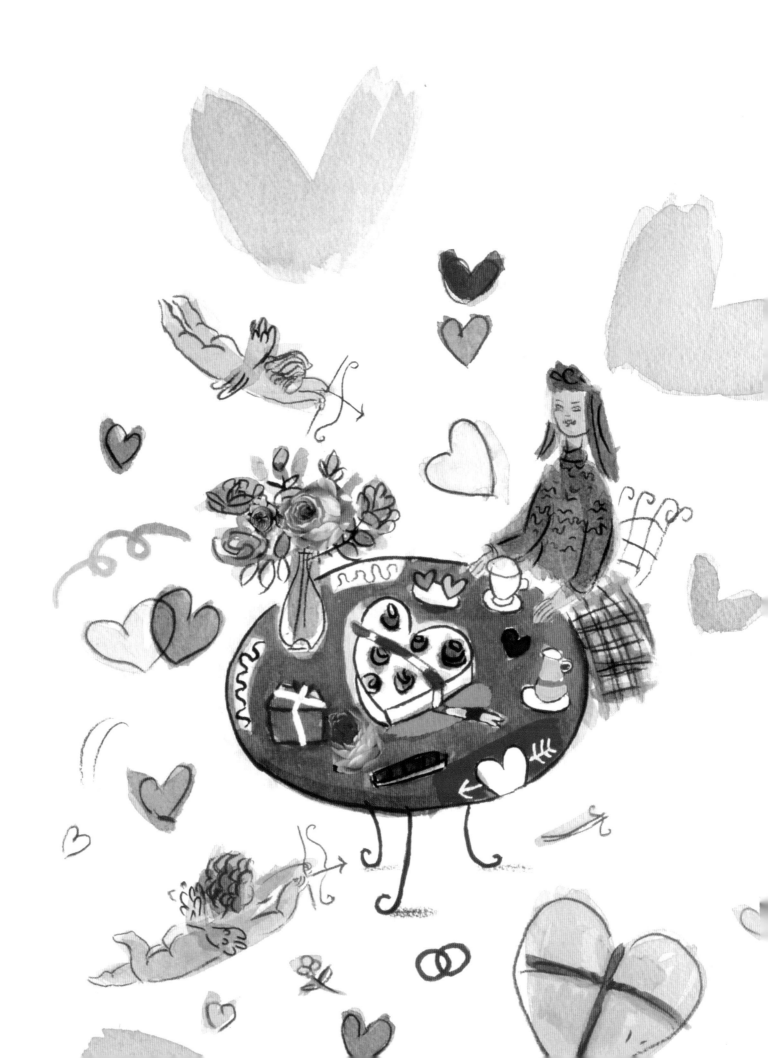

Have you ever had an enlightening experience?
Yes—the discovery of Abstraction, especially in Realism. It's a question of frame; if you zoom in very closely into a scene, composition, landscape, etc…you begin to enter Abstraction. I like this fragile limit between Realism and Abstraction, like in the paintings of Morandi.

If you were a cartoon character, who would you be?
Popeye.
He is cool, he doesn't care about money, he does whatever he wants, he is strong, nobody can put pressure on him, and he says, "I AM WHAT I AM!" (and like me he has an underbite)

Describe yourself in one word (or a few).
Anxious (but not afraid!)

If you could bring one person back from the dead just to hang out with you and let you bask in their utter and complete genius for a day, who would it be?
Without any hesitation: Yves Chaland. He is a French comic artist who died 14 years ago in a car crash at 33 years old. He was my "comic art teacher," my best friend, my oldest daughter's godfather…and a gifted children's comic artist.

Who did you idolize as a teenager?
Shaun Thompson, Martin Potter, Shane Dorian, Laird Hamilton—all great surfers.

And now?
My three daughters—Victoire (16), Penelope (14), Gloria (7).

What is the most important thing in your life?
My 3 daughters (it's becoming repetitive).
And to draw. I hope to draw to my dying day.

ぱっと目の前が開けるような思いを体験したことがありますか？
リアリズムにおける抽象の発見。これはフレーム（枠）の問題で、例えば風景などにどんどん
ズームインしていくと、抽象世界に入っていく事ができる。Morandiの絵にも見られる、
この微妙なリアリズムと抽象の境界線が好きだね。

もしあなたがスーパーヒーローだったなら誰だと思いますか？
ポパイ。彼はクールだし、お金のことを気にしないし、やりたいことをやっている。
彼はとても強いから、誰も彼に言う事を聞かせようとはしない。
いつも堂々と「俺は俺だ」と言っている（・・・それに、私と同じように彼も下顎が前に出ている）。

自分をひとことで紹介してください。
心配性（ただし怖がりではないけれどね！）。

**もし誰か一人、その人のあふれる才能に直にふれるためだけに一日だけ生き返らせることが
できるとしたら、誰を生き返らせますか？**
ためらいなく、Yves Chalandと答えるね。
彼はフランスのコミックアーティストで、14年前に交通事故で33歳にして亡くなった。
私の「コミックアートの先生」であり、無二の親友でもあり、私の長女のゴッドファーザーでもある。
何よりも彼は才能溢れるコミックアーティストだった。

子供時代に憧れた人は誰ですか？
Shaun Thompson, Martin Potter, Shane Dorian, Laird Hamilton―
みな素晴らしいサーファーたち。

今憧れる人は誰ですか？
私の3人の娘たち―16歳のVictoire、14歳のPenelope、7歳のGloria。

あなたの人生の中で、一番大切なものは何ですか？
私の3人の娘たち（何度も同じことを言ってるね）、そして絵を描くこと。
この世を去る日まで絵を描き続けていたい。

this page: Montmartre, 2003 (limited edition, Champaka/Ziggourat/Brussels)
overleaf: untitled, 2004 (More Magazine, Japan)
pp.130-131: new year card for Balzac Cinéma, Paris, 2004

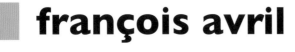

françois avril

フランソワ・アヴリル

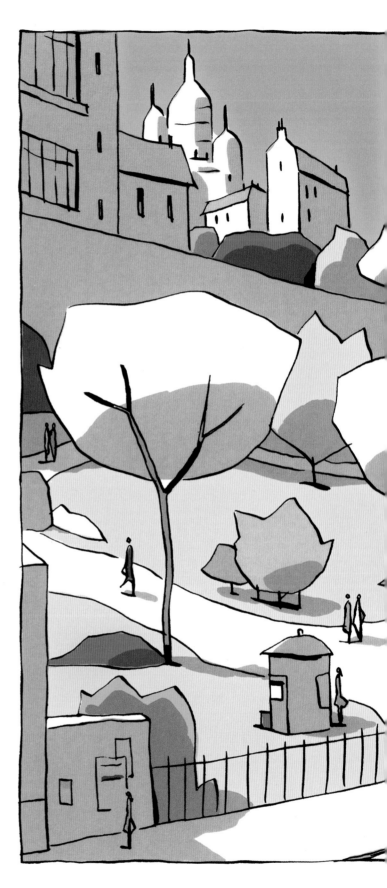

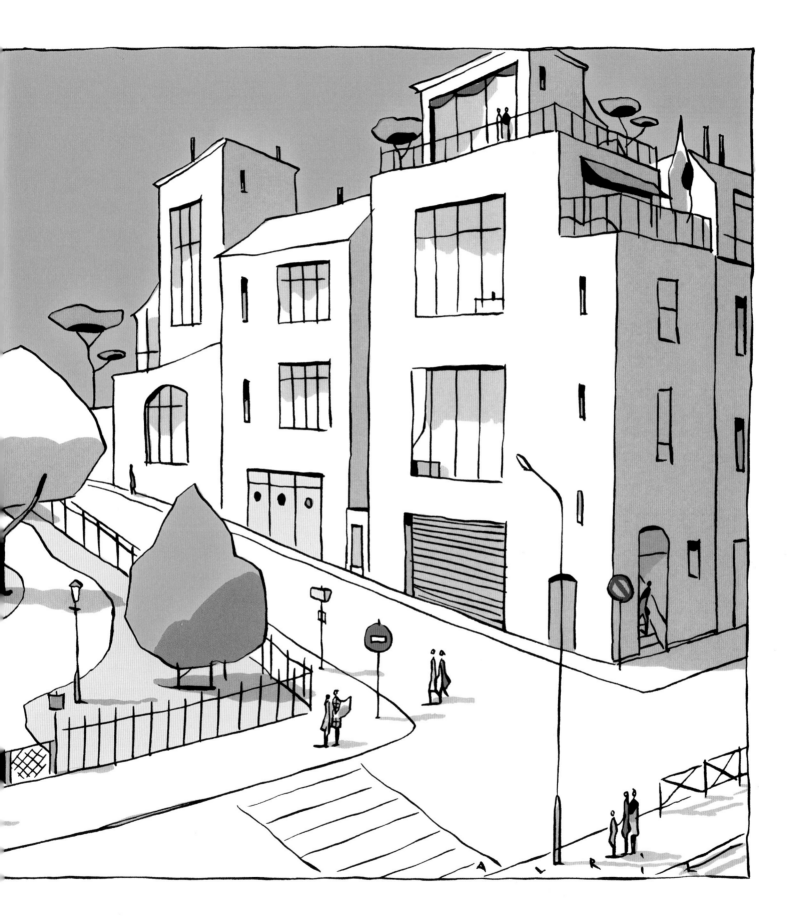

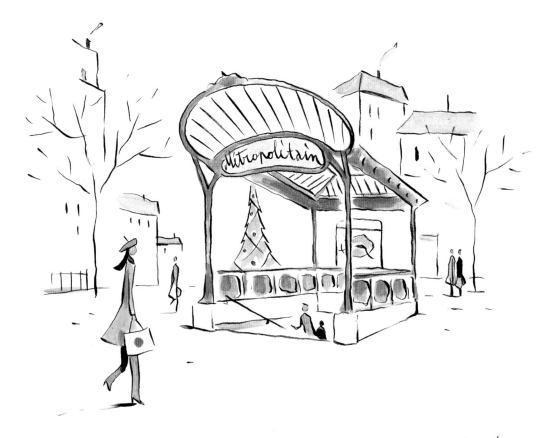

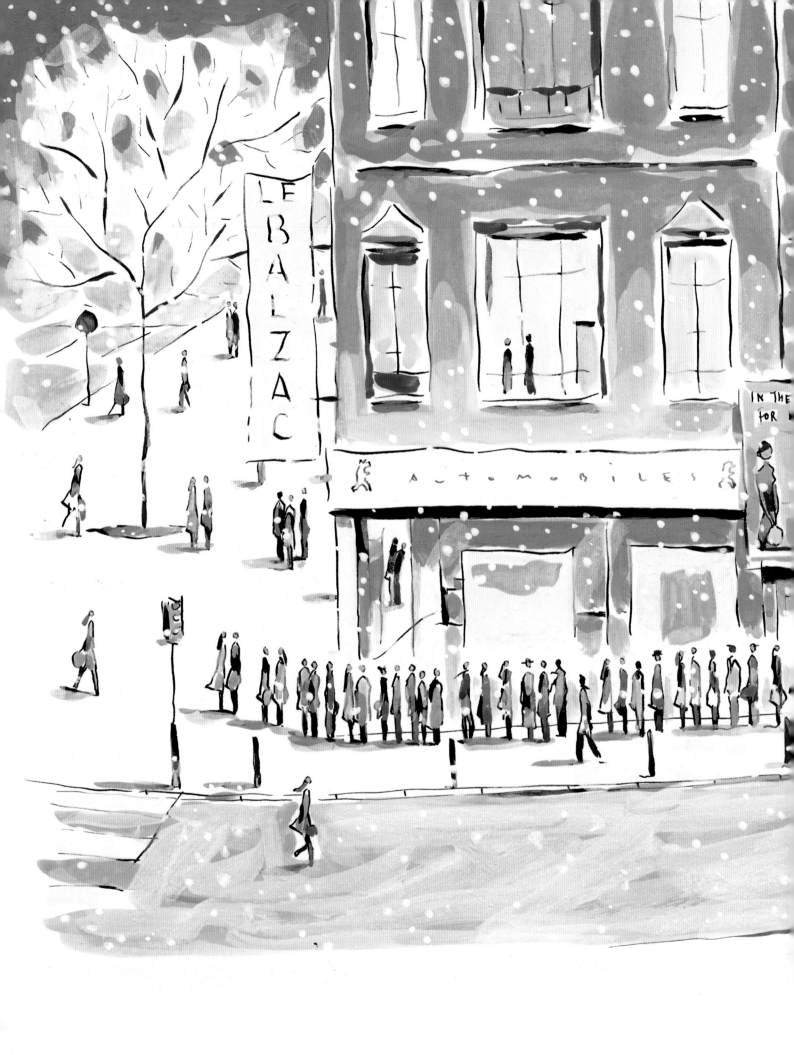

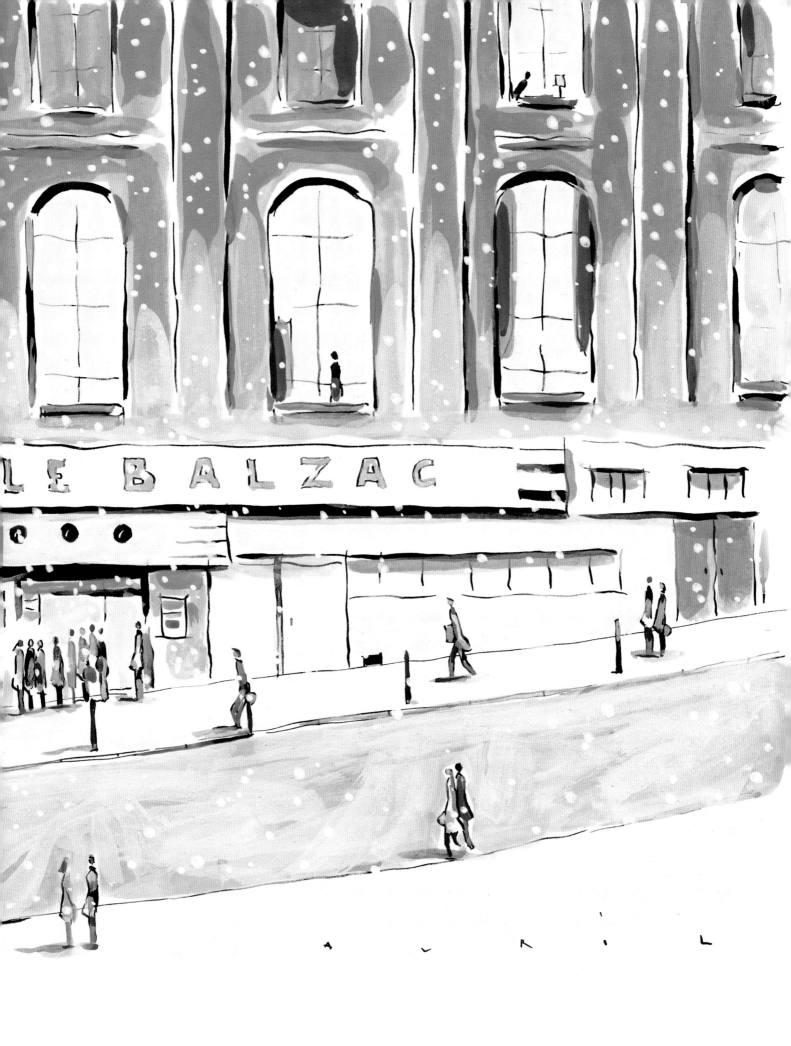

What is your favorite piece of clothing that you own?
My favorite piece of clothing is a Burberry's dark brown wool cardigan with mother of black pearl buttons. I must have had it for at least 7 years, it has become my security blanket. I have other cardigans in almost every color, I wear them all year around in foggy San Francisco weather.

What was the last book you read?
Just finished Nigella Lawson's *Forever Summer*, it sounds like a novel but it is a cookbook. After being skeptical of her, I was won over.

What is your current dream project?
Dream project: to publish a series of personal drawings/weird ideas that pop up just before I fall asleep. I scribble them quickly on cheap notebooks. Recently I went through everything, cut out the best and stacked up a thick pile of loose sketches. All I need now is to organize, refine and ink them. Somehow this is the hardest part since I agonize over every line.

Did you attend art school?
I was really immature when I started art school in France, things were very vague then. I really learned how to think and work when I took some night classes at SVA and Parsons later on, after a short period of soul-searching in New York City.

What is "fashion" in your context?
Fashion is knowing the exact time to retire the jacket you just couldn't go without a few years ago. The best thing to do is to hide it and wait for about twenty years to wear it again or pass it on to your teenager. You can then pretend that you just bought it. Fashion sets you apart; at the same time it makes you uniform within the group you belong to.

How does your background affect your art?
I was influenced when I was an adolescent by the French illustrators and humorists Roland Topor, Tomi Ungerer, Jean-Pierre Desclozeaux and André François. When I came to New York, I discovered classics like Ludwig Bemelmans, Syd Hoff, H.A. Rey, Charles Adams and William Steig. At one point I picked up a book at the Musée de la Publicity in Paris by Osamu Harada and this convinced me to take a trip to Japan, where I encountered hundreds of wonderful illustrators.
Specifically for fashion I admired Christian Bérard, Marcel Vertès who were working in the 30's, and more recently, artists François Berthoud and Mats Gustafson.

What do you consider to be an artist's societal role?
There should be all types of artists doing all kinds of art—decoratif, political, subversif. If society gives artists a narrow role, they will be confined and stale.

What kind of music inspires your artwork?
My friend Marie sends me CDs, she made me discover Pink Martini. Usually NPR is on while I am drawing, for news and interviews.

あなたの持っている服の中で、一番お気に入りのアイテムについて教えてください。
黒真珠のボタンがついたバーバリーの茶色のカーディガン。
もう7年くらいは持っているはず。赤ちゃんにとってのブランケットのように、それなしでは安心できないの。ほかにもカーディガンはありとあらゆる色のを持っているわ。霧の多いサンフランシスコの気候には必需品だもの。

一番最近読んだ本について教えてください。
Nigella Lawsonの「Forever Summer」を読み終わったばかり。小説のように聞こえるけれど、料理のレシピ本なのよ。これを読んで、セレブリティシェフとしての彼女の人気の理由がよくわかった気がするわ。

あなたのキャリアにおける具体的な夢を教えてください。
眠りに落ちる前に浮かぶ変なアイディアをまとめた本を出したいと思っているの。いつも安いノートにささっと落書きのようにスケッチしているのだけれど、最近それら全部を見直していいものだけ切り出したら結構な数のスケッチになったわ。後は整理してペンを入れていくだけ、でもそれがとっても時間がかかるのよ。私は線1本1本がパーフェクトになるようにさんざん悩んで描いているから。

美術学校で学びましたか？それは有意義な経験でしたか？
フランスでアートスクールに通っていた頃はいろいろなことが曖昧で、まだまだ未熟だったと思う。自分探しの旅の途中、ニューヨークにいた時にSVAとパーソンズでいくつかクラスをとったことで、本当にアーティストとして考え、アート制作をする、ということを覚えたわ。

あなたにとって、「ファッション」とは？
ファッションとは何かと言ったら、例えば数年前だったら、それなしでは生きていけなかったジャケットをいつ引退させるか、といった判断ができることだと思う。一番いいのはそれを隠しちゃって、20年後くらいにまた引っ張りだして着るか、もしくはそれを10代の娘に渡すことね。今買ったばかりのような気分になれる。ファッションとは自分と他人を区別化することだけれど、それと同時に自分が所属するグループに自分を帰属させることでもあると思う。

あなたの育った環境はあなたのアートにどのような影響を与えていますか？
思春期に、Roland Topor、Tomi Ungerer、Jean-Pierre DesclozeauxやAndré Françoisといったフランスのイラストレーターたちに影響されて育ったの。そしてニューヨークに来て、Ludwig Bemelmans、Syd Hoff、H.A.Rey、Charles AdamsやWilliams Steigといった大御所の作品に出会ったわ。そしてその過程のどこかで、パリのMusée de la Publicityで原田治さんの作品に出会ったことをきっかけに、日本を訪れたのよ。日本では何百人もの素晴らしいイラストレーターの作品に出会ったわ。ファッションイラストレーションの世界で言えば、30年代に活躍していたChristian BérardやMarcel Vertèsはいつも尊敬していたし、最近ではFrançois BerthoudやMats Gustafsonなど、素晴らしいと思うわ。

アーティストの社会的役割とは、どういうものだと考えますか？
装飾的、政治的、破壊的など、あらゆるジャンルのアートを作る様々なアーティストがいるべき。もし世間がアーティストに「こうあるべき」という役割を与えたりしたら、アートは抑制されたつまらないものになると思う。

あなたのアートは、どんな音楽にインスピレーションを得ていますか？
私の友人マリーがいつもCDを送ってくれるのだけど、彼女のおかげでPink Martiniを知ったわ。イラストを描いている時はだいたいNPRのニュースやインタビューを聞いているわね。

opposite: Very enlightened, 2004
overleaf: section openers for a magazine devoted to new mothers, 2004 (Rumina, Japan)
p.136: How to fight stress, 2003 (Shape Magazine)
p.137: Virgo, 1999 (Town&Country Magazine)

isabelle dervaux
イザベル・デルボー

i.D

The artists in this chapter are represented in Asia by the CWC Group.

本章に掲載されているアーティストは、アジア圏においてCWCグループがプロデュースしています。

What is your current dream project?
character design and development for animation

Describe yourself in one word (or a few).
snacky

あなたのキャリアにおける具体的な夢を教えてください。
キャラクターデザインとアニメーション

自分をひとことで紹介してください。
snacky（おやつ好き）

this page: sakura, 2004
overleaf: untitled, 2002

cybèle
シーベル

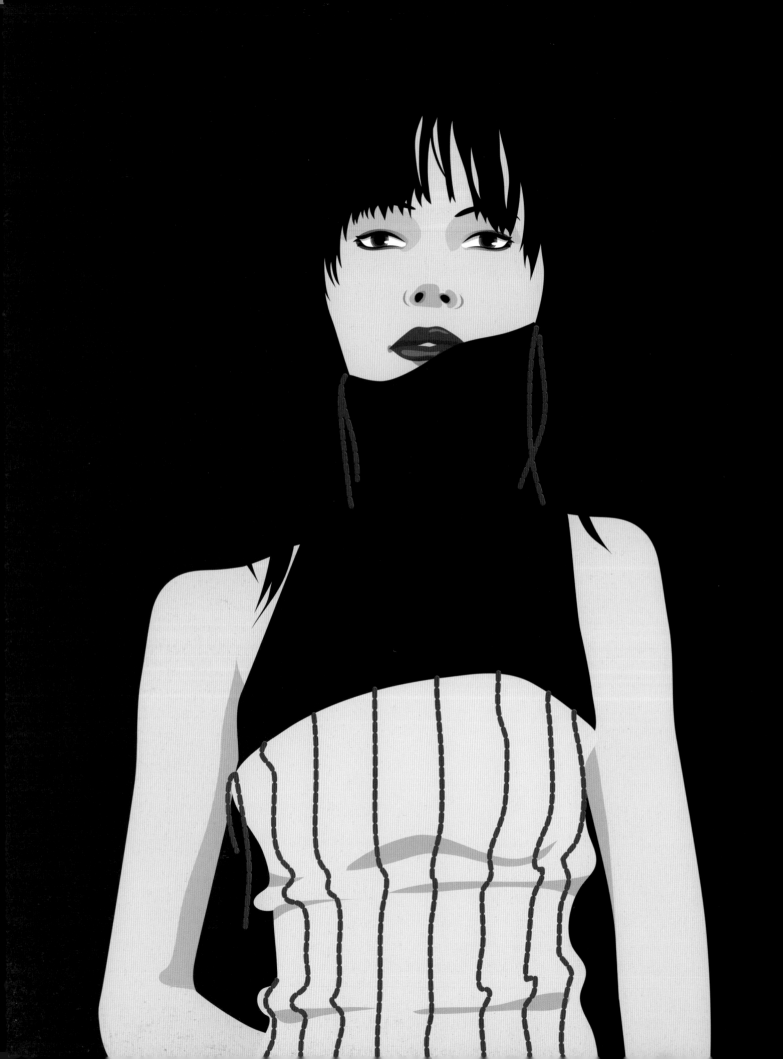

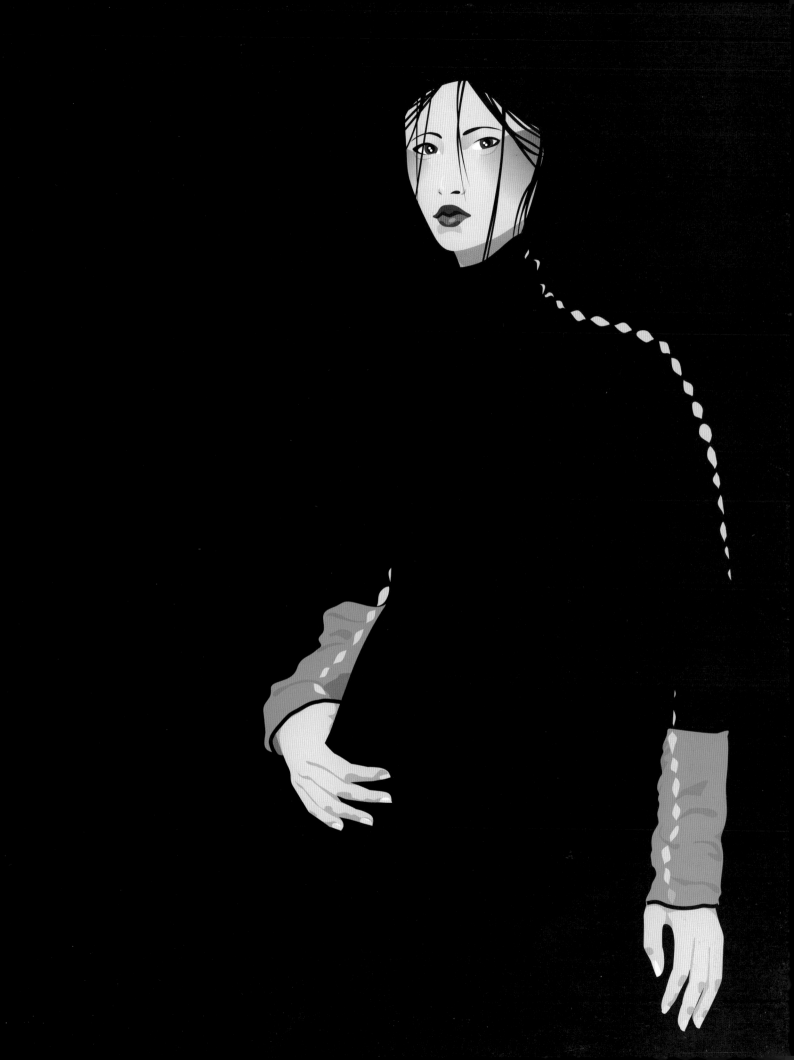

jeff fisher
ジェフ・フィッシャー

What is your current dream project?
my dream project is to design street signs

Your favorite word?
plank

あなたのキャリアにおける具体的な夢を教えてください。
道路標識をデザインすること。

一番好きな言葉は？
plank（板）

this page: Owl, 2003 (Pentagram London)
opposite: Moon, 2003 (Interlochen College)
p.146: Flower, 2003 (Interlochen College)
p.147: Sklave, 2004 (Art Directors Club, Switzerland)

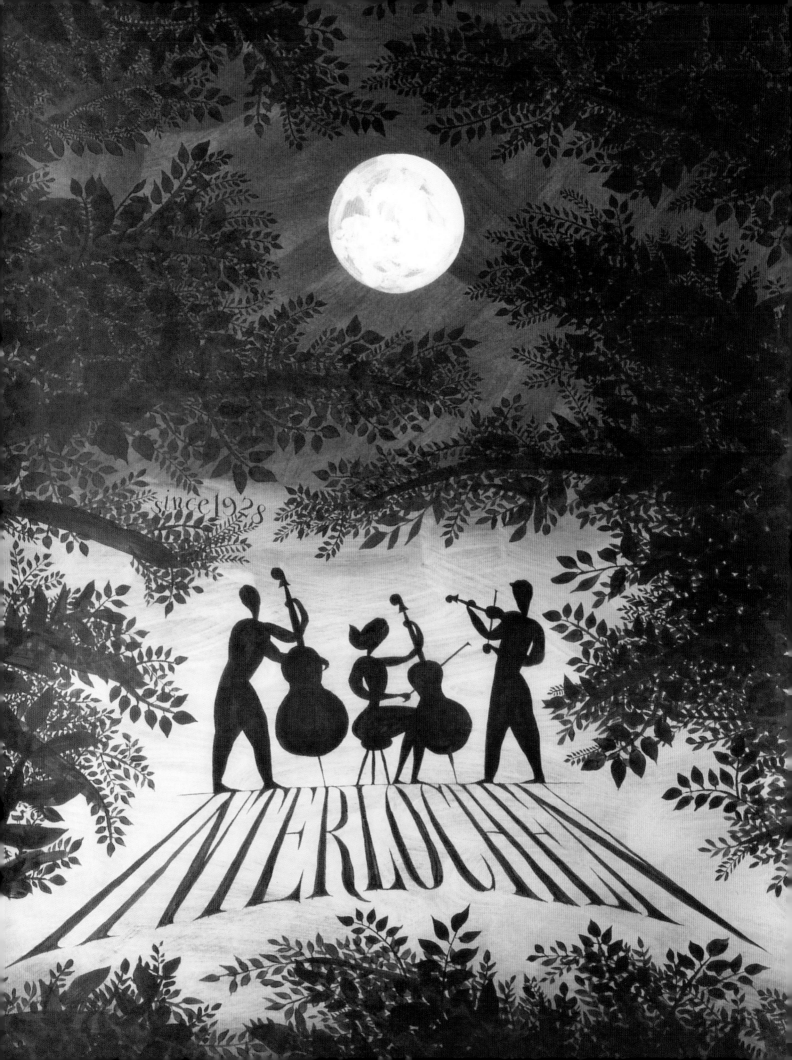

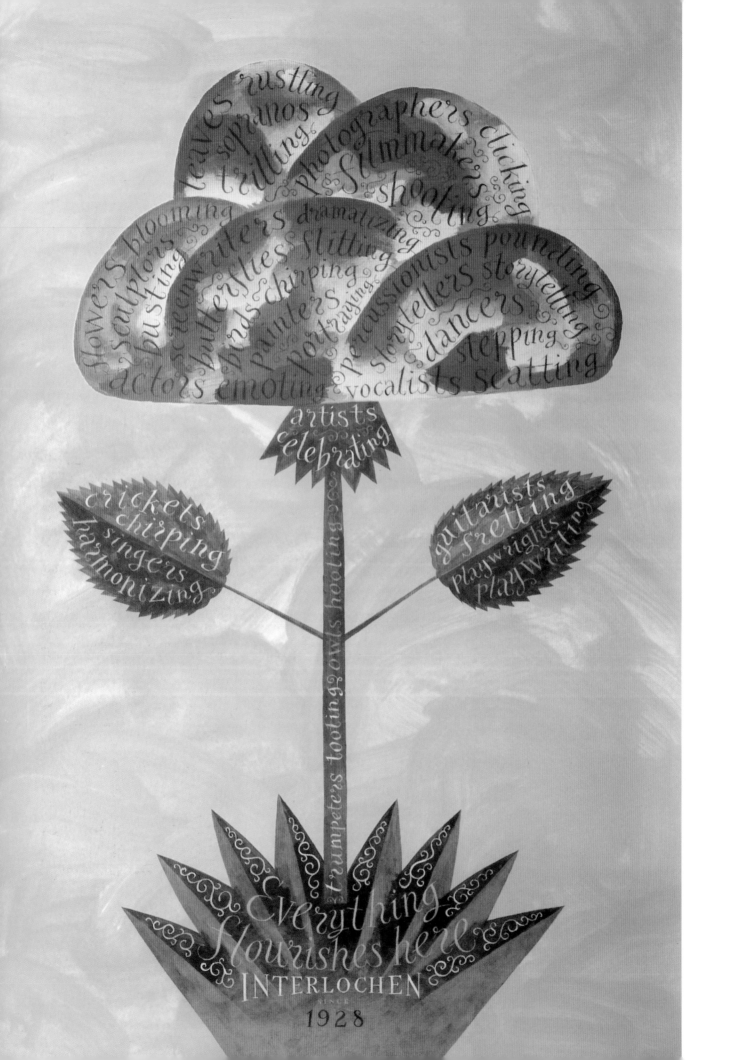

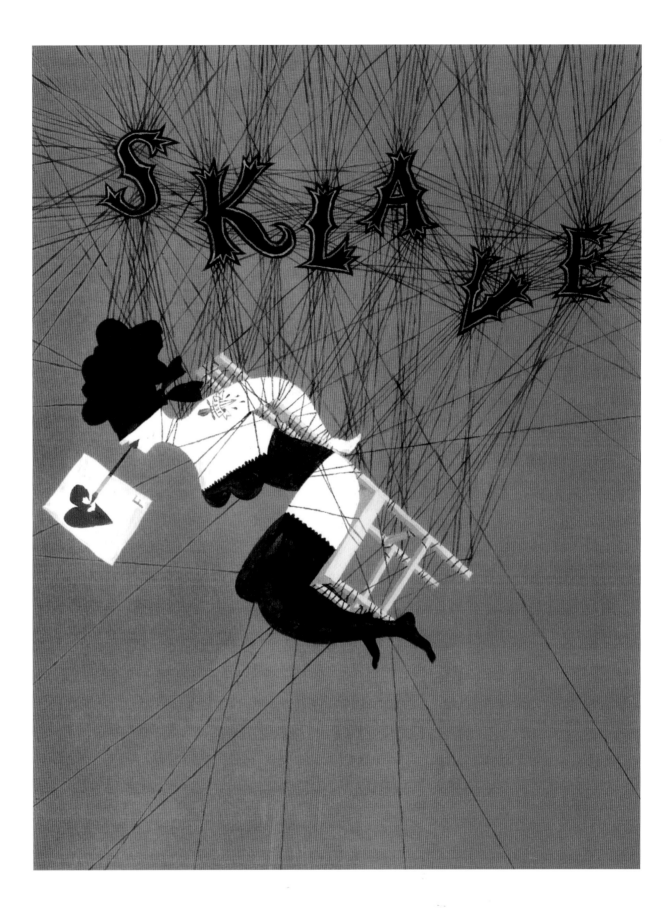

What do you consider to be an artist's societal role?
I don't believe we have a role—in fact, I believe just the opposite is true; that art is a selfish act, a need or desire to express oneself. It is one of the few ways in which I feel complete, that I have a reason for being. It is also an attempt at leaving behind a legacy. In a perfect world, I think an artist would create in an isolated environment for a lifetime, only sharing his work with a handful of close friends, and then, in his final years, possibly in his final decade, he would share this work with the world.

Favorite movie?
Blade Runner, the original version, not the director's cut. I have had periods in my life when it is often playing in the background while I work and live.

アーティストの社会的役割とは、どういうものだと考えますか?
アーティストに役割なんてものはないと思う。それどころか、その逆に近いのではないかな。アートというものは自己中心的な行い、自らを表現する必需性、したいという欲望であり、自分に存在価値があると実感すること。僕が充足感を感じる数少ない方法の一つでもある。また、アートは自分の足跡を残すということでもあるね。完璧な世界であったなら、アーティストはきっと隔離された環境で一生を過ごし、限られた友人たちとのみ作品を分かち合うだろう。そして晩年になって、初めて世界に自分の作品を発表するんだ。

一番好きな映画は何ですか?
ブレードランナー。ディレクターズカットじゃなくてオリジナルの方。僕の人生の中で、この映画が常に生活の背景にあったことが何度もある。

opposite: FENDI, 2003 (DONNA)
p.150: NIKE YOGA, 2003 (NIKE)
p.151: HIBISCUS, 2003 (Le Touessrok Hotel, Mauritius)

kareem iliya
カリーム・イリヤ

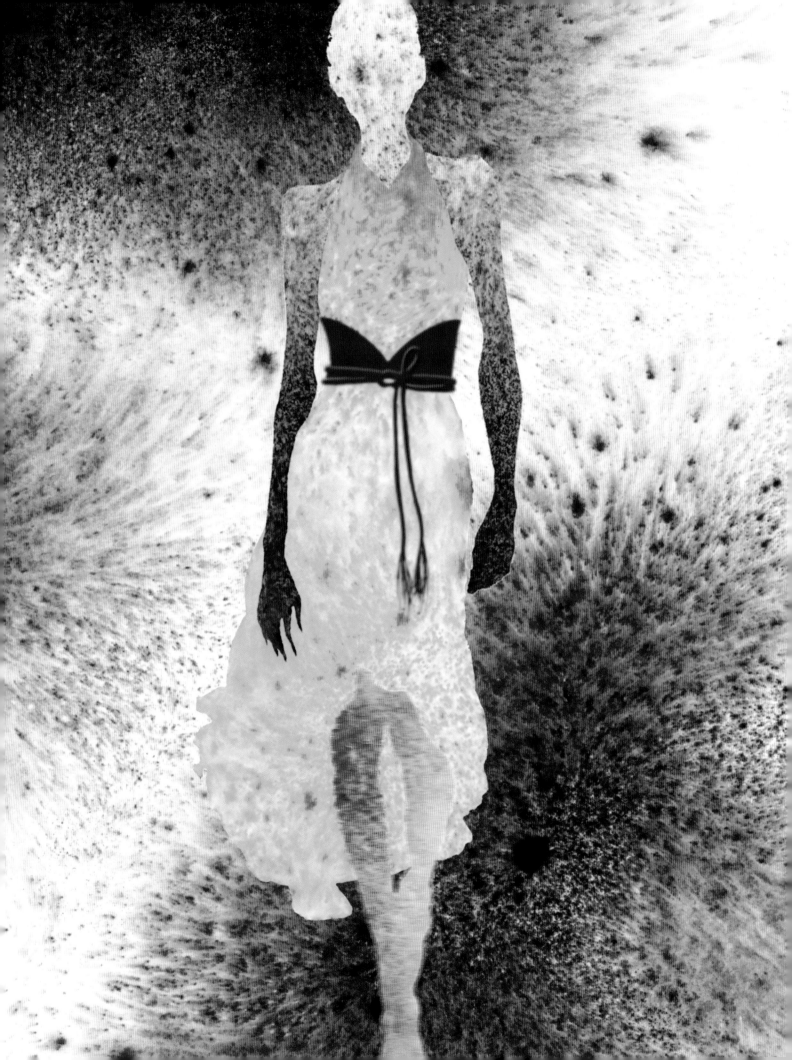

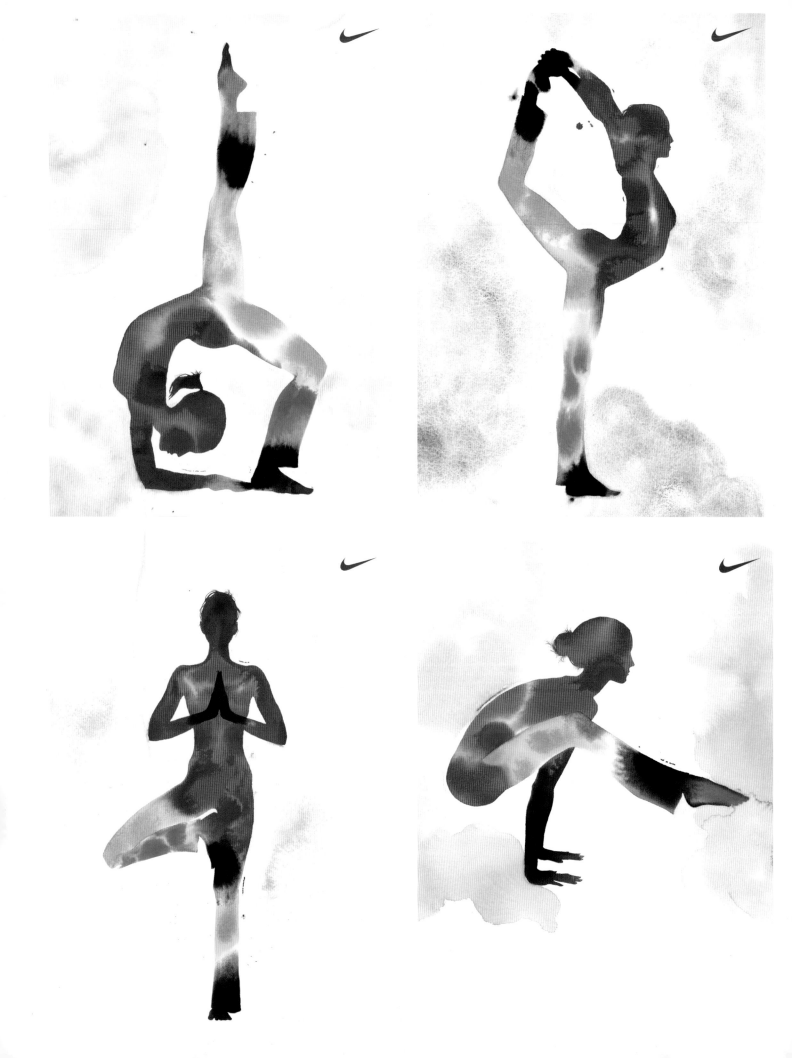

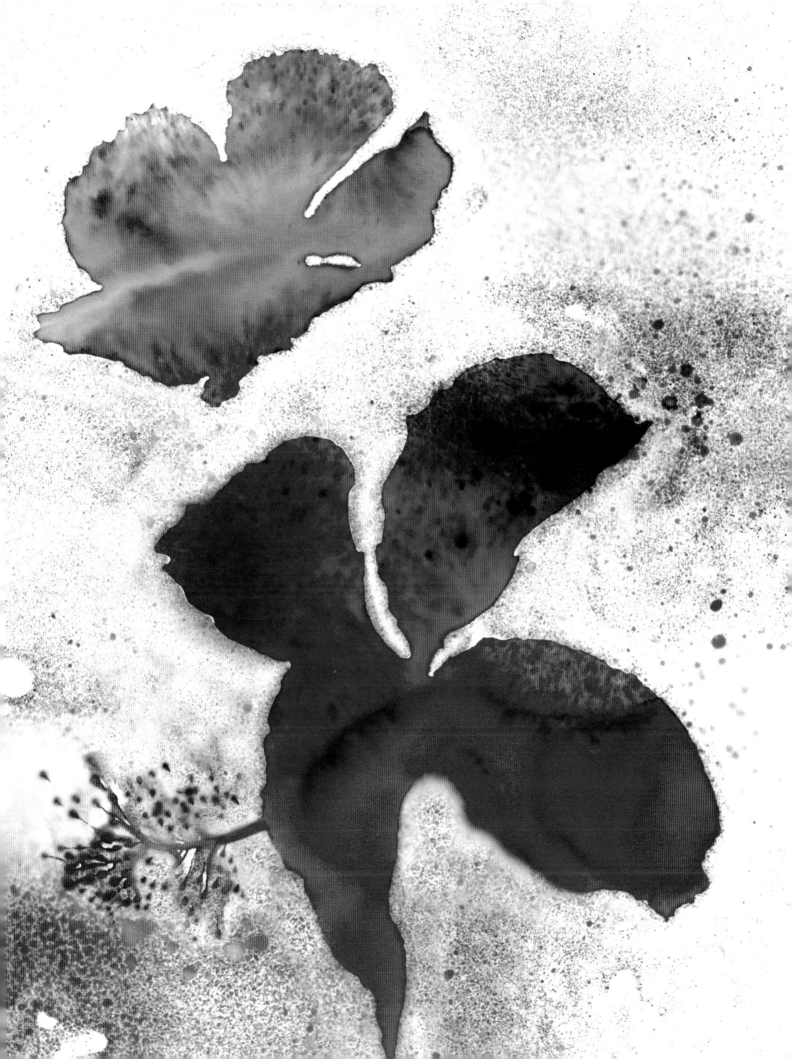

Karine daisay

カリーン・デゼイ

What is the ideal environment you want to live and work in?
In Paris, a little place in my appartement with a pair of scissors, some glue and a lot of magazines...

Favorite color?
All!

あなたが生活をするのに、理想の環境というのはどういったものですか？
パリの、自分のアパルトマンの小さな一角。
はさみとのりと、雑誌がたくさんあるの。

一番好きな色は？
好きな色？全部！

this page: Femmes et Chats, 2004
p.154: untitled, 2004
p.155: Les Européens ont-ils du nez?, 2004 (Thalyscope)

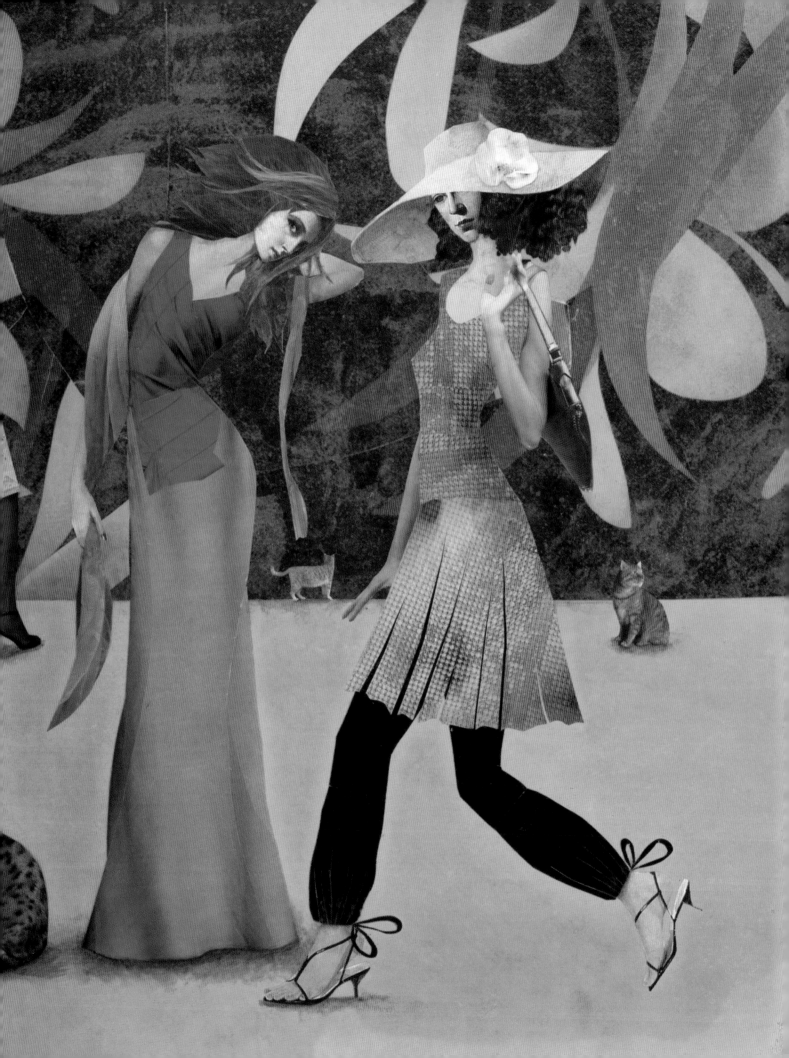

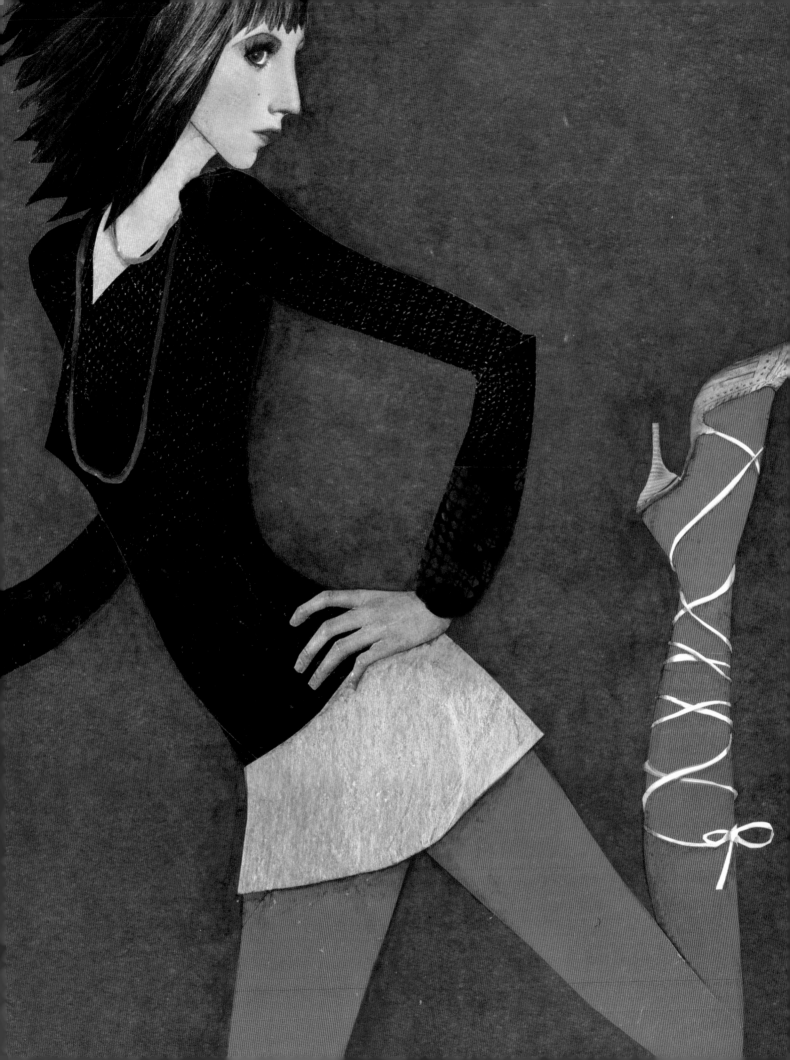

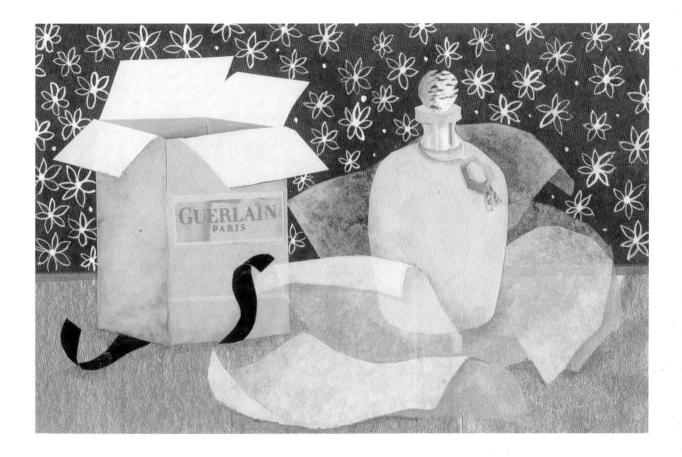

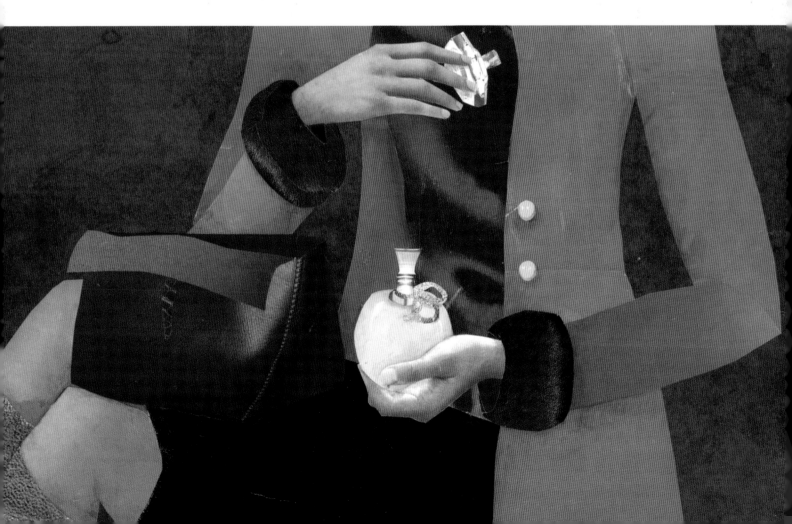

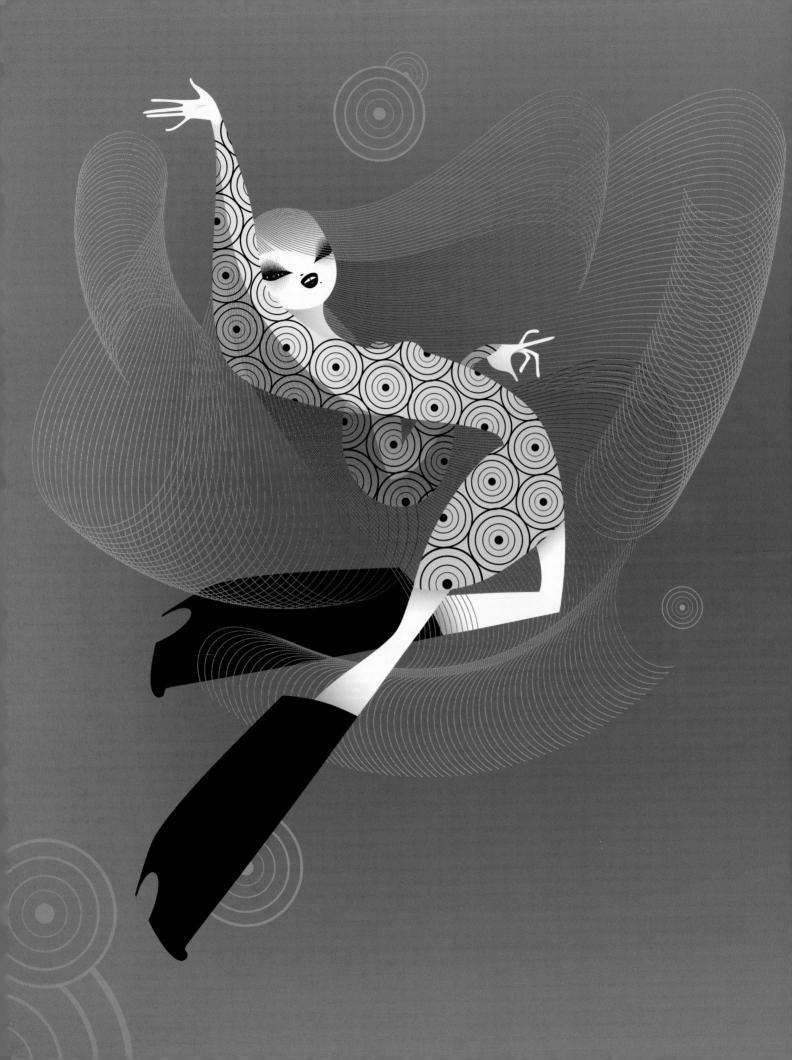

What are your sources of visual influence?
Other than the many great artists I look up to, here are a few of the more personal things that influence my work: candy, jewelry, fireworks, animals wearing clothes, the woods, travel, electronic music, puppets, dancing, gingerbread houses, haunted houses, Disneyland, early videogames, Lite-Brite, fashion, carbonation, space, ghost stories, getting misty while hearing musicians on the subway, parade floats, NYC, Fred Astaire and Gene Kelly musicals, technicolor movies in general, Vegas showgirls, Christmas ornaments, Halloween costumes, heavy metal, color on overcast days, anything miniature, Sasquatch, perfume.

If you could magically possess any one superpower, what would it be and why?
The ability to travel in time. I'm fascinated by ancient history.

あなたのヴィジュアル的なインスピレーションの源はなんですか?
私が尊敬するたくさんの素晴らしいアーティストのほかに、私がインスピレーションを得ているいくつかのものを教えてあげるわ：キャンディ、ジュエリー、花火、服を着ている動物、森、旅行、エレクトロニックミュージック、操り人形、踊り、ジンジャーブレッドでできたお菓子の家、お化け屋敷、ディズニーランド、初期のテレビゲーム、Lite-brite（アメリカのおもちゃ）、ファッション、炭酸、宇宙、怖い話、地下鉄で演奏するミュージシャン（耳を傾けながら涙ぐんだりして）、パレードフロート、NYC、Fred Astaire と Gene Kellyのミュージカル、テクニカラー映画、ラスベガスのショーガール、クリスマスのデコレーション、ハロウィーン衣装、ヘビメタ、曇りの日の色、ミニチュア、雪男、香水。

もしあなたに超能力が与えられるとしたら、どのような力が欲しいですか?
時間を自由に旅する力が欲しい。太古の歴史にとっても興味があるの。

opposite: Zero Gravity, 2004
p.158: Cosmo Bitches, 2003
p.159: Phoebe, 2004

kirsten ulve
カースティン・ウルベ

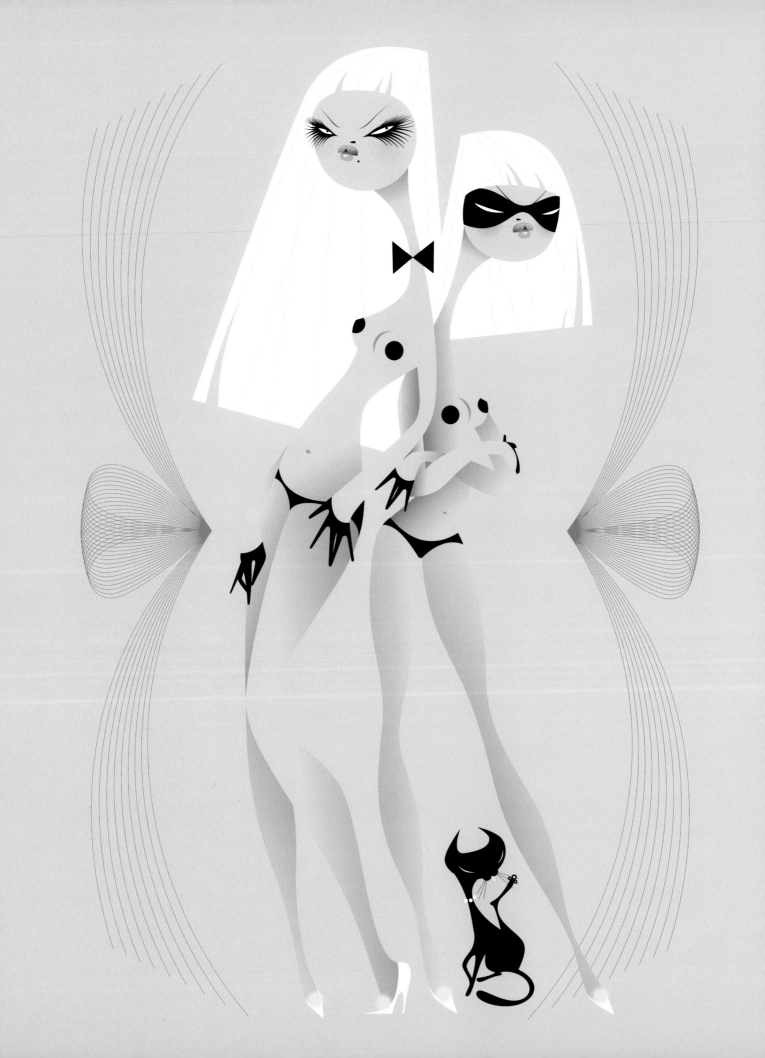

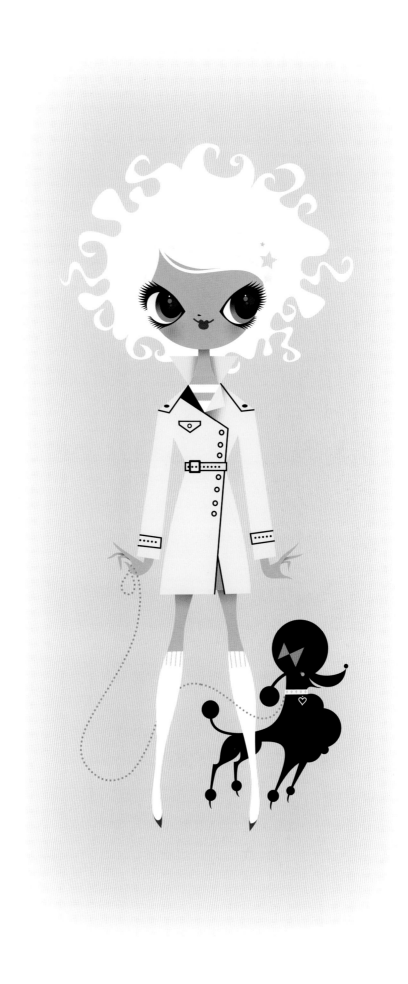

this page: for "Fashion Industry" article, 2004 (Damernas Värld DV, Sweden)

overleaf: for *Head Heart Hips* by Big Active (Die Gestalten Verlag, 2004)

What is "art" in your context?

Art is an investment of time in the future. Making and buying art are statements but also investments in an idea that is permanent. Exceptions include Picasso, who returned to canvases 30 years after creation to amend them, but the result is still a permanent object rather than a piece that is consumed. Picasso perhaps raises the question: is art merely the process or the result? I'd say both... for he was interested in both, an artist that had an interest in distributing and marketing his work as well as working within a free context.

What is "fashion" in your context?

A fleeting idea that is continually outliving itself rather than evolving.
It can be serious, it can be humorous, it may stem from economics and social politics, but it is never static.

What are your sources of visual influence?

I love psychedelics and the freedom of color. Music is equally important, as it is as autonomous as the process of drawing. Both aspects bring dynamics into the frame, especially in fashion illustration where dynamics is of prime importance.

Did you attend art school? If so, was it worth it?

Art school is great. I came from a provincial area right out of London and met a number of influential characters who helped me develop a personality. Without a personality and an expression of that, you can attend thousands of courses but you'll never say a thing. Art school was a catalyst but I'd also add that my development came from making real life decisions, like parenthood, traveling, opting for a career etc....

What is your current dream project?

The KRISTIANRUSSELLBOX will be available soon at www.kristianrussellbox.com

What is your favorite food?

Swedish meatballs are great but contain absolutely nothing nowadays (but they were probably worse nutrition-wise in the 70's when I grew up) so I'd go for sushi and seafood. I'm very Japanese actually.

あなたにとって、「アート」とは？

アートとは未来への時間の投資。アートを作ったり買ったりすることはそれ自体が個人の意見であると同時に
恒久的なアイディアに投資するということだと思う。30年経ってから自分の作品を手直しするためにキャンバスに
向かったピカソなどは例外だけどね。でも結果残されたものは消費される作品ではなく、恒久的な「もの」なんだ。
ピカソは問いかけていたのかもしれない、アートとは過程なのかそれとも結果なのか、とね。僕は両方だと答える。
なぜなら彼は双方に興味を持ち、自由なコンテクスト内で制作するのと同じくらい、自らの作品を広めたり、
マーケティングすることにも魅力を感じていたと思うから。

あなたにとって、「ファッション」とは？

進化をする代わりに、自らの寿命を延ばすことで生きながらえている暫定的なアイディア。
真剣な時もあれば、ユーモアに満ちていることもある、経済や社会的政治に根ざしていることもあるけれど、
決してとどまらない。

あなたのヴィジュアル的なインスピレーションの源はなんですか？

サイケデリック！そして、その色がもたらしてくれる自由がとても好きだね。
音楽も、絵を描くことと同様に自律的な行為であることから、同じくらい重要だ。
これら両方がフレーム内にダイナミックな息を吹き込んでくれる。
ダイナミックなエネルギーが最重要事項であるファッションイラストレーションにおいて、
これはとっても大事なことなんだ。

美術学校で学びましたか？もし学んだのであれば、それは有意義な経験でしたか？

アートスクールは最高だよ。僕はロンドン郊外の出身なんだけど、学校で何人もの個性的な人々に影響を受け、
自分の個性というものを築いてきた。個性とそれを表現する力を持たなければ、何千もの授業を受けたって
何も言葉を発することができない。そういう意味でアートスクールはある種の触媒だったのだけど、
僕の個性の発展はその後の人生の転機における様々な判断と経験の積み重ねによるところが大きいと思う。
例えば、子供を育てること、数々の旅、キャリアにおける判断等々・・・

あなたのキャリアにおける具体的な夢を教えてください。

KRISTIANRUSSELLBOXがもうすぐwww.kristianrussellbox.comでお披露目になるよ。

一番好きな食べ物は何ですか？

スウェーデンのミートボールは最高だけど最近のは全く何も入ってないんだよね。
（でも栄養価で言えばきっと僕がそれを一番食べていた70年代の方がひどかったんだろうけど）
だから寿司とシーフードの方がいいかな。僕って実は結構日本人なんだ。

kristian russell

クリスチャン・ラッセル

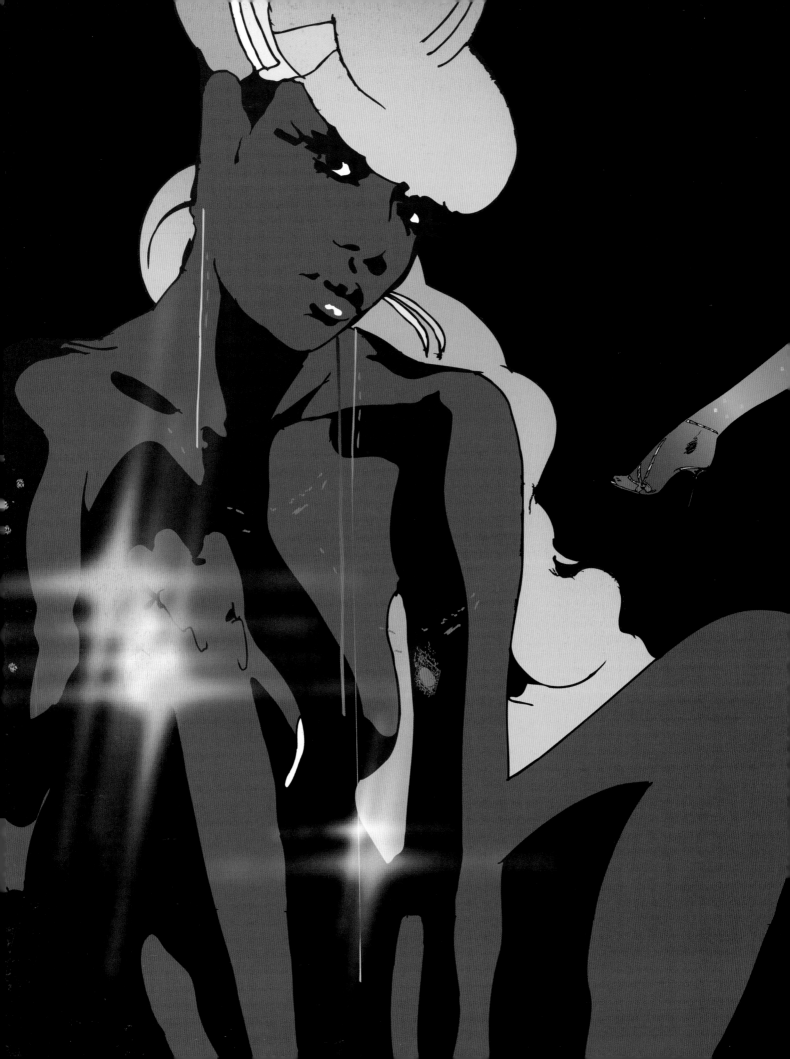

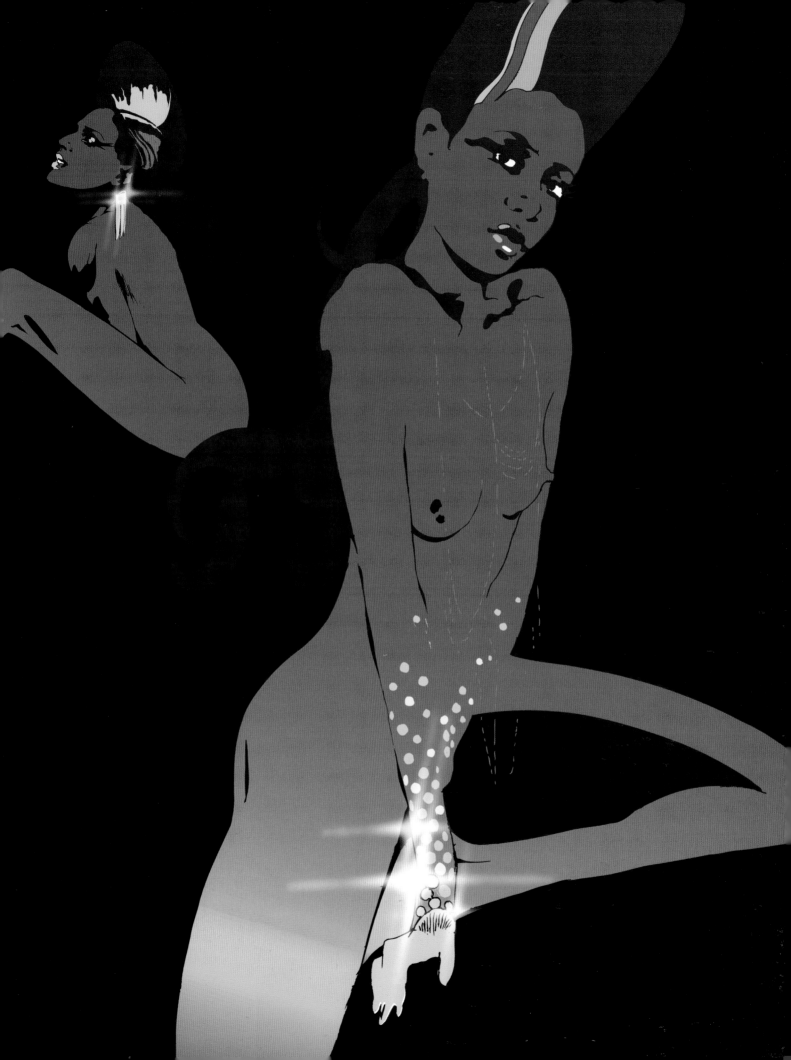

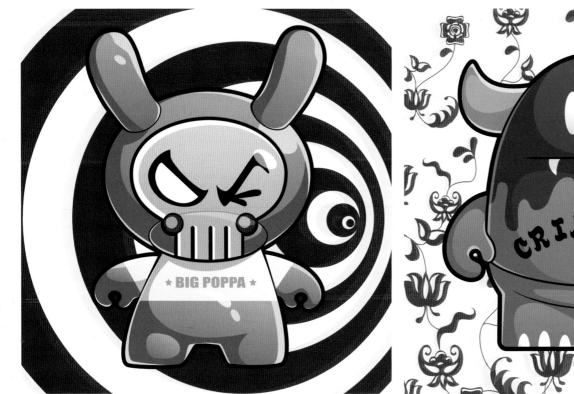

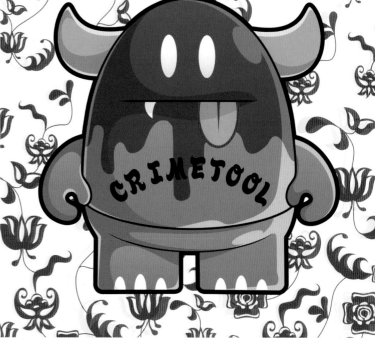

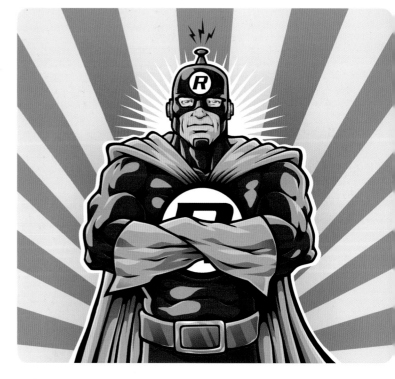

What is your current dream project?

My dream project is to design GIANT toys. Through "Blow Molding," a factory can produce toys up to 6 feet tall! Then I would fill my apartment with them and treat them like roommates. This would be a dream.

What is your favorite time of the day? Why?

I think my favorite time of the day is between 3:30 to 5:00 in the morning. I tend to be the most productive just before sunrise for some reason. I think it's because I can really lose myself in what I'm doing (and not have to answer the phone)!!!

あなたのキャリアにおける具体的な夢を教えてください。

理想のプロジェクトは巨大なおもちゃをデザインすること。
Blow moldingという手法を使えば工場で180cm以上のおもちゃを作る事が可能なんだ!
そうやって作ったおもちゃで自分のアパートをいっぱい埋め尽くして、彼らをルーム
メイトみたいに扱うんだ。それが夢だな。

一日のうちで一番好きな時間はいつですか?

朝の3時半から5時の間だと思う。日が昇る前のこの時間がなぜか仕事が一番
はかどるんだ。たぶん自分のしていることに没頭できるからだね。
電話もとらなくていいし!

this page (clockwise from top left):
Big Poppa Dunny, 2004 (Kidrobot) / Purple Felony Toro, 2004 (Kidrobot) / Killer, 2004 (TRACE Magazine)
opposite: Lord of the Ramp, 2003 (RAMP Magazine)

tristan eaton トリスタン・イートン

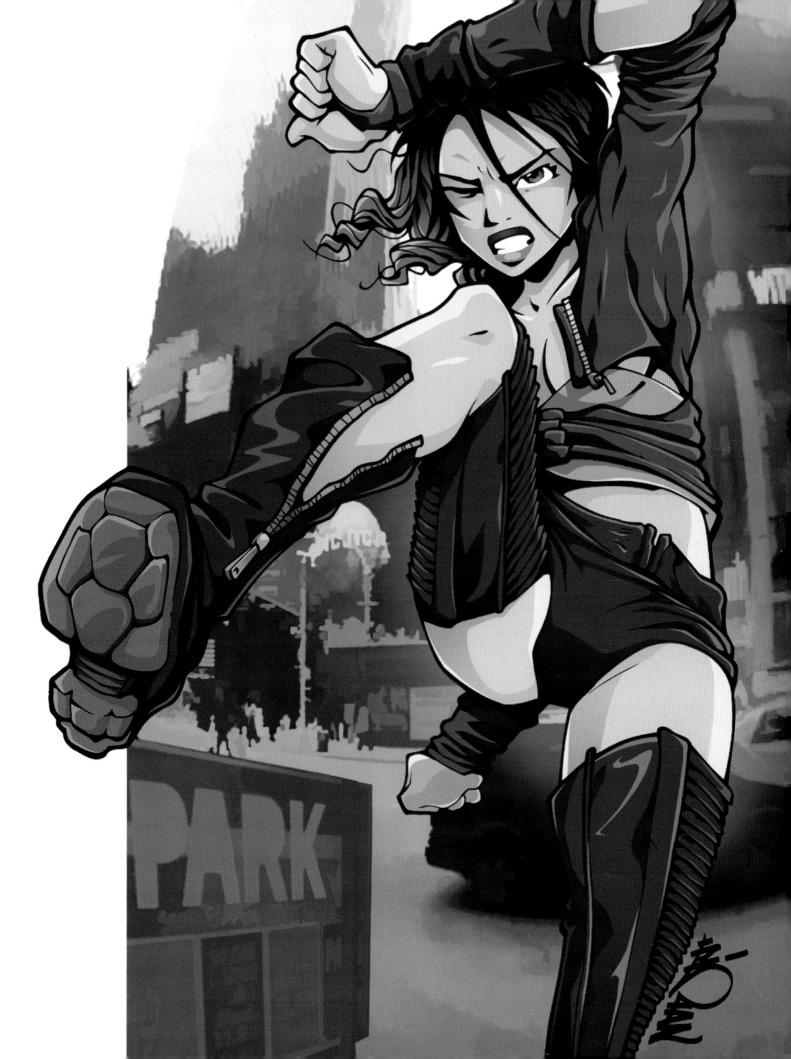

à la carte

The artists in this chapter are strong, young talent represented by the CWC Group depending on the territory.
ア・ラ・カルトは、期待される若手アーティストをひとつの章にまとめました。
本章に掲載されているアーティストは、それぞれの地域において、CWCグループがプロデュースしています。

Territories（契約地域）:
Angel Oloshove, Ayako Machida, Hiromi Sato, kaetan by mizuka, Kumano Gollo by Akiyoshi Chino : Global / Superdeux : Asia & North America

angel oloshove エンジェル・オロショヴ

How does your background affect your art?
The ratio of sky to land in Michigan is very dramatic. Looking out at my family's farm I felt that I could see the curve of the earth. There was vast expansion, potential for things to grow and go on forever. Because of this I felt no boundaries with what I could do and who I could become.
My parents are both very good at what they do (specialists, I think). I wanted to become a specialist in something too, so at the age of 13 I decided to become a painter. The murals at our family church taught me about communication through artwork. Symbols and allegory were a way to visually communicate a message, and this influence can be seen in my work today.

What is "fashion" in your context?
It is important to bring great fashion and design to people who don't even know they need it.

あなたの育った環境はあなたのアートにどのような影響を与えていますか？
私が生まれ育ったミシガンは、空と大地との比率がとてもドラマティックなところ。いつも家族の畑を見渡しながら、地球のカーブが見えるような気がしていた。そこには壮大な広がりがあって、ものが無限に発展していける可能性がある。そのせいか、幼い頃から自分ができること、自分がなれるものに制限を感じたことはなかった。私の両親は二人とも職人肌で、それぞれ自分の仕事がとても得意なスペシャリスト（専門家）達。私も幼い頃から何かのスペシャリストになりたくて、13歳の時にペインターになることに決めた。家族で通っていた教会の壁画などが、アートを通してコミュニケートすることを私に教えてくれた。特にシンボルやアレゴリーはヴィジュアル的なメッセージを伝えるのに有効な手段だし、この影響は今日の私の作品にも現れていると思う。

あなたにとって、「ファッション」とは？
ファッションとデザインを必要としていることに気づいていない人々にもそれらをもたらすことは大事なことだと思う。

this page: Come Here Dear, 2005 (CWC)

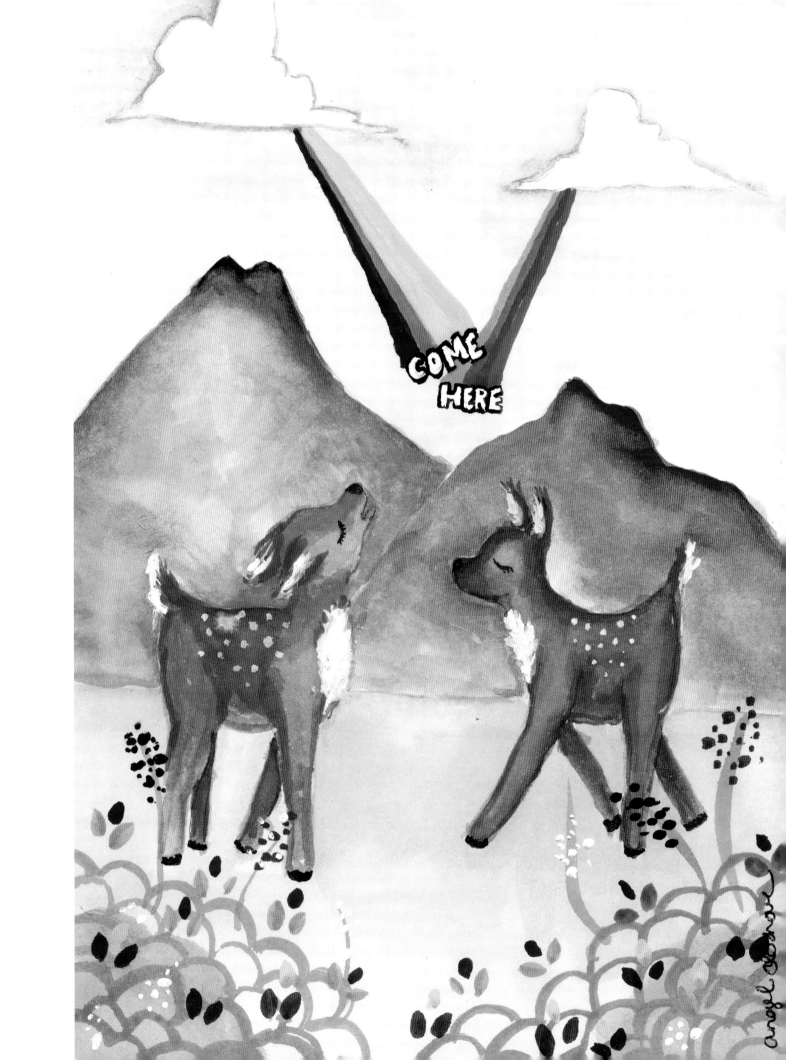

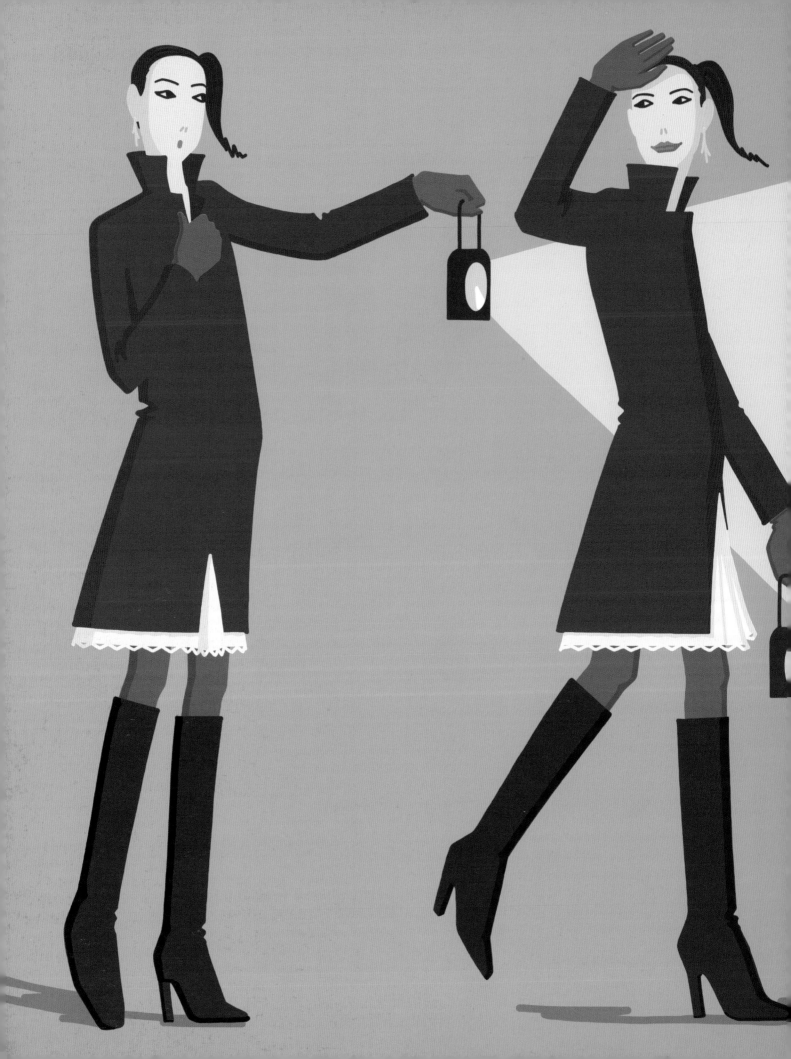

ayako machida

町田綾子

How does your background affect your art?
The first thing everyone says when they meet me for the first time is that I am exactly like the people I draw. I am not conscious of it, but I guess I show through in my work. Perhaps because I was raised in the old city of Nara, I notice a tendency to lean towards East Asian motifs and colors; yet I live a Western lifestyle, which is also apparent in my work. I often find myself tempted to add a touch of humor or a storyline to my illustrations, which probably can be attributed to my being raised in Kansai—the Kansai region has always valued comedy. My work is not overly dramatic, it's more mild and easy—I think that's a reflection of my middle-class upbringing with gentle, caring parents.

What is your current dream project?
I want my work to be used on the packaging of daily household items like detergent, milk cartons and medication. Not only will they liven up the supermarket shelves, they will be picked up by those who do not care for art otherwise. They're things you put away in cupboards, but creative packaging may make people want to keep them out where they can see them. I want my art to be assimilated into everyday life.

What was the last CD you bought?
I last bought HULA-HULA DANCE by Kenji Jammer. Highly recommended!

あなたの育った環境はあなたのアートにどのような影響を与えていますか？
初めて会う人に必ず言われるのは「イラストに登場している人そのまま！」ということ。意識はしていないけれど絵の中に自分がそのまま出ているかもしれない。奈良（古都）で生まれ育ったからかモチーフや色合いに東洋的な感じを出したくなる。西洋の文化生活なのでそれは普通に出ているし、少し笑いやストーリーを入れたくなるのは関西（お笑いが好きな土地柄）に住んでいるからか・・・絵に大きなインパクトがなく、緩やかな雰囲気なのは中流家庭に育ち、温和な両親の性格を受け継いでいる自分が表れていると思う。

あなたのキャリアにおける具体的な夢を教えてください。
洗剤、牛乳パック、薬などの日用雑貨のパッケージに使われたい。スーパーマーケットの商品棚を楽しくして、絵に興味のない人にも手に取ってもらって、普段家ではしまい込まれてしまうものだけど、あえて外に置きたくなるような。
生活の中に普通に溶け込むアートになりたい。

最後に買ったCDは何ですか？
Kenji JammerのHULA-HULA DANCE。
お勧めです！

this page: untitled, 2004
overleaf: untitled, 2004

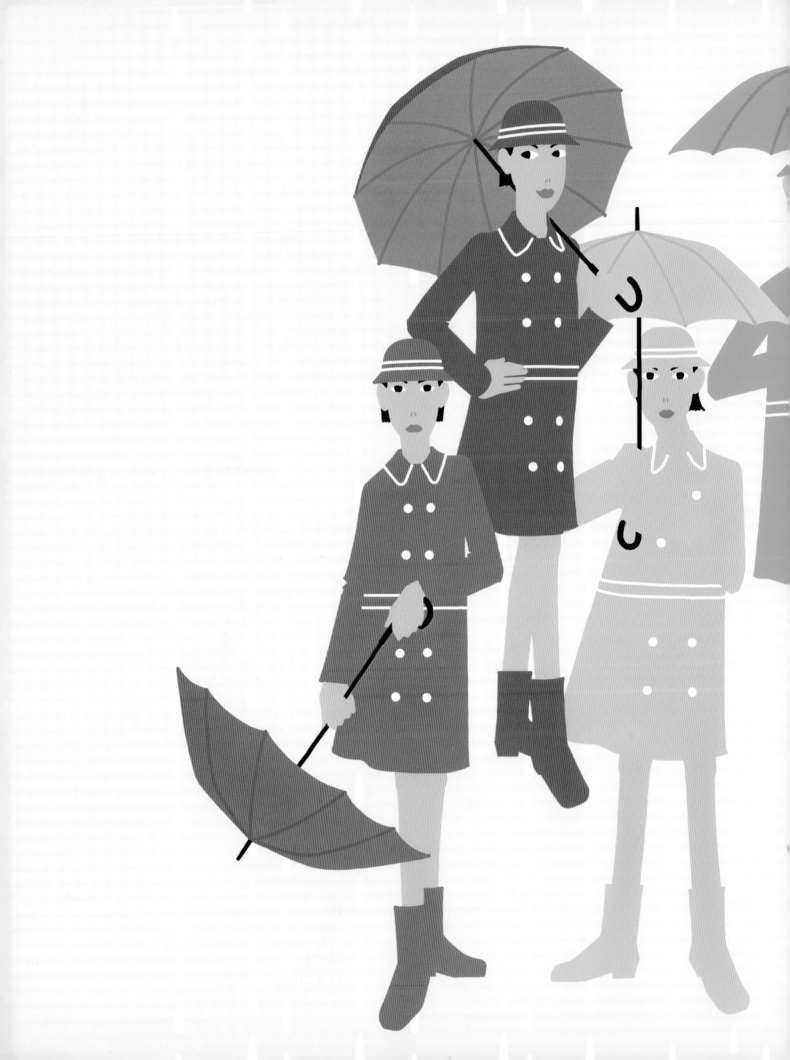

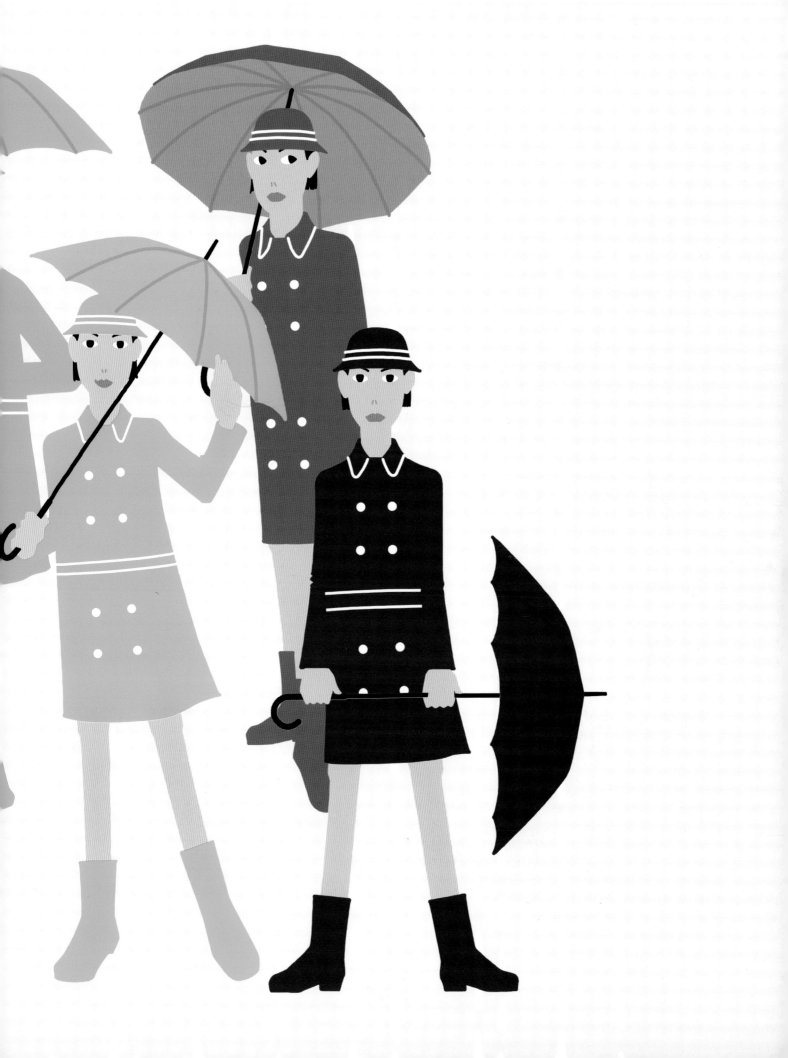

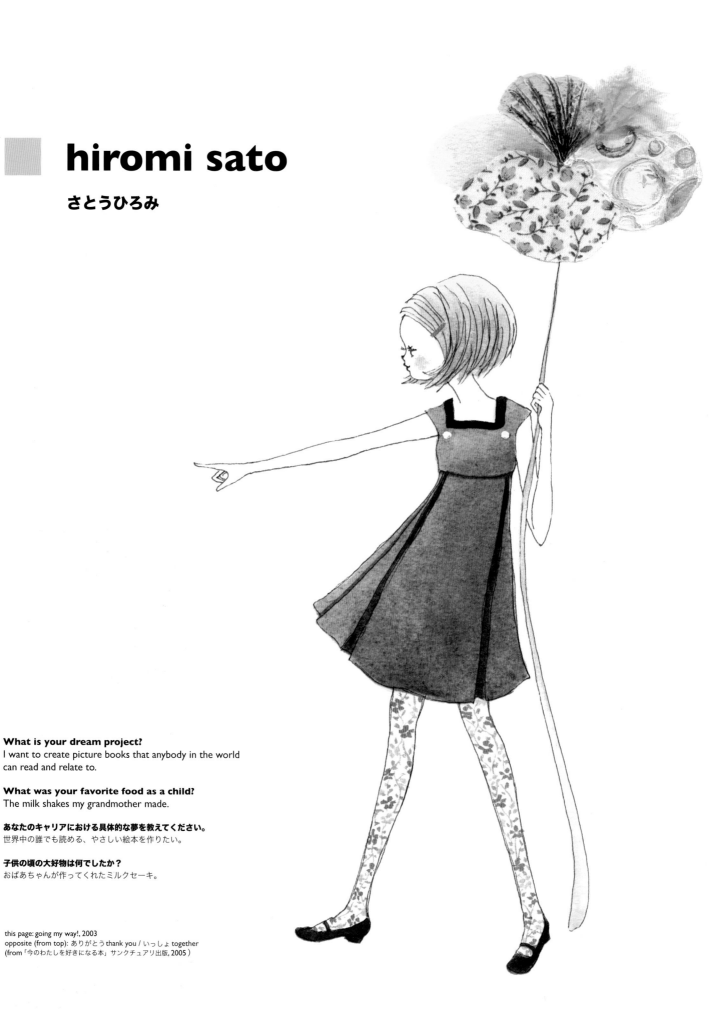

hiromi sato

さとうひろみ

What is your dream project?
I want to create picture books that anybody in the world
can read and relate to.

What was your favorite food as a child?
The milk shakes my grandmother made.

あなたのキャリアにおける具体的な夢を教えてください。
世界中の誰でも読める、やさしい絵本を作りたい。

子供の頃の大好物は何でしたか？
おばあちゃんが作ってくれたミルクセーキ。

this page: going my way!, 2003
opposite (from top): ありがとう thank you / いっしょ together
(from「今のわたしを好きになる本」サンクチュアリ出版, 2005)

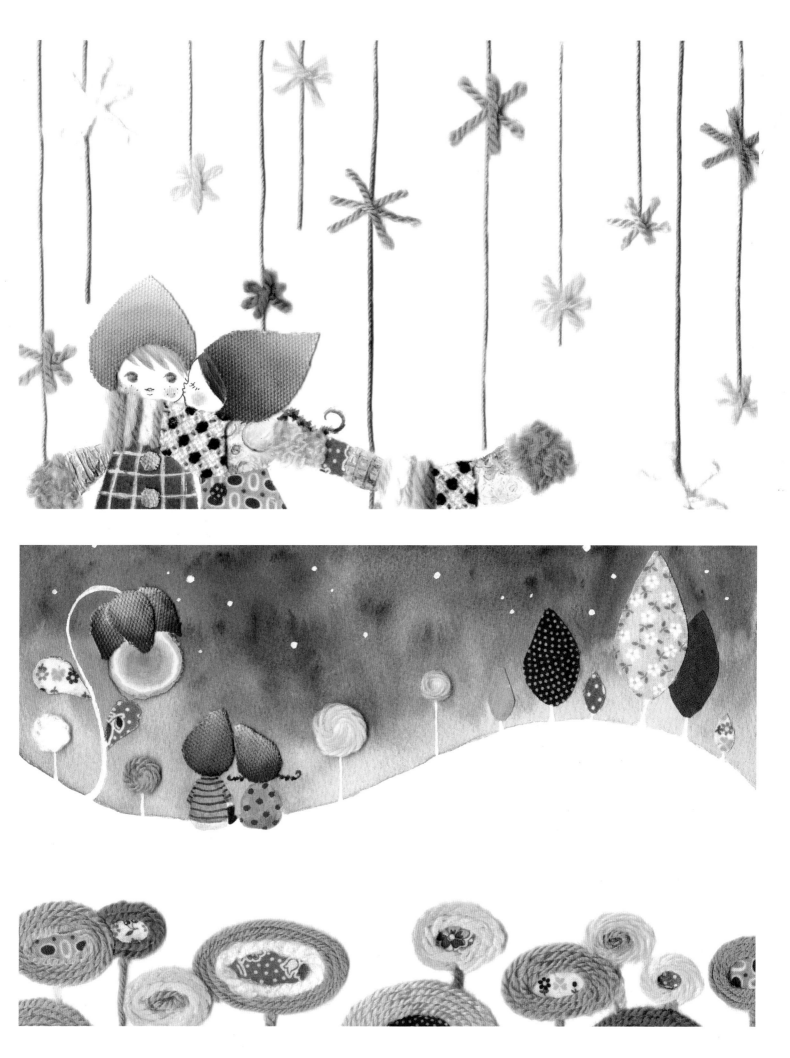

kaetan

カエタン by mizuka

What is "art" in your context?
A lovely item that add meaning to my life.
It can also be incredibly frustrating at times, however.

What is your current dream project?
Ultimately I want to create picture books.

As a child, what did you want to be when you grew up?
Caretaker of animals.

What do you think is the most important thing in this world?
LOVE

Describe yourself in one word (or a few).
Timid.

あなたにとって、「アート」とは？
私の時間を充実させてくれる素敵なアイテム。
でも時々どうしようもなく腹が立つ奴でもあります。

あなたのキャリアにおける具体的な夢を教えてください。
最終的には絵本を制作してみたいです。

子供の時、大きくなったら何になりたかったですか？
動物を飼う人。

この世界で一番大切なものは何だと思いますか？
LOVE

自分をひとことで紹介してください。
小心者です。

this page: kaetan島 (kaetan island), 2004

Where do you draw your visual inspirations from?
Things that aren't the focus of attention at the moment—things that aren't "in."
Things that are too unique that the mass ignores them.

Please describe a specific goal in your career.
To innovate a new market in which the industry of character design can fully function.
To create characters that even Hello Kitty would like to hug.

As a child, what did you want to be when you grew up?
4th up to bat, pitcher CHINO in the pro baseball league.

What skill or technique do you wish for?
A strong and eloquent voice and a comely smile that will draw people in,
shake their souls, and make whatever I say sound legitimate.

ビジュアル的なインスピレーションはどこから得ていますか?
その時に光っていないもの。アクが強すぎてマスに相手にされないもの。

あなたのキャリアにおける具体的な夢を教えてください。
キャラクターデザインがフル機能する新しいマーケットの開拓。
ハローキティーにハグしてもらえるようなキャラクターを作り出す事。

子供の時、大きくなったら何になりたかったですか?
4番 ピッチャー チノ〔プロリーグで〕

自分にあったらいいと思う特技、スキルやテクニックはなんですか?
相手を引き込ませ、揺さぶり、何を喋ってももっともらしく聞こえるような強くてよく通る声と透き通った笑顔。

this page: untitled, 2005

kumano gollo

by akiyoshi chino

熊野五郎 by 千野晃良

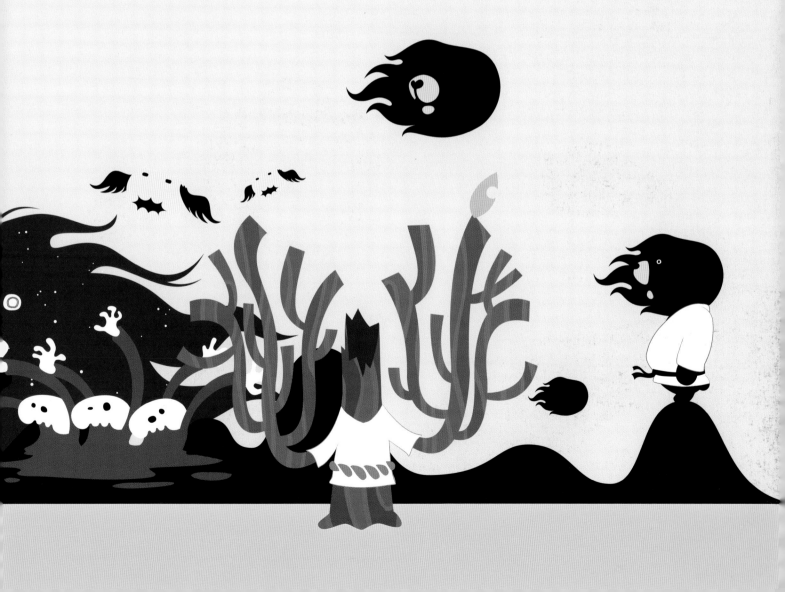

FEZ BECA PICO MEA

What about your art is most appealing to others? To you?
I think many people like my work because it makes them feel good and even makes them laugh. For me, my work is a reminder of how we can be ironic using sweet and cute imagery.

What are your sources of visual influence?
My interests have always been in using "international" images, whether it be American hip-hop, old-school urban culture or Japanese illustrations.

What futuristic invention do you look forward to?
I can't wait to receive my emails directly to my brain.

If you were a cartoon character, who would you be?
I would like to be the TOFU character by Devilrobot, because tofu will save the world.

Describe yourself in one word (or a few).
Glasses

Change the world in 5 steps. What would those steps be?
1- eat more pasta
2- make more toys
3- eat more curry
4- make more teeshirts
5- eat more rice+"furikake"

あなたのアートの何が見る人を最も惹きつけるのだと思いますか？あなたのアートの何があなたを最も惹きつけるのですか？
僕の作品が人々に気に入られる理由の一つは、見る人の気分を良くさせ、時に笑わせることができる、ということだと思う。個人的には、スイートでキュートなイメージを保ちながらもどれだけアイロニーを伝える事ができるかを絶えず思い出させてくれるのが僕の作品。

あなたのヴィジュアル的なインスピレーションの源はなんですか？
アメリカンヒップホップ、オールドスクールのアーバンカルチャーや日本のイラストレーションなど、「インターナショナル」なイメージにいつも惹かれる。

実現してほしい夢の発明品は何ですか？
自分の脳に直接メールを受けるようになる日が待ち切れない。

もしあなたが漫画のキャラクターだったなら誰だと思いますか？
僕はデビルロボットの豆腐キャラクターになりたい。なぜなら豆腐は世界を救うから。

自分をひとことで 紹介してください。
メガネ

あなたに「世界を5つのステップで変えなさい」という課題が与えられたとしたら、どんなステップで世界を変えますか？
1. もっとパスタを食べる
2. もっとオモチャを作る
3. もっとカレーを食べる
4. もっとTシャツを作る
5. もっとふりかけご飯を食べる

clockwise from top left:
bee and gee, 2003 / Stupid the Damaged Dog, 2005 / Mimil, 2002
background:
stereotype, 2002 (Red Magic)

superdeux
スーパーデュー

FEZ BECA PICO MEA

amore hirosuke

annika wester

chico hayasaki

chris long

dynamo-ville

erotic dragon
by miho sadogawa

jeffrey fulvimari

jessie hartland

jun iida

kacchi

kenzo minami

lulu*

marcus oakley

masaki ryo.

masayuki ogisu

matt campbell

michael bartalos

stina persson

tina berning

8

12

16

22

28

32

36

42

46

50

54

60

64

70

76

80

84

90

96

yuki hatori

yuri

dominique corbasson

françois avril

dovrat ben-nahum

isabelle dervaux

jeff fisher

kareem iliya

cybèle

karine daisay

tristan eaton

kristian russell

kirsten ulve

angel oloshove

ayako machida

kaetan
by mizuka

kumano gollo
by akiyoshi chino

hiromi sato

superdeux

READING LIST
Course:
BA Graphic Design
2007-8

イラストレーションアラモード

2005年10月25日　初版第1刷発行

著者　ジュンコ・ウォング ／ 中野圭子
発行者　ジュンコ・ウォング
デザイン　佐藤裕美 ／ 小林あづさ
発行所　CWC BOOKS（有限会社クロスワールドコネクションズ）
〒150-0033 東京都渋谷区猿楽町4-3、2階
TEL: 03-3496-0745
FAX: 03-3496-0747
agents@cwctokyo.com
www.cwctokyo.com　www.cwc-i.com　www.cwc-licensing.com

発売元　株式会社グラフィック社
〒102-0073 東京都千代田区九段北1-14-17
TEL: 03-3263-4318
FAX: 03-3263-3297
http://www.graphicsha.co.jp
印刷所／製本所　第一カラージャパン株式会社

振替00130-6-114345
乱丁・落丁本はお取り替え致します。
本書の収録内容の一切について無断転載、無断複写、無断引用等を禁じます。

ISBN4-7661-1642-9
Printed in Japan

illustration à la mode

Produced and Edited by Junko Wong - Cross World Connections / Koko Nakano - CWC International
Art Direction and Design : Hiromi Sato - Cross World Connections / Azusa Kobayashi - CWC International

Published by Junko Wong , CWC BOOKS
4-3, 2F Sarugaku-cho, Shibuya-ku, Tokyo 150-0033 Japan
TEL:+81-3-3496-0745 FAX:+81-3-3496-0747
agents@cwctokyo.com www.cwctokyo.com

Cross World Connections (Tokyo)
4-3, 2F Sarugaku-cho, Shibuya-ku, Tokyo 150-0033 Japan
TEL:+81-3-3496-0745 FAX:+81-3-3496-0747
agents@cwctokyo.com www.cwctokyo.com

CWC International (New York)
296 Elizabeth Street, #1F New York City, NY 10012
TEL:+1-646-486-6586 FAX:+1-646-486-7622
agent@cwc-i.com www.cwc-i.com

CWC Licensing
www.cwc-licensing.com
nyc@cwc-licensing.com / tokyo@cwc-licensing.com

Distributed by Graphic-sha Publishing Co., Ltd.
1-14-17, 4F Kudan-Kita, Chiyoda-ku, Tokyo 102-0073 Japan
TEL: 81-3-3263-4318 FAX: 81-3-3263-5297
info@graphicsha.co.jp www.graphicsha.co.jp